his favorite singer was, and he said Merle Haggard. God really blessed ol' Merle. He's the real deal!"

—Alan Jackson

"Merle Haggard is an incredibly versatile songwriter. He wrote all kinds of songs and all kinds of melodies. I think what we do is probably more influenced by music that was playin' twenty and thirty years ago than by contemporary artists from the last few years. In country, he was one of the top dogs. He always had that badass attitude that I like . . . he was the outlaw's outlaw."

—Kix Brooks, Brooks & Dunn

"We're always asked about what singer influenced us the most, and for me, it's hands down: Merle Haggard. He had not only just the voice but he had that dark side that he would apply to his writing. I think the emotion and stuff he put into his music may be a bad thing for him, but it's a good thing for all of us out there listening to his music."

—Ronnie Dunn, Brooks & Dunn

"When I started to have to deal with all those things that have to do with real life, that's when Merle's music started to make sense to me."

—Emmylou Harris

"In my opinion, Merle Haggard is one of the greatest country singers alive. I idolized Hank Williams, and he was a big influence on me, but when it comes to current singers, Merle is one of my favorites. There aren't many true country singers left. Merle Haggard is one of them."

—George Jones

"He has been called 'the working man's poet,' and from his songs and his type of singing, he does represent the working man."

—Robert Duvall

MY HOUSE OF MEMORIES

AN AUTOBIOGRAPHY

MERLE HAGGARD

WITH **TOM CARTER**

DEY ST.
AN IMPRINT OF
WILLIAM MORROW *PUBLISHERS*

DEY ST.
AN IMPRINT OF
WILLIAM MORROW *PUBLISHERS*

A hardcover edition of this book was published under the title *Merle Haggard's My House of Memories* in 1999 by Cliff Street Books, and a paperback edition was published in 2002 by HarperEntertainment.

Photo of Merle, Theresa, and Rose "Vegas" Waters © by Hope Powell

HarperCollins books may be purchased for educational, business, or sales promotional use. For information, please e-mail the Special Markets Department at SPsales@harpercollins.com.

FIRST IT BOOKS PAPERBACK PUBLISHED 2011.

Library of Congress Cataloging-in-Publication Data is available on request.

ISBN 13 978-0-06-202321-6 (pbk.)

17 18 [RRD] 30 29 28 27 26 25 24 23 22 21

To my fans, who have stood by me for better or worse and through sickness and in health. I want to thank them for their loyalty.

I chose *My House of Memories* as the title of my new book
because it is my mother's favorite song
that I have ever written or sung.

CONTENTS

CONTENTS

PREFACE

I've had a blessed life, despite many lows, many of which were of my own doing. There have been times when I simply could not see the light at the end of an economic, romantic, psychological, or emotional tunnel. I've lived through seventeen stays in penal institutions, incarceration in a penitentiary, five marriages, bankruptcy, a broken back, brawls, shooting incidents, swindlings, sickness, the deaths of loved ones, and more. I've heard tens of thousands chant my name when I couldn't hear the voice of my own soul. I wondered if He was listening, and was sure no one else was.

My unhappiness, at times, was overwhelming. If anyone had ever told me I'd be as content as I am today, I would have thought they were talking about someone else.

So I decided to share what has worked for me, knowing it will work for others. I'm a little embarrassed about some of the stories I'm going to tell. They're more like confessions than the mere reporting of events. I really can't communicate how high I've risen without first telling you how low I had

sunk. Today, I'm ushered into peace of mind by love—the love of God, a good woman, and family.

Think that will never be your good fortune? I felt the same way, at least when I allowed myself to have feelings, rather than deadening them with drugs and alcohol.

I'm told that when one writes his life story he's supposed to "tell all." I haven't. The incidents and ordeals in the following pages implicate no one but me. I haven't used the names of those who have abused me, or those I might have abused. I have passed out literary black eyes to no one but myself. I've never thought I could lift myself up by tearing others down.

When my story has required negative information, I've withheld names. The people know who they are. It's more important that you know what happened than that you know who did it. You'll see.

I asked Tom Carter to put my thoughts into words, as that's what he does for a living. I'm the first to admit the English language is not my specialty.

Rose "Vegas" Waters, one of my best friends and my business manager, asked me recently why I'm not angry with those who have taken advantage of me. I replied that I am letting God deal with them. God has given me an abundance of blessings; I'm trying to return an abundance of forgiveness.

Words are no more than what they say, and the following say much about this life, a runaway roller coaster that occasionally spun out of control.

Today, I'm on track.

Welcome to my world. Enter through the gate of "My House of Memories."

—MERLE HAGGARD

1

* * * * * * * * * * * * * * * * * *

"THE PARTY"

The people milled nervously, fidgeting and looking at their feet the way folks do when simultaneously embarrassed and angry. They gawked at what they probably thought was a madman in swimming trunks on the mammoth boat in front of them. He was yelling profanities that echoed across Northern California's sprawling Lake Shasta for hundreds of yards, as sound does on water.

"Shut up, Grandma, damn it Grandma, shut up!" is what echoed from this big mammoth fifty-five-foot houseboat with an ultralite airplane mounted on the rear.

The onlookers starred in disbelief. Maybe the man inside was drunk, maybe he was high. Then the man on the boat stepped way over the line. "To hell with you, Grandma," he yelled. As he stepped out the door, he suddenly noticed a crowd gathering in the area around his boat. He smiled sheepishly.

No one smiled back.

"It's not what you think," the man on the boat tried to explain. "Wait, I'll show you."

He sounded like a man yelling from inside a cave. The onlookers could still hear him snapping at "Grandma."

Eventually, he emerged from the boat. "This," he said, holding up the canine, "is Grandma."

The people looked at each other and then back at him. "This really is Grandma," he insisted.

No one spoke.

Still, the man stood there, holding a toothless, absolutely loveable, and incredibly old teacup poodle, with its limp tongue hanging out of its mouth.

That was Freddy Powers, my longtime songwriting partner who shared a houseboat next to mine in the late 1970s and early 1980s.

For thirty-one days straight I never left the lake. I had my toothbrush tied to the boat and let it dangle in the water of Lake Shasta. We drank cayenne pepper drinks and wore very little clothes, if any. There was lots of drugs, women, good friends, good music, and fun.

Freddy bought an ultralite aircraft equipped with pontoons, which he had no idea how to fly. I had a pilot's license and helped him learn to fly. I helped him as much as I could from the ground. One time he used it to fly around the lake and locate women who were sunbathing in the nude.

Freddy would call from the plane to announce the location of the sunbathers, or he'd wait until he flew back to the boat to tell me. He'd land his ultralite on the water in front of the dock. Then we'd take my boat to where the women were.

MY HOUSE OF MEMORIES

I saw potential in Silverthorn Resort, I bought ownership in the place. I turned it into a top-class marina, but it was also the worst financial mistake in my life.

Silverthorn was a marina renting houseboats and cabins. When I bought into it, I built a nightclub, a restaurant, and a store on the water. I also performed there as an entertainer and acted as a supervisor for over a hundred people.

I won't mention by name the people I went into partnership with because of the legal ramifications it might bring about, let alone hard feelings.

I once decided to examine the business records at Silverthorn, and sent Jim Upshaw, my friend and former tour bus driver, to get them. He loaded boxes of records onto my boat and was going to bring them to me at my ranch house. As he was departing the docks, a wife of an official saw him.

"Put them records back!" she yelled from the shore. "You ain't going nowhere with them!"

Upshaw put the boat into reverse and continued to back away from the dock.

At that point, the woman pulled a pistol and aimed it squarely at his head.

"I said you ain't going nowhere with them records!" she insisted.

Upshaw thought she was bluffing and opened my twin-engine V-8s to full throttle. He backed up so fast, it's a wonder water didn't come over the stern.

She never fired the gun. Upshaw later said that if he had thought she wasn't bluffing, he would have surrendered the records.

By 1990, seven years later, I was out of Silverthorn, I was

still paying off debts I had incurred because of my 49 percent ownership of the business and the tax bills on the place going back to 1948, which I had paid 100 percent. If I hadn't been busy working the road, writing and recording new songs, and doing drugs to keep up with the fast pace, I might have caught the thieves. Some of the brighter memories have nothing to do with a drug-clouded mind, such as . . .

We had a wet T-shirt contest on my boat every Wednesday night after Silverthorn's weekly water skiing show. The late Lewis Tally, who produced my first record on his own record label, was in charge of squirting the contestants.

The contest was rigged.

We gave a cash prize to the winner. Secretly, Freddy and I told the judges to select the sexiest girl to win second place. Her prize was a ride on our boat from the lake up Pitt River with Freddy and me.

A famous female country music star and I once spent five days nude on that boat. We snorted drugs the entire time and didn't go to sleep once.

I know my children will someday read this book, and so I'll stop the reports about my dissipation right here. I can only tell my kids that they don't need to learn from their mistakes; they can learn from mine. There is no percentage in drug or alcohol abuse. I've been drug-free since 1983, and even then, I didn't use them very long. Hard drugs were something that only lasted a couple of years in my life. They are not allowed in my company under today's rules.

I had won every major award and was headlining shows in front of tens of thousands of people. By 1980, I had recorded twenty-five number-one records and seven that

reached number two in *Billboard* magazine's surveys. I had won Grammy Awards and had been named Entertainer of the Year by the Country Music Association, the highest honor the CMA bestows. I had performed at the White House on several occasions.

But it wasn't as glamorous as it sounds, riding a bus back and forth across America several times each year. I knew every interstate highway and major truck stop from sea to sea. I was getting weary of the grind.

The number-one songs would total forty-one by 1989, the highest number ever recorded by a living country music soloist, I'm told. In addition, another sixty-three of my tunes reached the top three. More than one hundred songs made the *Billboard* survey. I'm not bragging, just trying to make a point.

I had done it all, I felt, so burnout and the boat hideaway went hand in hand.

My popularity was unusual for those days, since country music wasn't as fashionable as it is today. Garth Brooks would lead the way to country's unprecedented popularity beginning in 1989. Country music is different today and more popular than it has ever been. But it seems a little short on soul and substance sometimes, and it doesn't turn me on!

I didn't even know wife number three was planning to leave. One day I had stepped on my boat when the telephone rang; she simply said "Bye-e."

"What?" I said.

"Bye-e," she said again.

I begged her to come back. I had been doing that for six months, and suddenly got sick of myself and my pleading.

Something inside me snapped. I instantly went from sorrow to anger. When she phoned again, I said, "Can you hear me?"

"Yes," she said.

"Can you hear me real good?"

"Yes," she said again.

"Fuck you!" I shouted.

I never spoke to her again, except once when we won an award for "You Take Me for Granted." She wrote the song. We were called on stage to accept our trophy. The moment was a little strained.

I intentionally haven't mentioned her name. I gave her a chance to tell her side of the story for this book, and she declined. She doesn't want to be in my book, well fine. I don't want to mention her name. But I want to thank her for leaving me. Seriously. It was one of the best things to have ever happened to me.

Wife number three retained famous divorce lawyer Melvin Belli, who got a court order for temporary support long before the divorce was granted. I had to pay $25,000 a month in after-tax dollars, a tidy sum in 1983. And she had withdrawn cash from our joint bank accounts.

My third wife was a singer who wanted a career of her own. She had a few records but never anything big. After our divorce, I vowed I'd never again marry anyone in show business. To the best of my recollection, I never again even dated anyone in the entertainment industry.

To this day, her kids come to my shows. Things must not have been too bad in our household for them. It's hard to remain friends with children to whom you've been a stepfa-

ther, but I seem to have done it. I loved 'em all and they know it.

Johnny Carson and I were spending more money on spousal support in the 1980s than any other Americans. He used to make jokes about it.

Once my third divorce was granted, I vowed I'd never remarry. Someone said I should follow the advice of the late Lewis Grizzard, and that the next time I was tempted to marry, I should just buy the woman a house and go on with my life.

I first met Upshaw after he walked up to my boat while visiting a Lake Shasta bass tournament. He'd recently made a large sum of money from the sale of his orchard near Bakersfield.

He came aboard and said to Freddy Powers, Lewis Tally, and me, "Boys, do you mind if I buy me a houseboat and hook up right over here? I'd like to join this party." He could have lived anywhere in the country, but a glimpse of the party and he was sold on Silverthorn Resort and my T-shaped dock. So he returned to Bakersfield, the only place he'd ever lived, and moved lock, stock, and bathing suit to the boat next to mine.

He single-handedly built a second story on my boat and became a surrogate member of my family.

Upshaw, who admits he used to drink heavily, almost died in my arms the day we met. Perhaps it's fitting that he would later save my life, because I saved his during the first minutes of our acquaintance.

Upshaw was approaching my boat when he stepped on a

piece of floating material he had mistaken for solid dock. He was drunk.

The material went out from under him, leaving him floundering in the wintertime waters of Lake Shasta. I knew he'd drown quickly in the cold water.

I jumped onto the dock and got Upshaw out of the lake.

Friends helped me revive him. When he at last came to, he looked up at me hovering above his body. I could tell he was trying to focus on the stranger peering into his blurry eyes.

"Thanks," he whispered. "Thanks."

Upshaw became a fixture on the dock and another player in the party. I don't remember the following incident, but Upshaw says it's true, and I've never known him to lie.

He recalls a binge that left me overloaded with drugs when I went to sleep. The last person to whom I spoke was Betty Adams. I told her not to allow anyone onto my boat, because I wanted to sleep without being disturbed.

When Upshaw started to come aboard the next morning, Betty stopped him.

"You can't go on," she said. "Merle said he doesn't want to be disturbed." He argued with her, but she wouldn't give.

When Betty wasn't looking, Upshaw slipped onto my boat. He later said he simply felt he was "supposed" to disobey my orders, and was "supposed" to barge onboard.

He found me passed out with a woman. He called our names, but we didn't move. He began to shake us, and still there was no response.

Finally, the woman and I came around, he said.

I thought I was out of it from severe exhaustion more

than the drugs. But Upshaw and everyone else sized it up differently.

I apparently told Upshaw he had just saved my life and then sat on the bed and wept. He and I must have cried for thirty minutes, Upshaw says.

During those days, I was down more than I had been in years.

2

"THE FIRST THING
I REMEMBER KNOWIN' . . ."

I was born on April 6, 1937, at Kern General Hospital in Bakersfield, California, and I was reared inside a former Santa Fe reefer (a refrigerated train car), referred to as a "boxcar" in most stories about me. My dad, James Haggard, had heard about a boxcar that he thought he could convert into a home, and he did, despite remarks from its owner about his plans.

"Oh yeah? I've never heard of an Okie who'd work," my sister Lillian remembers the seller saying.

"Oh yeah," Dad shot back. "I've never heard of one who wouldn't."

Dad moved to Oildale, a town outside of Bakersfield, from Oklahoma, one of the thousands who fled Oklahoma's dust bowl in 1935. His barn had been hit by lightning and burned to the ground. He left for that reason. He did not yield to the depression or the elements, like many did. The fire cost him everything he had, so he gave up and joined the migration to the West. It seemed the most sensible thing to do for a possi-

11

ble new start. My daddy was a rambler, and was never happy in California. He wanted to be footloose. He always talked about going back to Oklahoma, almost every night. He'd say, "Mom, I've been studying. I think we ought to sell out and go back to Okie." It never happened. It just wasn't in the cards. What an unselfish man he was, to do what he needed to instead of what he wanted to.

The boxcar he converted into a house lay three hundred feet from the Santa Fe Southern Pacific oil spur—an oil line that drew from the bowels of the city. I grew up with the coming and the going of the trains. The unending line of tank cars, and the gigantic steam engines, with the engineers and firemen who would take time to wave at you because you were a boy. I guess that old oil train that ran twice a day was the first one I fell in love with.

My daddy was a railroad man, and died a railroad man. Railroad men were heroes in the era in which I was raised, and oil was the most sought after commodity.

I guess one of my earliest memories of our life in the boxcar had to do with my dad taking me to buy a puppy when I was three. Dad bought the puppy from Harold Granger. Funny whose names we remember and whose we don't. Jack was a black-and-white male fox terrier that I had for twenty years. He looked like the RCA dog.

You know the first words ever uttered from my lips at the age of two concerning an opinion on music were "Stewed Ham." My mother, being a great lady, was trying to feed me something to eat, when I began pointing at the radio, still demanding, "Stewed Ham, Stewed Ham!" Mom, being quick as she was, knew what I wanted. It was four o'clock in the

afternoon, and Stuart Hamblen was about to come on the radio. Stuart Hamblen's radio program originated from Los Angeles in those days. A lot of the shows were from the foothill club in Long Beach, California. At any rate, he came on in our town every weekday at four o'clock. Stuart Hamblen, with his own band, and his own style of music. For those of you too young to have heard Stuart, too bad. The records that remain don't do him justice. Stuart was famous for composing such songs as Rosemary Clooney's "This Old House," for the gospel standard "It Is No Secret," the standard from the thirties "My Mary," and of course the great "Remember Me, I'm the One Who Loves You." I recorded a couple of his tunes myself, and met him during one session. Life has funny turns.

My childhood was never really normal. I grew up in the midst of World War II. Every family in America had at least one or two involved in the war. We were fighting the Japanese in the South Pacific, and Germany and its allies in Europe. We had brothers, cousins, brothers-in-law, and friends inlisted. My dad was thirty-nine, so he was slightly too old to be of legal draft age. So he got to stay home, or we might have lost him sooner than we did. I guess God knew I needed him for those precious nine years.

Toys were few, mostly homemade by my father. Sundays with Grandpa and Grandma Harp were wonderful with food grown from my grandmother's garden. Homemade raisin pies that she dried herself on the roof. I think anyone would have considered us poor, but somehow we always had plenty.

I remember my seventh Christmas on this earth as if it were yesterday. I awoke at 3:30 in the morning hoping to

catch Santa Claus, because I knew if I didn't talk to him personally, he probably wouldn't leave the electric train I'd asked for in my letter. It cost $9.95 in the Sears Roebuck catalog. But I knew that not even Santa Claus had that kind of money in 1944 to squander on the wishes of a child. But as I rubbed the sleep from my eyes, I could see that Santa had already been there. Someone, probably him and Dad, had already set the train up around the tree. There were two versions in the catalog, the $14.99, and the $9.95. The more expensive having an extra tank car, two switches, and a side track. I thought, "How did Santa Claus know I liked old trains?" Somehow, before that day was over, I figured out who Santa Claus really was.

Although it was wartime, those were the most peaceful years of my life, because of the love, security, and dependability of my parents. Lowell and Lillian were already grown and gone, so basically I was a loner, because they lived their own lives somewhere else. I was content to play with my dog, and spend a lot of time with my dad. He used to drive home from work with two wheels on the railroad tracks, just to make me laugh.

Many years later, I took the wheels off an old Ford and replaced them with guide wheels from a boxcar so I could drive the car down the railroad tracks. *Life* magazine published a picture of me doing just that with a caption pointing out that I had been arrested for the stunt.

School was boring for me, and church was confusing. It seemed none of my family agreed on which church to go to. I am currently part of the Gene Scott ministry. I am proud to be a part of his army. I believe Christ rose from the grave,

and will return again. But as a child, church seemed to me to be a place of argument between adults. I guess you would call me undenominational or, better yet, "christian." I believe in the doctrine of Paul, and the power of faith, and one's ability to strike up a rapport with his God.

Back to my childhood in the 1940s and wartime: The only thing I knew that my dad hated for sure was a liar. I don't remember any sermons on the subject, but it was something that I always knew. I must have inherited his dislike for liars, because I feel the same way about anything less than the truth. My dad was known for his trustworthy handshake. Everyone knew his word was good. Ever since my early childhood, I have found more importance in the trait of honesty—and was aware of its necessity—than maybe most children. In my mother's autobiography I read where she said of me as a child that I was never selfish and that I could never be a store owner, because I'd give the store away. If I could have had brothers and sisters my age, and a Daddy that hadn't died, I think I would have had much more in my house of childhood memories.

3

★ ★ ★ ★ ★ ★ ★ ★ ★ ★ ★ ★ ★ ★ ★ ★ ★

"I WAS BORN THE RUNNIN' KIND"

Less than two years after my daddy's death, I left home. I was barely past eleven.

After Dad died, my mother had the wisdom to know I needed a positive role model in my life other than Lowell, who was fourteen years older. So she arranged for me to spend the summer with my great-aunt Willie and great-uncle Escar in River Bank, California, near Modesto.

They lived in a two-room house with an outhouse and a woodstove. Escar and Willie had a little nine-acre dairy farm. They grew their own food and made extra money during peach-picking time in Modesto. Although they were poor, they were rich with common sense and ways to provide and make do. Fishing in those days was not only a pleasurable outing, it was a necessary excursion. Escar's stepson and Willie's boy, John Burke, was admired by my brother Lowell, and influenced his character as well as my own. I can summarize John Burke but not adequately explain the outstanding character of the man who taught me the E-chord on the guitar.

17

His wife, Claudia, was like a second mother to me. The entire Burke family—Norma, Doug, Joe, Lillian, and Margaret— were always sweet to me. And I was sweet on Lillian. She was the first girl I ever kissed—in the moonlight on the banks of a northern California river.

I learned to ride a freight train because Jimmy and Lefty sang about it. I was there to learn about life.

Fourteen years later, music would become my salvation. If it had not, I'm convinced I'd be dead today. Just another nameless man with a number who died behind bars. A song I wrote, "Mama Tried," had lyrics that said, "I turned twenty-one in prison, doing life without parole." The line is half true. The prison was San Quentin. When I turned twenty-one I was an inmate, but the part about no parole was written to fill out the line.

I conspired with my buddy Billy Thorpe, who had lived down the street back in Oildale. There had to be life outside Hughson and Oildale, and we were going to see it all. We weren't old enough to drive and didn't have enough money for the bus, so we decided to hop a freight train.

"Take it to where?" Billy asked.

"Anywhere it goes," I said.

During the next eighteen hours, we planned what we thought would be a journey that would last the rest of our lives. We agreed to meet after school, the last day we thought we'd ever attend, carrying all the worldly goods we'd ever need inside pillowcases.

The train stopped, as it always did, for the switch. I climbed up to a boxcar but couldn't get the door open. The next two proved equally stubborn. The train would be depart-

ing soon, so Billy and I climbed aboard a hopper car that hauled grain or chemicals, and we stood on the piece of iron framework that sticks out beside the wheels. The framework was less comfortable when the train started to roll, but we were convinced we had bolted a few feet closer to our destinies. Within minutes we had the wind in our faces and Oildale to our backs.

It was after midnight, maybe about 1 A.M., when the train pulled into Fresno. We were stiff from hanging on and from the cold that goes with open exposure at fifty miles per hour. I could feel and hear the gravel of the train yard crunching beneath my shoes. I wasn't entirely sure where I was and, of course, had no idea where I was going.

But the railroad detective knew.

He took us straight to a detention hall. Why was the place open at such an hour, I wondered? And what made him think two young boys less than five feet tall carrying pillowcases were runaways?

The railroad detective did the most humiliating thing he could have done to me: He called my mother.

She showed up at the detention center, worried and relieved. And confused. She couldn't understand why I had hopped a train when I had a pass. Since my dad had worked for the railroad, the pass was good until I was eighteen. I tried to explain that anybody could ride with a pass; it took a man to ride the way we had. It wasn't the first time she didn't understand me, and it wouldn't be the last.

I went to high school in Bakersfield, because there wasn't one in Oildale. While I was there, I became friends with Mildred Carr (now Copeland). We were in the same class at

school and she had the most beautiful eyes. I made eyes at her. We became friends at a hamburger stand where I also met Carol Sloss.

One day we went across the street for a smoke and didn't return. We went downtown, the two girls and me. We had five dollars among the three of us. I decided that it was enough for us to hop a train.

After spending fifteen cents on bus fare, we had four dollars and eighty-five cents remaining for our trip to Las Vegas, our new destination. We had also determined that I was going to gamble, make a ton of money, and then we might use some of the proceeds to ride a passenger train home, if we went home at all.

The girls had trouble hopping a freight car. In fact, they hadn't learned how and, after twelve hours of trying, I decided they never would.

I had hopped on earlier and was knocked off by a switch. I finally got the girls onto a lumber car that was standing still. Since they couldn't learn how to hop, I went for the parked car.

Once on board, the girls and I caught our breath for the trip northeast to Vegas, not knowing that the train was going south to Los Angeles.

We were out in the Mojave Desert on a flat car loaded with lumber.

When the sun went down, the girls got cold. None of us had thought about how cold it would be after dark on an open and moving train car. No one even had a light jacket. All I wore was a short-sleeve cotton T-shirt.

The girls wanted to sleep. They were tired and thought

they wouldn't be as miserable asleep. But they couldn't nod off in the breeze. I told them to lie still and that I would lie on top of them to keep them warm.

I woke up at dawn. Mildred says she remembers rubbing the sleep from her eyes and seeing me walking and crawling on top of the boxcar ahead of the lumber car.

There is something about moving that liberates me to this day, even though I sometimes get burned out from all my traveling.

In November 1997, a group of singers got together for a tribute to me and my music that aired on the Nashville Network. I was interviewed and asked to sum up my career in a few words.

I only needed six: "A thirty-five-year bus ride."

Some folks think I was oversimplifying, but sometimes that's how I look at it.

"I'm on the run, the highway is my home," Liz Anderson wrote in 1966—a line from "I'm a Lonesome Fugitive," my first number-one song. I later wrote "The Runnin' Kind," a song that, in essence, says I've always been running, for no particular reason. There is a restlessness in my soul that I've never conquered, not with motion, marriages, or meaning, although I'm more satisfied today than ever. My restlessness isn't as pronounced as it was when I was young. I've mellowed a lot, but it's still there to a degree. And it will be till the day I die.

By nightfall, the train had pulled into a giant yard in the Los Angeles area. The girls stayed on the flat car while I took our pocket change to get some food. We hadn't eaten for several

hours. Mildred later recalled how the girls went for fifteen hours without peeing. I didn't think about their discomfort at the time. I could whiz into the wind to relieve myself.

I returned to the flat car with cigarettes, Campbell's bean and bacon soup, bread, and baloney. We had no can opener. It took me a long time to open the soup can with a pocket knife. Then we realized we had no spoons. The girls and I were hungry. Famished. We ate the thick soup right out of the can with our fingers. We each had a sandwich, leaving enough for a second sandwich apiece.

We left the train after we ate. Forty-seven years later, I can't remember if the yard was in San Bernadino or Burbank, and neither can Mildred.

We started walking into the night and came upon a little black car. I stole it. Just a little matter of popping the hood and some hot wiring, and we were on our way. There were no inside car latches in those days and no alarm systems either. We were just having fun. I'm sure we'd have realized that what we were doing was wrong if we had stopped to think about it. But we had stopping thinking about the time we decided to take the trip. Fun, not felonies, was all we had on our minds.

We were tired, and Las Vegas seemed a long way off. We decided to drive back to Bakersfield, where we could embellish our story. With only a few lies, we'd sound like the adventurers of the century to our friends.

We didn't get five miles before the stolen car ran out of gasoline. Those old cars had unreliable fuel gauges.

So we got out and began to walk. Now, where were we

going to walk—all the way from Los Angeles to Bakersfield? Maybe, we said, we could catch a train come dawn.

The next car we saw had a police emblem on its side. It was illegal for fourteen-year-olds to be on the street at 2 A.M. Luckily, the stolen car was several blocks behind us, so the police never knew I had taken it.

Mildred was put into a room, Carol was put into another room, and I was put into a cell. I had decided I'd play hard-ass and refused to give my name. It didn't matter. The girls gave theirs, and their names matched the missing persons reports our parents had filed.

Our parents drove from Bakersfield and picked us up.

None of us went to school for the next three days. That was fine with me. Once again, I was punished for skipping school by being kept home from school.

Then my mom did something that revealed her financial struggles. I didn't appreciate the significance of this story until Mildred reminded me of it in October 1998.

My mother and my sister Lillian went to Carol's parents' house, and then to Mildred's. At each home Mom asked for only one thing. I had loaned the girls some pants when we had first hopped the train.

"I've come after my boy's pants," she told the girls' parents.

Back then, a pair of Levi blue jeans cost about $3.95. No way could Mom afford to buy two replacements.

"Mama Tried" debuted on July 27, 1968. The song talks about my mom's nonstop struggle as a single parent pitted against my inner restlessness. In the early 1980s, I recorded

an album called *For the Mama Who Tried,* a collection of her favorite gospel songs. I did a lot for her, but I realize now that much of it was too little too late. For years after Dad died, neither she nor anybody else could tell me anything.

Reporters and the general public have always been fascinated by my juvenile delinquency. Many have been taken by the fact that I'd been to prison. Johnny Cash had his own television show on ABC back in the 1960s. During my first appearance on it in 1968, he and I did a routine about one of his concerts inside San Quentin.

"That's funny, Merle," he said. "I don't remember you being on that show."

"I wasn't, John," I replied. "I was in the audience."

Folks told me ABC got a lot of negative mail, because it had an ex-convict on a prime-time variety show. Can you imagine what would happen today if I were twenty-four, just out of prison, and trying to get a record deal in Nashville? When I got my deal, the labels were looking for artists who had their own style. Today's sanitized country music is produced by a bunch of artists who sound like each other. No label would take a chance on my sound, especially with my background, if I were trying to start over.

My trip with Mildred and Carol came a few months after another brush with adventure that stands out a little more clearly in my mind. That's because it involved music.

I was fourteen and hanging around Bunkie's drive-in restaurant, Oildale's "in" place in 1951. Everybody came to see and be seen, although we'd all seen each other there scores

of times. Most of us were too poor, too young, or both, to afford a car. So we walked to Bunkie's.

One night I noticed a guy who, in retrospect, reminds me of a James Dean–type character. I was especially intrigued with Bob Teague because he had been in the Marines for two years. He lied about his age and joined at fourteen. When he was found out at sixteen, he was immediately discharged. The fact that he had a military background, had pulled a fast one on the government, and was now eighteen made him immediately cool to me.

When we got to talking at Bunkie's, Bob said he'd heard I could sing like Lefty Frizzell. (I could if I tried. I've always had an ear for imitating my musical mentors.) Bob told me he could sing like Hank Williams, a statement that only raised my opinion of him.

Bob said he would teach me how to play guitar.

I'd tried to teach myself a few chords on a relic my brother had brought home from his gasoline station. A customer had given it to him for only two dollars worth of gas. The thing was beaten up pretty badly, with strings that were too high off its crooked neck.

Bob had a Epiphone guitar that had belonged to his brother Frank. I spent a lot of time listening to the radio and couldn't have been more complimented when he said I sang like Lefty. Lefty was my favorite, singing his songs came naturally to me because our voices were alike.

Lefty Frizzell himself, Bob said, was going to play Bakersfield's Rainbow Gardens in a couple of weeks. Boy, how I wanted to go!

When the big night arrived, Bob and I rode in a borrowed car and took some beer. Before the show began, we got drunk and passed out on the lawn outside the Gardens. I wonder now why I wasn't arrested for public drunkenness—a kid my age out cold, surrounded by empty beer cans.

We were shaken awake by someone shouting that we were missing the show. That man was Billy Ray, my beloved brother-in-law. We got into the show in time to hear the last song or two. I was reluctant but excited to get close to the stage for the second show.

While waiting for Lefty to return, I remember dancing with Jeanine Hilton to a Hank Williams tune called "You Win Again." I was almost in a trance because of my infatuation for her. Then the spell was broken by someone saying, "And once again, welcome, the great Lefty Frizzell!"

The crowd rushed the bandstand, making it hard for the people in the back to see. Some considerate soul brought a kitchen chair to Lefty. Between songs Lefty stepped onto the chair and raised the microphone as high as possible, accommodating fans all the way to the rear of the dance hall.

What a thoughtful entertainer to consider even the short nobodies like me.

Lefty's magnetism was overwhelming and his voice was better than his records. He ended his set with his soon to be released, double-sided smash, "Always Late with Your Kisses/Mom and Dad's Waltz."

He introduced the last song of the evening and dedicated it to his mom and dad. Then he said something that affected the way I designed my whole career.

My House of Memories

"Folks, I want you to know that all the royalties from 'Mom and Dad's Waltz,' will be going to my mom and dad."

In some roundabout way this would someday inspire my own songs about my life and family.

Because of a similar taste in music, Bob Teague and I conjoured up a trip to Texas. Who knows, we might see why Bob Wills wrote "San Antonio Rose." Or maybe I'd grow tall on my visit to Texas. I didn't find the answers I was looking for.

After two days of hitchhiking we found ourselves in Amarillo, "Texas, that is." I remember Bob saying, "Merle, we're in Texas. I don't know about me, but you don't look like no Texan."

At the time of our departure, our total bankroll equaled $180. You must remember, we were riding our thumb and coffee was only a dime back then; bacon and eggs could be purchased for seventy-nine cents, coffee included.

We went to a secondhand store and bought secondhand boots and secondhand hats. We looked in the mirror and decided that we might fit in a little better.

We had been very conservative with our traveling money, and after subtracting the purchase of the wardrobe, we agreed we could afford a visit to the red-light district.

What an exciting decision. Two greener cowboys had never been seen walking into the Texas hotel. The "Davis Brothers," as we were known back then. I had an illegal draft card that said my name was Roy Leslie Davis. The card also stated that I was eighteen rather than fourteen.

The madam said, "Identification boys!"

The old place was truely a brothel inside and beautiful

ladies were everywhere. I was breathless, scared, and excited. A voice slapped me out of my stupor. It was a lady who seemed to be the boss. For the lack of a better description, let's call her a west Texas version of Shelley Winters. She looked at me and said, "I'm the madam, I'm in charge here. Could I help you?"

With his John Wayne attitude, Bob said, "What's the price of pussy in Texas these days?"

"The starting price is five dollars."

One of the ladies of the evening looked at me and said, "I'm not touching that kid with a ten-foot pole, he's not eighteen!"

My own personal "Shelley Winters" came quickly back with an answer for the problem.

"I'll baby-sit with him."

She was the first and the greatest.

She was not only the boss, she was the best.

After the whorehouse it was on south to Lubbock, where we were about to have our first conflict with some boys of another race. Bob and I had purchased a P-38 pistol back a few miles in Albuquerque, and also a six-inch switchblade knife. In less than forty-eight hours of our investment, we found good use for the weapons. Along came a two-and-a-half-ton flat-rack truck, I think it was a Chevy. On board were five men and a woman.

As they sped by the two cowboy hicks on the highway, one yelled, "Suck me, you white son of a bitch!" The suggestion rang out from the truck as it passed. There were three men on the back, holding to the flat rack looking back for

our response. It came simultaneously. The bird we flipped took flight at the same time.

"We be back, we be back, we're going after gas!"

"We be back, we be back, we're going after gas!"

Sure enough, in about twenty minutes on the other side of the road came a truckload of hateful people. One of the men started to shake his fist as they made a U-turn back in our direction. They skidded to a stop beside us. We jumped back a bit in preparation for war. A voice from the truck again, "Now what did you assholes say?"

My blade came out of my pocket. Bob unbuttoned his shirt exposing the butt of the gun and said, "You boys was the ones doing all the talking."

All eyes went to the pistol.

Then an older, bigger man appeared from somewhere in the driving area up over the back. With a surprisingly friendly attitude he proclaimed, "Hey, you dummies, can't you see these boys don't want no trouble?" I've never seen such an attitude change in my life. He looked like Redd Foxx. It might have been Redd Foxx. I think he was from Texas, too. Whomever he was, his move was right on time.

Funny, I have never thought about using a gun or a knife very many times in my life. When you travel the world as I do, and when you have done as I have, you learn to follow your intuition and to be prepared. I realized that day, that the Lord does go before us.

My first night in San Antonio, Texas, was hot, sleepless, and noisy. We'd been lucky. The first day in town we landed jobs

building fences. Starting time was 5:30 A.M. I don't know about Bob, but sleep never came for me till sometime after 3:00 that morning. Blame it on the honky-tonk below, or the high humidity, or the lack of air-conditioning. Whatever, we didn't wake up on time to make the first day on the job. We were fired before we worked a single day.

Our money soon ran out, living in hotels and not working. Bob said, "I think we had better do what we came down here to do."

"And what was that?" I said.

He said, "Go spend a couple days with Grandpa."

Grandpa's house was a nice place in an average neighborhood, but there was something cold and lonely about it, as though something was missing. Maybe it was Grandma.

We were soon to wear out our welcome, but Grandpa handled the problem gently. He said, "Boys, you know it's time to get on your way."

By this time, of course, Bob and I were flat broke. As we got in the old man's Buick, Grandpa said, "I wish I was young enough to go with ya. What's it like out there in California?"

Bob said, "You wouldn't like it, Grandpa."

"Well, I'm too old anyway."

It was about then that I noticed we were in the area of the San Antonio freight yard. Grandpa pulled his well-kept old car into a small grocery store, the kind that you see in the old movies. He got out and walked inside, leaving Bob and me in the car. When he returned, he was carrying a brown paper grocery sack. He handed it over the backseat to me and Bob.

MY HOUSE OF MEMORIES

"Now boys, I'm gonna let ya off here. Inside that bag there you got two loaves of bread, a pound of round, and here's five dollars in cash. Across the street there is a freight train made up for the west."

It was then that he looked at Bob and me and said, "You know what to do with that bread and baloney in that bag don't ya?"

Like a couple of airheads we both replied, "No Grandpa, what?"

He said, "EAT THE SHIT OUT OF IT!"

In those days, men didn't say words like that with every breath. He'd meant to shock us. And he did. He laughed. We laughed. We ALL laughed.

We got out of the car, shook hands with the old man, then somebody said, "No, give me a hug." I think it was Bob.

The train rolled out of San Antonio sometime later. We were on our way back to California.

That freight train ride from San Antonio was a tough, hard ride, boy let me tell ya. I guess it was about a thousand miles by rail from San Antonio to El Paso. If not, it sure seemed like it was. It was on that ride that I learned some Marine Corps judo from my good friend Bob Teague. I remember him teaching me how to take a knife away from a person (provided they come at you just the way you want them to). He also taught me a couple of different methods of breaking loose from a headlock.

I remember stopping in the middle of the Texas desert in the middle of the night. It was so dark I couldn't see my hand in front of my face. The slow freight rattled to a stop. I said, "Bob, are you there?"

Bob answered, "Yeah, I'm here. . . . But where do you suppose here is at?"

We crawled around on the wooden floor of the boxcar in search of the sliding exit door. We had wedged it open with a piece of wood so we couldn't be locked in with a jerk in the train. We butted heads as we stood up in the blackness, in search of our balance. Bob found the door in the darkness, and slid it quietly open. It was still black.

Hanging our heads out the door, we looked out the train for some signs of life. All we could see in either direction was one green railroad signal light on the side of the track to the west. It was half a mile ahead of us. Other than the starlight and the signal lamp, there was no light at all, not even the moon.

It was obvious that the train was stopped for some time. Finally it began to roll again and we were on to El Paso.

We arrived in El-Paso sometime the next day. It was about eleven o'clock in the morning. We were tired, hungry, and disgusted with freight trains.

It was back to the thumb. We took a whore's bath in a service station rest room and made ourself presentable for hitchhiking again. We got lucky—or at least we thought it was luck. We caught a ride with a guy going all the way to Los Angeles. He had a good-looking 1948 Ford sedan. He was friendly enough that he even bought us breakfast. Bob would soon offer what money we had left to help buy gas in exchange for the lift.

Over the next many hours we made our way to Gila Bend, Arizona. It was morning again, and the owner of the car was

tired. You must remember, I was fourteen at the time, claiming I was eighteen. Bob was eighteen, claiming he was twenty-two. The man with the car claimed he was twenty. On the same ratio, he was probably about sixteen. At any rate, he had driven all night and he was sleepy. Bob was summoned to drive.

Bob had been a truck driver, a Marine, and a rough-neck in the oilfields. I knew he could handle the job. I decided to go back to sleep in the backseat and spend the rest of the day nodding off. I was dreaming about Mama and the old boxcar that I was raised in.

The whole world went into a tunnel. Like in the midst of an emergency, something happens. Things slowed down. We were rolling across the Arizona desert and Bob, just like the owner of the car and myself, was sleepy, too. He had gone to sleep at the wheel. The car flipped over and over and over, until it finally came to rest on its top. We were upside down.

Bob had turned the gentleman's car over in the desert. I had been in a car wreck! It seemed as if, before I knew it, I had made my way through a small rear window. I crawled on my belly until I was completely clear of the automobile. I then made my way back to my feet.

Bob hollered, "Is anybody hurt?"

There was a groan or two, but everybody seemed to be in one piece. The windshield was broken, the top was caved in, and the headlights were broken out. I remember a Bible, still in its place, that had been riding in an area between the backseat and the rearview window. It stayed in the same place throughout the wreck. It had somehow lodged there. Even

the three young stupid men remarked about the condition of the Bible. Bob and I would tell about it many times in our lives.

Somehow the car was turned upright, and we continued on our trip as though we had blown a tire. We knew we had to make it to Los Angeles before dark because our headlights had been busted out. Sometime in the late afternoon, as we neared the L.A. area, we all noticed a crippled hitchhiker on the side of the road. Bob and I both yelled, "Hey, let's give him a ride!"

The car owner said, "OK."

He whipped the car to the side of the road and we boarded a new passenger. It was now late afternoon, August 15, 1951. For the sake of fact, it was on a Wednesday.

Since we had wrecked the car earlier in the day. I guess we thought by doing a good deed we could change our luck. It was not so. We were about to make a big mistake.

Remember, Bob Teague and Merle Haggard were entertainers, and even then we took great pride in captivating our audience. I had sung every song I knew, and Bob had told every story that he knew, when the subject suddenly came to guns.

As we rode into Los Angeles Bob showed our crippled friend our Japanese P-38 pistol. He jokingly remarked that we only had one chance to use it. I knew what Bob was referring to, but I'm sure the car owner and our crippled friend misunderstood that remark, maybe reading more into it than there was.

L.A. was the car owner's destination and it was almost dark. Somewhere in the area of Lincoln Heights, the man

said, "This is as far as we go boys. This is where I turn off."
It was like the end of a covered-wagon ride across the country. We had survived an interesting trip together.

We bid the owner farewell and told the crippled guy to get well. We then started on what we thought would be the last hundred miles of our trip.

With what happened next, the camera should have been rolling. It was like something I had seen on television. As Bob and I carried our two suitcases, we suddenly had six police cars on top of us. They were also beside us and underneath us. The sirens were screaming and the red lights were everywhere. "Spread 'em boys! Down on the sidewalk, or we'll kill ya! In fact we'd love to!" was the trailing remark that we heard as we fell on our faces.

"Here it is!" one of the cops yelled.

From the corner of my eye I could see them going through Bob's suitcase. They had found the pistol.

Oh my God! You would have thought we were Frank and Jesse James. The cops acted like that's who they had captured. The squad cars numbered at least half a dozen. There were too many cops to count.

They strapped the leg irons on our ankles and put the handcuffs on us from behind. They literally threw us into the back of the police car.

4

"DOWN EVERY ROAD . . ."

Bob and I stayed in jail for a year that was only five days long. The real robbers were caught, the charges against us were dropped, and we were released. I wished the cops who had taken us in had been the ones who had to let us go. But it didn't happen that way. The jailer who said we were free didn't even apologize.

After Bob and I made our way back to Oildale by way of our thumbs, we went our separate ways. I walked from the highway to my house, where Mom told me over and over how glad she was I was home. I kept waiting for her scolding for taking off, but it never came. Maybe she was kind simply because she was glad I was safe. Or maybe she was beginning to realize that nothing she said would do any good. I was going to come and go as I pleased. So she fussed over me and made me breakfast.

When school started up again, I attended class for nine days, then I stopped going. The truant officer again hauled me off to Juvenile Hall. I didn't like it there any more than I

liked school. The only place I wanted to be was anywhere except where I was. So once again, six years before reaching maturity, I took off. Again, my companion was Bob Teague. That time, we went north to Modesto.

We got jobs as day laborers loading hay. We hoisted that stuff from daylight until about eleven P.M., five days a week, and we worked until noon on Saturdays. We earned a dollar and a quarter an hour plus a room in which to sleep.

I thought about returning to school or Juvenile Hall, but not for long. The fact that I was willing to do such backbreaking work rather than attend class should give you an idea of how much I hated school.

Bob and I worked for a man named Slim Rayford. Slim had heard Bob and me talking about music and told us about the Fun Center, which featured live country music. On our way to the place, Bob and I pooled our money and bought a guitar that cost five dollars. Nobody was going to mistake it for a Martin D-45.

But the guitar wasn't nearly as bad as the one inside the Fun Center. It looked as if it had been beaten harder than some of the customers. This was a knife-and-gun club, where both sometimes yielded to the wooden bat kept under the bar. The place had a concrete floor, concrete block walls, and bar stools with uneven legs. I walked in with eyes wide and Bob's and my new guitar strapped on my back.

Before long, a customer asked if I could play it.

"A little bit," I replied.

The guy asked me to play. I walked to the corner. There was no bandstand. Bob picked up the battered guitar, and I

hit a chord on ours. We broke into Lefty's "Always Late," of course.

Bob followed with Hank Williams's "Your Cheatin' Heart," of course. Those were the predictable parts of our repertoire.

Then the bartender offered us five dollars to play for the rest of the night. Before we could say yes, he threw in all the free beer we could drink.

It was my first paying job making music.

I'll remember it forever as one of the most thrilling experiences of my life. People who don't play music have no idea how great it feels to play it *right*. (And we thought we were great.) To play it right, while getting paid, is the all-time natural high. If the bartender had extended his offer to a nightly basis, I would have never returned to the hayfields. I would have found a way to live on $2.50 a day, my share of each night's take. Two dollars and fifty cents would have bought a lot of baloney and bread, and I would have been content to sleep inside that smelly, drafty old place.

Little did I know that on the night of the best experiences of my life so far, I'd have one of its all-time worst. My silver lining got to me only a few hours before a dark cloud.

It was nearly closing time when three guys asked us if we needed a ride back to town. We crawled into the back of their 1935 Ford. We drove for a while and the conversation drifted to boxing. The three men were older than Bob or me.

We talked about the headline-grabbing boxers of the day, and then one of the guys mentioned a leather-tough but relatively obscure fighter named Lew Jenkins.

Bob made the mistake of mentioning that Jenkins was his cousin. The drunks had probably decided before we ever got into their car that they were going to whip our asses. When Bob said his cousin was Lew Jenkins, they took that to mean Bob thought he was as tough as Lew.

The guys in the front began to giggle, then laugh, then roar with laughter.

"I once beat the hell out of Lew Jenkins's cousin," said the driver. I knew we were in trouble. My guts were in a knot.

Bob broke the silence with a remark that sounds leading but was actually innocent. He was just trying to set the record straight.

"You say you once beat the hell out of Lew Jenkins cousin?" Bob asked matter-of-factly. "Well, it wasn't *this* cousin."

The driver hit the brakes so hard Bob and I were thrown against the back of the front seat. No one wore seat belts in those days.

The driver swung his door open and leapt out of the car. He then challenged Bob to step outside.

He came out on the opposite side of the driver, ran around in front of the car and proceeded to show him whose cousin he was. He hit him in the back of the head and then kicked him in the face. After his foot smacked against the man's face, Bob's loafer flew sixty feet into the air. I was glad Bob was an ex-Marine.

The two remaining guys in the front jumped out, as did I. Bob yelled at me to keep them off his back.

I threw the first punch and was astonished when the guy went down. The second guy went for Bob to make it two

My House of Memories

against one. He punched, missed, and Bob caught him when he was off balance. He hit him in the back of the neck, the guy went down, and Bob kicked him in the mouth.

Teeth and blood flew in every direction. On a dark and lonely California highway, Bob and I were fighting for our lives. These guys were going to beat us to death and simply drive away.

Bob had two of the men on the ground when the guy I'd clobbered got to his feet. Then all three of our assailants were standing.

Our assailants suggested that we get back into the car and that they take us to our destination as a peace offering. They said it was the least they could do, as we had whipped them fair and square.

We instead asked them to take us to the bus station in Modesto, where Bob had earlier that day left some things in a locker. We said we'd walk from the station to our lodging at the hay farm.

The driver wouldn't hear of it. He insisted I go into the station to fetch Bob's package. Everyone else, he said, would wait in the car.

I got Bob's package, which contained a new pair of cowboy boots. I stepped smartly back to the car, but not smartly enough. How was I to know that the same men who had offered us a ride home as a ruse to beat us up would try the same thing again? And how was I to know they had a wrench under the front seat? It was one of those giant steel wrenches that could loosen the plug on a fire hydrant. As soon as I was inside the bus station, one of the men produced the weapon and hit Bob squarely in the face. His swing had momentum

coming from under the front seat and down into Bob's skull. While Bob was down, the assault with the wrench continued. If a blow had landed in just the right spot, he would have suffered a concussion, or maybe even died.

When I stepped out of the station I saw the free-for-all going on inside the car. The interior was a tangle of fists and legs, with the occasional flash from the shiny wrench.

Bob, on his back, used both legs to kick the car door. He was an incredibly strong man, and those old cars didn't have double locks like modern vehicles. He kicked the door open, rolled out of the vehicle, and, miraculously, stood on his feet. I've never seen a face so bloody. Then he began to stagger in various directions, and I realized he was blinded by blood. I took his arm to steady him.

A taxi pulled up as the assailants burned rubber to get away. I suspect they thought Bob would bleed to death and wanted to be long gone when the authorities came.

Bob Teague hated to fight, but not as much as he hated being ambushed by three men who had tried to make nice after he had whipped them once. So we got into a cab and told the driver to follow the car that was fading out of sight.

After the cabdriver told Bob not to bleed on his backseat, a high-speed chase ensued between a hopped-up Ford and a broken-down Modesto taxi. There was no way we could have caught them, but we didn't have to. The driver of the other car ran a stop sign and was pulled over by the police. Before any questions were answered, we drove up in the taxi. Bob looked terrible when he emerged. He should have been inside a hospital emergency room, not on a street corner confronting his attackers and arguing with cops.

MY HOUSE OF MEMORIES

Why the men fled is ironic. Bob was beating the shit out of all three, despite their wrench. When he got out of the car to escape their wrench, they could have jumped out after him. Instead, they chose to speed away. Two clobberings in one day from this invincible man was enough for that trio.

The three were arrested for assault and battery, and Bob and I were ordered to testify against them at the arraignment set for the following Tuesday. (The wheels of justice turned more quickly in 1951 than they do today.) But the case boiled down to our word against theirs. They painted themselves as Good Samaritans who had offered a ride home to two men who attacked them.

The judge finally heard enough. There were, after all, no independent witnesses. So he called all five of us to the bench.

His looked carefully at the three men, who were clearly larger than Bob and me and who, of course, outnumbered us. He made no reference to the fact that they were *men*, Bob was a youth, and I was a boy.

When the judge demanded our ages, Bob told him he was eighteen. When I said I was fourteen, the court reporter, the defense lawyer, and the district attorney groaned out loud. The judge was disgusted and did something I'll never understand.

He said, "It looks like you men found some boys you couldn't handle." He sentenced the three men to six months in jail, and then before he closed the case, he said to Bob and me, "Now you boys, you go back to work."

After Bob and I finished out the hay season, I returned to Oildale, as I always did. School had long been under way, and

I suppose I could have enrolled. But I didn't bother starting something I knew I'd quit. So in no time, I was popped again by the truant officer.

I was returned to Juvenile Hall. The place had become my second home to such an extent that I kept my phonograph records there. They had a better record player than Mama. When I was in Oildale, I spent more of my days and nights there than under Mama's roof.

I spent my fourteenth birthday locked up in Juvenile Hall. My mother came on Christmas Day with a Martin guitar, the first I ever owned. She was my only visitor, and that was my only gift. I think I used to wonder about the sense of family enjoyed by some of the other residents. I'd see them with all of their loved ones and wonder what it would be like to live in a house filled with so many people and so much love. Why would those kids in Juvenile Hall run away?

God, I loved that guitar Mama brought. God, I hated to leave it. But the old ramblin' fever took over, and I began planning another escape, this time with two buddies.

We were being held in a new Juvenile Hall. I'd had no trouble escaping the old one, with iron bars. I can't believe that with my record for running, they put me in a place with incomplete construction. In short order, I found a window that had chicken wire sandwiched between two pieces of glass. If I'd had heavy gloves, I could have put my fist through the thing.

My buddy Bob and I put chewing gum wrappers inside the locks on our doors. When the dead bolts were thrown, they hit the paper and didn't lock all the way. After that, the only thing standing between us and the lobby was a hall door

with a door handle lock. I've seen guys pick those things with a credit card. I used an ordinary playing card.

Bobby and I left our rooms at the agreed-upon time, then made our way down to the hall door where I jimmied the lock. We crept into the corridor, easing our way to the glass window lined with chicken wire. We needed something to break it with and had decided on a heavy, wooden bench.

The three of us tried to suppress our groans as we hoisted the cumbersome bench. We didn't want to make noise that would alert the nearby guard, who was engrossed in something on his desk, perhaps a newspaper.

When we rammed the glass as hard as we could, it shattered. We were all three through the window and bolting past the guard into the lobby before he could find the source of the noise.

"Where are you boys goin'?" he yelled.

Stupid question.

We were out the door and running at full speed when I yelled back at the guard.

"We're leavin'!" I screamed.

We picked up the bench and hurled it through the chicken wire. We did perfect forward rolls after a nine-foot leap on solid sidewalk and came up running. We ran four hundred yards across the ground of the institution to the bottom of the twelve-foot chain-link fence topped with barbed wire. You remember the number of barbs when you have to crawl over them. At least that was better than concertina wire, which is what topped the fences at San Quentin, where I'd eventually wind up.

We shimmied up the fence. We didn't take the time to

climb down. We just dropped. Hell, we could handle a little twelve-foot fall, we had decided.

What we didn't know was that the fence was built on a hill. The ground was twelve feet below the top of the fence on one side, twenty-five feet on the other. We fell through darkness for what seemed like forever.

We would have broken our legs, and maybe more, if we hadn't landed on soft, freshly plowed ground. Talk about luck.

The Juvenile Hall was located on top of China Grade. At the bottom of the grade was a little river known as the Kern, which separated Bakersfield from Oildale.

The river was a boundary where my darling and I used to swim.

That was the first and last time I would ever swim Kern River at night. My first escape didn't buy me much freedom. Mom and the rest of the family talked me into turning myself back in, hoping that they would go easy on me. They went easy all right. I got six months in Camp Owens, a county road camp for boys located in the southern Sierras above Bakersfield. My stay there lasted five days and then I was gone again. Only this time, it wasn't just a swim across Kern River.

Me and a kid named Thomas stole a 1949 Mercury from one of the small mountain communities at the base of Mount Whitney.

It must have been three in the morning by the time we got underway. Highway 178 was our route of escape, and of course it would have to be one of the most dangerous highways in the world—curve after curve of two lanes carved out

of solid granite. The distance was about thirty-five miles to Bakersfield. I sometimes wonder if I was running away or running back.

Luckily at this time of the morning, traffic was light.

"Thomas, I hate to bring this up, but you're going to have to find someplace on this road to pull off," I told him.

With the fastest running river in the United States on one side, and sheer granite cliffs on the other, turnouts were only available about every five miles. We felt sure the police were just a curve or two behind us. In fact, I ran with that feeling in my mind for years.

Sure as hell, in the midst of this terrifying escape attempt, I had to use the bathroom.

Thomas ignored me again.

"Look man," I said. "Either you find a place to pull off, or I'll have to go in my pants!"

"Alright, alright. There's a turnout coming up. I just saw the sign."

He whipped to the side of the road into a turnout just barely big enough to accommodate two cars. I threw the door open, and I ran around the back of the old Mercury. I then propped my stupid ass against the bumper of the car.

Right in the middle of my early morning bowel movement—that moment of treasured privacy—the lights of an automobile came around the curve. Figuring it was the cops, I thought, "Hell with it. I'll finish my business and wipe my ass before I put my hands in the air. Maybe I could flip a little shit in their eyes!"

Once again, I was totally wrong. The car was loaded with teenagers, mostly girls. What an embarrassment! Though it

was quick and painless, it was still irritating. There's nothing worse than being interrupted at moment like that. Many years later, I would laugh whenever I'd think about my embarrassment. What I didn't know was that this excursion would eventually lead to more stolen cars, and a journey that would take me across the state line to Las Vegas, Nevada.

A stolen vehicle transferred across the state line violates a federal law known as the Dire Act. A couple of guys I picked up in Bakersfield, whose names I won't mention, joined my run from the law. We were caught and placed in a Vegas jail for what we found out was a federal offense. After two months in different jails in Nevada, I was released back to the California authorities. Being fourteen years old, one year younger than my good friend Jimmy, would save me from the federal boys' prison in El Reno, Oklahoma and it would land me right back into the same old Juvenile Hall.

I'll never forget the ride from Reno, Nevada, to Bakersfield. It was an all day affair in leg irons and handcuffs. I arrived in Bakersfield and was rebooked by nine o'clock that evening. As I entered the old familiar dayroom, I noticed the chicken wire on the exit door, which I had earlier thrown a bench through, had been replaced with jailhouse bars.

Picture this tired fourteen-year-old fugitive being brought back to this hateful hellhole where I had spent so much time in my young life. To say the least, I was not prepared for what was about to happen.

I feel I must describe the dayroom of this juvenile delinquent center. It was about sixty feet long and about the same width. At one end of the room was the supervisor's area, which was surrounded by a circular desk. On the desk

was an old record player with stacks of old 78 records. These records were given to the children, mostly by their parents.

What I walked into that evening could be considered as a semi-riot. A lovely old man named Mr. Hicks was over-whelmed and overpowered by a couple of mean-ass eighteen-year-old men. These inmates should have been in jail rather than a juvenile facility.

One of the troublemakers was white, and one was black. James Bell, the black boy, was flinging 78 records across the room. Records in those days were very easily broken.

During an earlier stay at the facility, my mother had brought me four 78 records of Lefty Frizzell. They were in the stack that James was tossing around and breaking. And I knew it. Unbeknownst to me, though I would soon find out, James was the toughest man I would ever fight. I walked up to the asshole and politely explained that my mother's Christmas gifts were in the stack, and I asked if he would please sort through it and remove the Lefty Frizzell records. He responded to my request with an innocent look and said, "Oh, really? Let me help you find them."

I don't think he removed more than two or three before he found one of my treasures. For the sake of those who care, it was part of Lefty's tribute to Jimmie Rodgers, "My Rough and Rowdy Ways."

He said, "Oh, would this be one of them?"

It was the old Columbia record I recognized, because my mother had written my name across the label in her beautiful handwriting.

"That's one of them," I said.

We were standing close together and he placed the record between us as though he were handing it to me. As I reached to receive it, he simply dropped it on the floor between our feet. The record shattered. And I went crazy. What took place in the next twenty minutes could only possibly be described by the onlookers. After it was over, I remember thinking, "This is the only fight I have ever been in where no one tried to interfere." Mr. Hicks should have stopped the fight, but he didn't.

We both were placed in lockdown. As I began to examine myself, I found that I had been hit everywhere except the bottom of my feet. I wondered what condition James was in. I later fought him again with gloves and found out that he was a semi-pro boxer! He was the toughest guy in the entire place, and he whipped everybody that came in.

If you drive over the speed limit enough, you're eventually going to get arrested. If you commit adultery enough, you'll eventually be found out by your spouse. And if you're threatened enough about the consequences of fleeing Juvenile Hall, ultimately the threats will be made good.

It happened to me.

In February 1952, less than two months before my fifteenth birthday, I was remanded to the custody of the California Youth Authority for eighteen months. I stepped from a car in handcuffs outside the Fred C. Nelles School for Boys in Whittier. The place was a drab, redbrick building surrounded by a twelve-foot fence topped with nine strands of barbed wire. I know. I counted each as I was led into the facility. We went through door after door, gate after gate, just

to get inside the place. If it was that hard to get inside, how would I ever break out? What did they expect me to do, serve my entire time?

I was one of twenty new inmates. That's what I was called now, because I was no longer the ward of a school system. I was a ward of the state. I was a juvenile inmate.

We new inmates would lodge in one of nine cottages, each of which was named after a U.S. president. I was assigned to Lincoln Cottage. The other inductees and I named the cottage supervisor "Prune Face."

I'll say one thing about Prune Face: He didn't discriminate. He hated all boys equally. What a pathetic life he led, spending each day overseeing the lives of boys he hated but never bothered to get to know.

We new inductees stood in formation as Prune Face walked among us like a drill instructor. He stopped directly in front of me and looked me up and down. His eyes were dead, and he stood so close to me that I could smell his breath. He bent his beefy forefinger and punched me in the chest, right above the sternum. My uniform bore a patch where he hit me. The patch was his target, he said, because it enabled him to hit me where it hurt most.

Prune Face punched me once and I nearly went down. The man had obviously done this to other boys. Then he hit me again. Then he hit me each time he said a word, and he was talking nonstop. Prune Face had no idea I was listening to his ranting without hearing a thing. I was already thinking about how I'd get out. I wanted to do a visual survey of the place but knew he'd knock me to the ground if my eyes strayed. I was supposed to stare directly in front of me, but

not make eye contact with him. Anyone who's ever stood in a military formation knows what I mean.

I attempted four escapes, an average of one every four and a half months. I never once even got to the wall, much less over it. It was much harder to break out of a California penal institution than it was the Oildale School District facility for truants.

It was at the Fred C. Nelles School that I saw firsthand how men in authority arbitrarily beat their underlings. I had another sadistic supervisor: Troup. He would inspect the boys, usually after we'd gotten out of bed. We were given five minutes, no more, to get up, brush our teeth, and dress. We then stood at attention so Troup could check that our clothes were properly pressed and our boots properly shined. I never understood how he knew what we looked like, since he never inspected us from the front. He'd saunter up to a boy and stand behind him for as long as five minutes. I felt him breathe on the back of my neck many times. Sometimes Troup yelled, directly into my ear, and I was not allowed to jump from the startling noise. Other times, he just stood behind me, quiet except for his heavy breathing.

Then wham!

He would hit you on the side of the head with a blow that you never saw coming. Ducking was out of the question. He had his swings down to an art, and would come with a side-ward and upward shot that I saw lift boys off their feet and send them sailing. Think about it: If a man weighing more than two hundred pounds hits a ninety-pound boy who's standing rigidly at attention, he can knock him spinning. As

I look back on it, I wonder what kept Troup from snapping some of the boys' necks.

Although I was assigned to Lincoln Cottage, I didn't spend much time there. I spend most of my time in Disciplinary Cottage. I never asked when President Disciplinary held office.

I took seven buddies on my first attempt at escape. I must have thought there was strength in numbers. We were working in the yard, which meant the only thing between freedom and us was the twelve-foot chain-link fence. We had decided which guy would give the command, and he did. As I look back, we should have had a silent signal. As it was, he shouted "hit it," and that alerted the guards. We sprinted for the fence nonetheless. A few may have made it part of the way to the top, but we were all easily caught. I was one of four boys sent to Troup for punishment.

He marched us into the blacktopped courtyard. Running on blacktop hurts your legs and arches more than running on dirt.

"You boys want to run?" He yelled. "Well, goddamnit, run!"

He ran us until we dropped, then kicked us to our feet and made us run some more. I was suffering from exhaustion and sliding inside my boots. My boots, you see, were size eleven. My feet were size seven. I ran until blisters formed and then broke. The inside of my boots were soaked with sweat. So when the blisters popped, my raw flesh was rubbed against wet leather. The pain was overpowering.

The only thing holding my shoes onto my feet were laces

I had wrapped around my legs. By now the laces were cutting into my skin and I was sure blood was running down my legs. I couldn't stop to see how seriously I might be bleeding. So against my better judgment, I told him.

"Keep running, you little bastard," was his only reply, screamed directly into my ear, as if it were his personal megaphone.

I could go on no longer. I simply stopped. I would have walked toward him, but I couldn't walk at all. As I stood motionless, he stomped toward me.

"I ain't runnin' another step," I told him.

He stared at me in disbelief. I replayed my words in my mind, also in disbelief. Then he smirked as he assured me that I would run some more.

He began beating me from behind with a rake, nearly knocking me down. I thought about letting myself collapse, but didn't want to be on the ground so that he could swing vertically at me with the rake.

"Run, you little fucker," he bellowed, running beside me and beating me endlessly with that rake. I was probably five-foot-seven at the time. I could still buy my clothes in the boy's department. And this maniac was going to beat me and run me to my death.

I was sure of it.

5

"MAMA'S PRAYERS"

During my first visitors' day at Nelles, I couldn't wait to spill my guts to my mom, sister, and her husband about the barbaric treatment.

None of them believed me. I had hoped one or all three would go to the board of directors. Instead, they wrote off my complaints as exaggerations.

(The bruises on my body had faded before visitors' day. The guards were cagey enough not to beat anybody just before a scheduled open house.)

I had seen boys tied to posts and beaten like dogs with no chance to dodge, much less run. Yet on visitors' day, Nelles was gleaming with the spit and polish of preparation. It looked like a private school, except for the chain-link fence and barbed wire.

The guards weren't my only problem at Nelles. I also had a problem with the other residents. I hesitate to call them inmates, but that's what they were. The place was overrun with groups that were more like gangs. The Mexicans, blacks,

drug dealers, and other groups hung together. Prisons and other places of confinement are very cliquish. I belonged to no one's group and was therefore a sitting target for all of them.

Almost anyone who's ever been incarcerated has faced a beating from another prisoner just for the beating's sake. The best thing you can do as a victim is to fight as hard as you can and then report the skirmish to no one. If you fight with all of your might, you'll usually be left alone after that, even if you lose. You'll have earned the respect of the others. If you cry, run, or tattle, all you can look forward to is another ass whipping.

I got the hell beaten out of me on the football field by a Mexican who was twice my size. He beat me into the ground, then kicked my butt around the field with his heavy boots. It's a wonder I didn't suffer internal bleeding.

Talking after lights were turned out was prohibited. Nonetheless, I was whispering to a kid in the bunk next to mine one night before I drifted to sleep. My hand touched the floor, and I was awakened by the feel of something sticky on my fingers. I became fully conscious about the time someone landed his knee squarely in my back.

The sticky stuff was the blood of the kid to whom I'd been talking. The knee belonged to his assailant, who had stabbed the boy in his sleep. Out of pure instinct, I rolled onto my back and clobbered the guy on top of me. That's when I saw his knife.

Back when I was doin' time there's a night I can't forget
A madman with a knife in hand tried to kill me while I slept

MY HOUSE OF MEMORIES

And somehow the knife missed its mark and I pinned the ragin' man
Somehow my mama's prayers worked again.

I wrote those words years later as the opening to "Mama's Prayers," a song about how Mom's pleading with God to watch over me has repeatedly saved my life. There is no other explanation for my having survived so many near-death experiences.

That night at Nelles, as if it were choreographed, I leapt from the bed and pulled the blanket with me. I held it at arm's length between me and the black guy with the knife. My buddy was still on his bunk, his blood still dripping onto the floor. The crazed black man kept stabbing and slashing the blanket. He was out of his mind with rage. Otherwise, he would have stripped the blanket from my hands, giving himself an open and probably fatal shot at me.

I had never met the knife-wielding Nelles resident. He had attacked my friend and me for two reasons. One, we were asleep and easy prey. Two, we were white. I was almost sliced to death with a knife before I was old enough to own a shaving razor.

I've been invited to perform at the White House. I've headlined in Las Vegas and the world's largest concert halls. I can't count the times I've appeared on prime-time television.

When I think about my adult life, and then recall my troubled youth, it's as if all this violent stuff happened to someone else. I've often wondered if some of the heads of state who have graciously received me would have done so if they'd known about my lawless youth.

Recalling some of this stuff makes me shudder. I never

talk about it, and I wouldn't be discussing it now if I weren't writing a book. The memories make me cling ever more closely to my wife, Theresa, and our two children, Jenessa and Ben. They, and God, have saved me from a troubled past and sustained me during the peaceful present.

I had escaped from Juvenile Hall many times, and I made that foiled escape attempt from Nelles because I couldn't stand confinement and being told what to do. To this day I don't like to take orders and almost always don't.

I hate it when a security guard at a show with a hand as big as a catcher's mitt puts it on my back and ushers me to where he thinks I'm supposed to be. I always tell those guys to take their hands off me.

Jim Upshaw recalls a private party I played for Pepsi-Cola in Texas during the 1980s. He remembers that the president of the local distributorship ordered me not to sing "Rainbow Stew," a song that rose to number four in 1981. He told me I couldn't sing my own hit record because it contained a line about "free bubble up." The executive thought "bubble up" was the name of another soft drink.

"Whatever you do," he said, "you can't sing that bubble-up song or anything about Coca-Cola. Do you understand?"

At first I thought about loading the band into the bus and driving away from the show, leaving the guy with a few thousand guests and no entertainment. Then I changed my mind.

I don't tell him how to market beverages, even though I buy his product. He shouldn't tell me what to sing, even though he buys my services.

"Remember," he said, as I walked on stage, "don't men-

tion Coca-Cola or any other soft drinks." Then he really pissed me off when he pulled on my coat sleeve to be sure he had my attention.

I opened the show with "Coca-Cola Cowboy," a song I'd never sung in my life, then I went into "Rainbow Stew," and emphasized the line about "free bubble up."

Then I sang both songs again, and asked if someone could bring some Coca-Cola to the stage for the band. I think the bottling executive was pissed.

I don't mind being asked for things. I hate to be ordered to do anything. And if I'm ordered, I usually won't do it, even if I think it's a good idea.

My dislike of being told what to do wasn't the only reason I planned a second escape attempt from Nelles. I thought if I stayed there, I would die.

I didn't want to die. Not before turning fifteen.

Years later, when I saw Paul Newman in *Cool Hand Luke*, it seemed like a documentary of my young life. Newman's character escapes his work detail on a road gang by blending in with other prisoners, then simply walking away. He didn't make the mistake I had made at Nelles of sprinting openly for the fence.

One day, when other residents and I were working the fields, I, too, simply walked away. I took no one with me, and I didn't yell. I just sorta faded into my surroundings. The guard didn't notice the stray, because he was focused on the herd of bodies.

I slowly ambled fifty yards from his scrutiny, then a hundred. By that time, I could drop to my knees and let the other workers pass me. The guard followed the group. Once I was

safely out of his sight, I ran like hell. I didn't stop until I was several miles from Nelles.

I hid for several hours, and that proved to be my mistake. My absence had been noticed and the California Highway Patrol had been alerted. I had been incarcerated for habitually escaping, and I was doing it again.

Dirty and sweating, I made my way to California Highway 10. I intended to ride my thumb, this time to the inconspicuous town of Indio. The authorities would search for a runaway youth in the big cities, such as Los Angeles or San Francisco, I figured. I never got to find out.

Two cars came along at about the same time. I was about to get into the first when I glanced at the second. Its side bore the emblem of the Highway Patrol. Shit.

Once again I did what I did best in those days—I ran.

California has almost as many potato fields as Idaho. I ran off the highway through the crops and hid under a shed. I knew the cops and their dogs would be coming in for me, so I decided to hide myself and my scent. I buried myself alive, leaving little more than my nostrils aboveground. I stayed there, warmed by the earth I had wrapped around me, until dawn.

I awoke to the sound of angry voices that belonged to the cops I had expected. But it was worse. Searching for me with flashlights were about twenty vigilantes, furious men who were determined to take the law and the lawless into their own hands.

I've already told you about how I was once picked up and jailed for five days for a robbery I didn't commit. This time I

was sought for a rape and murder I didn't commit. The vigi-
lantes had been told that a man fitting the description of the
suspect had been seen fleeing across a potato field.

I heard one of the men say they were bound to catch me.
Another said he would kill me himself.

When the self-appointed posse walked away, never seeing
me tucked far under the shed and dirt, I bolted for the high-
way. I wanted to find a cop, and I got lucky. Can you believe
that I, a repeat runaway, thought I was lucky in finding a
highway patrolman?

He had his car parked alongside the road, probably wait-
ing for me to come out of the field into which I'd disap-
peared. I saw him before he saw me, and I approached his
cruiser.

When I told the officer I was the escapee from Nelles he
was looking for, he stared at me in disbelief.

He told me in great detail about the rape and murder of
forty-eight hours ago. He read me the description of the sus-
pect, and it sounded like a verbal portrait of me. He was
aware of the vigilantes, who were the victim's father, broth-
ers, and neighbors.

The furious and grief-stricken men had told authorities
they were going to kill the guy who'd raped and murdered
their girl. They had broken no law in saying that. The patrol-
man said he was convinced they would have killed me, and
he was convinced they would have been caught.

But, he pointed out, I'd still be dead.

The officer rolled down his window, probably so he
couldn't smell me, as we rode in silence back to Nelles.

MERLE HAGGARD

As I mentioned earlier, I hate being told what to do. I espe-
cially hate being told what to do by people who are dumber
than I am. Prison guards, with a few exceptions, are a bunch
of failed men working within the system because they can't
make it on the outside. It's the unlearned making the unwill-
ing do the unnecessary.

So I broke out of Nelles four more times.

Realize that I could have gotten out of the California Cor-
rections System if I'd simply stayed in one facility long
enough to serve my time. But I spent my time on my own
version of an "equality" program: I saw to it that officials
spent as much time looking for me outside the walls as I
spent inside them. One guy asked if I had studied Houdini.

I was only a pretty fair escape artist. What I lacked in skill,
the guards made up for in stupidity. Most of them were out-
of-shape men who would have been criminals themselves if
they'd had the intelligence. They hated society and took plea-
sure in persecuting its outcasts—the inmates.

Mike Tyson may be one of the most controversial celebri-
ties of the twentieth century. I don't know if he raped that
woman, or if he should have been sent to prison for it. But
he said something about his experience there that I agree
with. He talked about the harassment he underwent while
serving time in the 1990s, and pointed out that harassment
served no one. Nothing done to him aided rehabilitation, and
none of the guards were better men for having done it. They
just took delight in spitting in his food or making him clean
his cell so they could trash the place and make him clean it
again. Upon his release, Tyson didn't really bad-mouth the

guards. He simply said he wondered about the mentality of anyone who would have such a job, much less enjoy it. I feel the same way.

Before I turned sixteen I was transferred to the Preston School of Industry. It was a higher security facility at which residents were supposed to get vocational training.

I got a job in the school dairy. Perhaps they thought they were training me to be a milkman. Preston was made of solid brick, had the obligatory high walls, and it had more guards than Nelles. It was definitely more secure. It took me six months to escape.

You hear a lot these days about how America has lost her innocence. People say Norman Rockwell's nation is dead. They're always comparing the country with the way it rallied behind the troops during World War II and how it rallied again during the Korean conflict.

"Back in the fifties, we didn't have to lock our doors," I've heard people say. "Why, we didn't even take the keys out of our cars."

I've got a response to that.

The Preston School of Industry was situated near Ione, California. Not exactly a thriving metropolis, right? It was small-town America, straight out of Jimmy Stewart's *It's a Wonderful Life*.

At about four A.M., I was walking its squeaky-clean streets lined with wood-frame houses whose residents were fast asleep. In minutes, the milkmen and paperboys would come along. I walked into a yard, saw a car with the windows down, and reached for the ignition.

Sure enough, the keys were there.

Neighbors, I thought, it's nice to be among trusting folks like you.

I eased into the car with my PSI escapee buddy, Rick. We didn't even close the doors, so as to ensure our silence. I started the engine, slowly released the clutch, and probably attained a getaway speed of five miles per hour.

The car jolted to a stop so suddenly I almost went through the windshield. The owner had used a log chain to tie the axle to a towering oak. He feared a PSI escapee might try to steal his vehicle.

What kind of trust was that? It was getting so nobody believed in anybody. And why the log chain? Was he trying to anchor his car to the tree, or the tree to the car? What was this country coming to?

The noise awakened the guy inside, who, of course, called the cops. Rick and I lay under the man's house all day and chuckled at the parade of squad cars. For the first time in my criminal career, I became worthy of helicopters. My breakout prompted more activity than that little town had seen in years, and maybe since.

Late that afternoon, the man of the house walked outdoors. Rick and I could see his feet. Another set of big feet approached his. We could hear the mouths that went with the feet.

The second man asked the home owner where he thought we could be. The owner said we were probably miles away.

Then a third pair of feet joined the other two. They were the feet of a kid so short I could see a toy pistol strapped to his waist. He kept nagging his dad about where the escaped bad boys might be hiding.

My House of Memories

His dad kept blowing him off and finally became annoyed.

He told the kid to be quiet because, for all he knew, the bad boys were hiding under the house and might jump out and grab him.

Would you believe, that kid took his old man seriously?

The kid got on his hands and knees and crawled under the house with his toy pistol. When his eyes met ours, I think he peed in his pants.

He screamed, the grown-ups rallied, and my pal and I crawled out from under the house with our hands in the air. The only gun trained on us was made from plastic and loaded with paper caps.

But we couldn't have outrun the posse of neighbors that instantly assembled. In those days, people spent a lot of time in their yards. It was mostly a pre–air-conditioning society.

We were arrested and put in handcuffs that weren't plastic. Once again, I felt steel bite into my wrists.

6

★ ★ ★ ★ ★ ★ ★ ★ ★ ★ ★ ★ ★ ★ ★ ★ ★

"IT'S NOT LOVE,
BUT IT'S NOT BAD"

I'm told that whenever some-
one writes one of these books he's expected to tell about his
first sexual experience. I've already told you about mine. That
was purely sex and was a whole lot better for me than it was
for her, I'm sure. I was inexperienced and quick.

I think it's time I tell you about the first time I made love.
Any man who doesn't know the difference between sex and
making love is wasting his erections.

I finished my time at PSI. They had so many guards
watching me that the other inmates could have juggled
straight razors and no one would have noticed.

My first love was Dolly. I'm not talking about Dolly Par-
ton, although I fell in love with her years later. I even wrote
a song about Dolly Parton called "Always Wanting You." I
got drunk and called her home at four A.M. to sing it to her
sometime before its release on February 15, 1974. The tune
was number one for two weeks.

Anyhow, the sleepy person who answered the phone said

Dolly was asleep. I said to awaken her and refused to hang up. She actually woke Dolly up, and I sang the song about being in love with her into the telephone as she lay half dozing beside her husband. He's never wanted to meet me.

Anyhow, back to my first Dolly, whose last name I won't divulge. I may have taken her virginity, and her eventual husband may think the same thing. Virginity was a precious gift for a woman to give a man in the early 1950s. (The only virgins I know today are little girls. I saw a survey on Cable News Network recently that said 44 percent of American girls have had sex by age sixteen.)

I guess my Dolly was ahead of her time. She had sex at sixteen. I was fourteen.

Dolly was not exactly well behaved in any area of her life. Most youngsters back then met in school or church. Dolly and I had met at Juvenile Hall. She didn't like to go to school either.

I had been discharged from the various California Youth Authority institutions and was back home in Oildale. I was working inside a potato packing shed. In the spring of the year, I could work in potatoes—they were everywhere around Bakersfield. I was working in the shed and was making real good money for a boy fourteen years old, maybe $150 a week. I got off work on a Friday and had to ride a city bus from Oildale to the eastern side of Bakersfield, where the potato processing sheds were situated along the railroad tracks. There, people sorted little potatoes from big potatoes. That's what happens inside a potato shed.

On the bus, I spotted a girl I'd known from detention hall. She and I had made eyes at each other, never thinking we'd

ever touch because she was on the girls' side and I was on the boys'.

We had a magnetic pull. We had seen it inside detention hall, and sure enough, we had run smack into each other. She had just gotten off work, too. She said she had some money and wanted to live her own life.

"Are you tired of Bakersfield?" I asked.

"Boy, I sure am," she said, "but I'm on probation."

"I'm on probation, too," I said.

"How would you like to go to Eugene, Oregon, or someplace?" I said.

"That would be nice," she said.

I told her I had money, but she said she had her own. She told me that a train left Bakersfield at one A.M., and said she thought we could get to the station in time to buy a ticket.

I thought she was joking.

She was beautiful. She looked like a combination of Julia Roberts and Cher. Dolly and I got on that train. And that was my first time to really make love to a woman.

We didn't realize anybody else was on the train. We got after it in a chair. We must have been a sight. It's a wonder we didn't get arrested. It was a twenty-two-hour ride, and we made love for the majority of twenty-two hours. We finally got off the train the next evening in Eugene.

We had no idea what we'd do for a living. Well, sure enough there was a Tidy's Waffle Shop that was hooked to the chain of waffle houses where Dolly had worked before. She went to the manager and told him the truth.

"Me and this guy ran off in a wild rage, and I was working down there and I'd like to work up here, if you all aren't

too mad," she said. She went to work. She was an excellent waitress. I went to work inside a produce house unloading lettuce instead of potatoes.

I don't remember anything bad about our relationship except that Dolly and I got along so well that the slightest little thing set me off.

There was a guy next door who was obviously gay. I had nothing against gays. I'd been in jails and other confinement. I treated the man the way he wanted to be treated. He mistook that for the fact that I might be gay, too.

I have never discriminated against anybody. I've never hated blacks, Mexicans, or Chinese, although I've come to despise attorneys, but they're not all the same race. (You have to have them, though. I finally have one I like.)

This guy who mistook my demeanor invited me to supper. Dolly had a key to the house, I didn't, and I couldn't get inside. Our neighbor offered me some supper while I waited for Dolly to come home from work.

I was hungry, and I could smell this food—spaghetti—so I said I'd come eat. I set my lunch pail in front of his door so Dolly would know where I was, and I sat down and filled my glass with wine. I drank the first glass fast because I was thirsty.

The man offered me more wine. As he came down with the glass, his beard touched me. And then he kissed me. What happened next was so quick that I don't remember exactly how it occurred. The kiss struck me the wrong way. I hit him, and it was just like in the movies. He went up against the icebox, and withered to the floor. I threw only one blow. I think it was a left.

My House of Memories

The wine and spaghetti went everywhere.

About that time I went out of his house as Dolly was coming up to the porch.

"What the hell happened?" she asked.

I told her, and she acted as if she wanted to check out my story. I always took immediate offense to that, and I'm still that way. If somebody doesn't believe me, it really bothers me.

So I asked her.

"You don't believe me, do you?" I said.

"Not really," she said. "I think he's too nice a guy."

I walked over to the ironing board and started taking money out of my pockets. I gave her all I had, and took one quarter and one dime for myself. I walked out the door.

"It's been really nice," I said. "I'll talk to you later."

I haven't seen her to this day.

I walked to a railroad crossing just as a train was rolling past. I hopped a gondola car but quickly became cold. At Klamath Falls I jumped off and hopped another train, this one going south.

People ask if I could hop a freight train today. I honestly think I could. It's like riding a bicycle, you never forget. But it's risky business to learn.

I pulled myself into an open boxcar and let my eyes adjust to the light. The thing was filled with hobos—eight in all. They wanted to know why I wasn't in school. I wanted to ask why they weren't at work, but I had better sense. I had long ago learned to respect my elders, especially those who were on the bum.

MERLE HAGGARD

One of the men, who appeared to be the oldest, tossed a pouch of tobacco and some rolling papers across the floor to me. When I looked into his face, my eyes locked with some of the kindest eyes I'd ever seen. They glowed, they smiled, and they were all-knowing. His eyes looked as if they had seen it all—pools of a poor man's wisdom.

The men continued their small talk, which was mostly derisive of me, someone so young riding the rails. I'm sure they thought I was wasting my life, because most of them had done the same thing when they were my age. And look where it got them.

I told the men I was hungry and was going to run the tops of the moving cars until I found a food car.

Almost in unison, the hobos barked at me not to break the seal on any food car. It was a federal offense. They didn't particularly care about my hide, but they didn't want the railroad detectives coming down on them. In those days the railroad dicks sometimes looked the other way if transients rode the rails without breaking any laws.

I had walked across only a few cars when I came to one marked FOOD and broke its seal. I did exactly what my hosts had told me not to do.

All my efforts earned me a few cans of green beans. There were other canned goods in the car, but I couldn't carry them and balance on top of the moving boxcars.

I whipped down into the open boxcar with the green beans and the men erupted. One threatened to whip my ass. He said they could all go to the penitentiary because of me.

Then one of the old men, who had been speechless, held

up his hand, like an aged Indian tribal leader. The other seven fell quiet.

"Open up them beans, son," he said, as he slid a rusty pocketknife my way. None of the geezers helped while I struggled to open the can, but they sure helped with the eating.

By now you may be wondering if I ever did anything except travel illegally or run from the law as a young man. I don't think there's much reason to wonder. I set myself in illegal motion at age ten, and I've been moving ever since. I'm sixty-two, and my travels today earn money, are totally legal, and totally safe . . . and a whole lot less fun, at least some of the time.

On that trip with the boxcar filled with green beans, I awakened and found myself alone inside the boxcar. Funny how eight men with sixteen feet could walk across a suspended wood floor and not make enough noise to wake a kid, who, no matter how sleepy, is edgy because he's trespassing. But that's what happened.

I rolled off the stopped train and began walking. It was almost daylight when I saw a distant sign that said DUNSMIER GREYHOUND BUS STATION. Once inside, I found out I was in a mountain town in California or Oregon. I wasn't immediately sure which.

I was hungry again. Someone was frying breakfast in the bus station diner. With only twenty-five cents, I decided I'd have to make do with coffee. A kind waitress, who looked as if she'd eaten plenty of meals, refused to take my money. Her

generosity stopped at the coffee. There was no mention of free food, and I sure as hell wouldn't have asked for any.

I asked for change for the quarter, and she gave me five nickels. I could call home collect with ten cents. I did just that, knowing that Mom would be cooking breakfast, too. Mom accepted the call and wired some money to me at the bus station.

I remember the sound of two nickels dropping into the telephone and the sound of Mama's voice.

As hungry and as far away as I was, I remember even more a jukebox, dropping two nickels into it, and playing "Hey Good Lookin' " by Hank Williams.

I talked to Mama while Hank sang to me.

I had a musical idol in my ear, my mother on the line, arrangements to get home, and five cents to my name.

It all meant one more first chance for Merle Haggard.

I don't think there is much point in telling more stories about my illicit travels. You get the idea. There were plenty more trips, just different places with different faces, but for the same reason—the inner restlessness I tried to flee but always awaited me when I arrived. I had a lot of fun, but I was too young to realize—or care—that I had no peace of mind.

There is one more recollection about one more trip I should tell. If not, it will leave a big hole in my life story, since it almost resulted in my going back into the California penal system for years. I was sixteen. That was the year I learned about the Mann Act.

MY HOUSE OF MEMORIES

I'd never heard of the Mann Act. Once it was explained, I naively wondered why the law against transporting women across state lines for immoral purposes was called the "Mann" Act. Seemed to me it should have been the Female Act or something like that. See, I wasn't a hardened criminal. I was just a kid with a surplus of energy and a shortage of discipline. Dad had been dead for seven years. Mama had long since lost her hold on me. Lowell and Lillian had long ago left home.

I only went home when I had no place else to go. Even when I stayed there in body, I wandered in my mind, curious about the destination of every passing freight train, curious about the people who might be inside its boxcars. Curiosity and restlessness are a dangerous combination for someone with no sense of roots.

Anyhow, back to the Mann Act.

My best friend, dating back to childhood, was Dean Holloway, and he had a 1941 Plymouth that ran as fast as a striped-ass ape. The year was 1953, and driving ninety miles an hour in a twelve-year-old car was dangerous. The car didn't even have tubeless tires. The heat of the California highways could have blown a tire at any time, and we'd probably still be rolling.

The car was ugly. One fender was gray or white on an otherwise blue car. Dean didn't care about its appearance, only its speed.

I ran into Dean one night and we took a half-drunken ride in his hot rod. We were joined by another guy and his girlfriend.

She was fifteen. A fifteen-year-old girl is a minor and has no consensual rights in any state in the union—not then, not now.

I had told Dean the juicy details about shacking up with Dolly in Oregon, and he said my yarns gave him rambling fever. He wanted to travel for the sake of traveling. But where would we go?

He had folks in Arkansas. Arkansas? I'd never been that far east. That was even farther east than Oklahoma, where my folks had made their early married life.

So I agreed to go with Dean to Arkansas, and Dean's friends decided to go with us, although I'm not sure they were even asked.

I was so obsessed with music by then that people who knew me equated country singing with me as much as they did my first name. I was consumed with the country stars and had told the story a hundred times about having seen Lefty Frizzell in Bakersfield.

Maybe that was on my mind when we entered Arizona, spotted a limousine, and decided it carried Lefty. I urged Dean to catch the car so we could get a peek at ole Lefty.

I never once gave a thought to the odds of Lefty being in the Arizona desert. In fairness to me, Lefty worked a lot around the Southwest, and I hadn't seen many limousines. The car had to be carrying Lefty, we decided.

Dean's pursuit of the vehicle marked one of the times I saw his speedometer pass the 90 mph mark. The cop got us in Ash Fork, Arizona. I don't know why they didn't chase Lefty. He had to be going faster than us, or we would have

caught him. I think the cop discriminated against a car with a mismatched fender.

Of course, no one was tossing beer cans out of the limousine.

The cop did his regular thing; I knew the drill. "Get out of the car. Got any identification?"

The officer walked to his squad car, spoke into the radio, and came back with a speech that increased my legal education. He said there was an "APB" on the girl.

"What's an APB?" Dean asked.

"An all points bulletin," the cop said. It seems her parents had notified the authorities that their minor daughter was missing and in the company of three youths, all of whom were older than she.

Then the cop did the most curious thing. He told us to drive ahead to Prescott where other policemen were awaiting us. He said there wasn't a single side road between us and Prescott, and there was no point in driving a few miles then turning around, as we'd be driving right back into his jurisdiction.

"You can't go sideways, and you can't go backwards," he said. "All you can do is go forward into the arms of the law. It will take you about an hour to get there, and there just ain't no chance for escape."

No chance for escape? That's all I needed to hear.

We took off from the shoulder of the highway. The cop had told the truth. There was not a solitary side road. The highway led straight to Prescott and nowhere else.

Dean, whose nickname was Dean Roe, got frustrated, and

put his fist through the car window. He said he couldn't abide the notion of driving right into the open and waiting arms of the law.

"Then don't," I said.

"What do you mean?" he asked.

"It's true, there are no roads for escape," I said. "But who says we need roads? There are hundreds of miles of open desert out there."

Dean Roe drove his blue car with the gray or white fender into the red desert at maybe seventy miles per hour. The terrain was so rough that our heads hit the ceiling.

The desert was a jungle of tumbleweeds. Those that weren't already tumbling did so after being uprooted by Dean Roe's car grill. Weeds flew into the windshield so densely he was blinded. So what did he do? He accelerated.

"I can't see shit," he hollered, "but it ain't like I'm goin' to hit nothin'. There ain't nothin' out here to hit!"

I got a rush whenever I ran from the law. I never planned to be caught, but things didn't always go as I planned, as you've gathered by now. But I didn't care. The means justified the end. I got a high off temporarily outsmarting cops. Getting caught was a terrible letdown. But, as Kris Kristofferson once wrote, "The going up was worth the coming down."

Who did we think we were? Were we just going to drive into the desert indefinitely? Eventually, we'd have reached the Rio Grande and been unable to drive the car across the river into Mexico. What were we thinking? That's the point: We weren't thinking. We were just taking one more fun-filled lap on the joyride of life, not worried about where it would stop.

We halted when we were about twenty-five miles into the

My House of Memories

desert. I can't believe they didn't have a helicopter looking for us, since we were caught in the commission of a Class A felony. Maybe they just figured people couldn't live in the desert for very long, and sooner or later we'd make our way to the highway, where they'd pick us up.

We drank beer, and I sang and played my guitar all night. The next day was firsthand exposure to life in the desert. We had no food or water and all the beer was gone. We were dehydrated, hungover, thirsty, sweating, hungry, and no longer having a very good time.

The young lovers had even stopped smooching.

I recalled old Western movies where I'd seen guys try to drink from empty canteens after having to shoot their horses beneath the baking desert sun. I talked about that, then Dean Roe told a similar story about a movie he'd seen. Our imaginations were running wild.

We got into the car and headed back to the highway, knowing the cops would be looking for us near Prescott. We decided we might have a chance if we went back the way we came. We had no money, and at the first gasoline station we saw, Dean Roe traded his watch for gasoline and food.

We then eased the car forward into the Arizona night en route to Bakersfield, our starting place.

And we made it. We had gotten beyond the long arm of the law. Or so we thought.

We split up. Dean Roe wanted to go to a nightclub, and stopped at the Rainbow Gardens. I wanted to go home. The girl wanted to go somewhere else, but eventually went home.

When her parents asked who she'd been with and where she'd been taken, she told all.

I first heard the expression "white slavery" in connection with the Mann Act when the cops came to Mama's house the next morning. I had actually gotten a night's sleep in a stationary bed before they arrested me. It was law enforcement by appointment.

I wish I could remember my parole officer's name.

That guy pleaded my case with the passion of a defense lawyer. He said I was one of four crazy kids who may have taken a minor across state lines, but I was also one of four who saw their way to return. He assured the cops of the girl's sexual purity.

No comment.

The four of us were scolded, but not one was arrested.

I was told again about the Mann Act, white slavery, and serving hard time.

The only sentence I received was to stay at home, and the only advice I was given was to get back in school.

Of course, I ignored both.

7

★ ★ ★ ★ ★ ★ ★ ★ ★ ★ ★ ★ ★ ★ ★ ★ ★

"MOVIN' ON"

Most people in my generation can tell you exactly where they were the day Kennedy was shot, the day man first walked on the moon, and the day Elvis died.

Many can also tell you the first time they ever saw a telephone or television, the two inventions that transformed twentieth-century life more than anything else, including computers.

My recollection of where I first saw a television is as boring as everybody else's. I'm much more excited about what I saw *on* the television—music, live music. I'd heard it on the radio and in the dives I was often too young to enter legally. And I'd played it for small and often captive audiences. Right there in Bakersfield I could watch *The Billy Mize Show* on Channel 29, the first TV station in the San Joaquin Valley.

Can you imagine a town the size of Bakersfield had only one television station? That's how it was around 1950, when I saw my first televised talking head.

Almost all television was done live in those days. Video-tape hadn't been invented, and nothing was filmed for local television, except parts of the news.

When I was fifteen or sixteen, I felt about news the way I told you earlier that I felt about history. I didn't want to *study* either. I wanted to *make* both.

That doesn't mean I wanted to be a star. I didn't. I just wanted to make music. I didn't even want to be a singer. I sang because it was my ticket to getting to play guitar. To this day, if I had my preference, I'd be a guitar player in some singer's band. And to this day, I don't care about being a star.

Someone once asked if playing for small audiences early in my career bothered me. The answer is no. I've never played music primarily for the audience. I've played it for myself and for the sake of the music. I'm not interested in being a celebrity or in being rich. I just want the music to be right, and when it is, well, great music is better than average sex.

Writing songs and singing them has sat better with my fans than my mere guitar playing. Besides, I've had some awesome guitarists in my band. Why would I want to try to play lead when they could play it better? I want the best band I can possibly have, and I am willing to turn over the lead guitar work to anyone who can play it better than I.

When my career initially took off in the mid-1960s and I formed my band, the Strangers, I played rhythm guitar in all my shows. It nearly killed me, and I wanted so badly to take an instrumental break. But I had my little acoustic guitar and left the lead to Roy Nichols. I could *feel* the way it should sound. He could *play* the way it should sound.

Roy Nichols was and still is my idol. The Roy Nichols that

MY HOUSE OF MEMORIES

I know is still the same. The soul of the man is what I admired. There've been great guitar players since Roy, but I think they would be the first to say there's only one Roy Nichols.

I recently asked Roy's daughter if she still played piano. Her answer was a typical Roy Nichols return. She said, "I still play piano and my brother Michael still plays guitar, but if you're looking for another Roy Nichols there isn't one." The direct answer reminded me of her father's guitar playing.

In 1953, I watched the Billy Mize show and Lewis Tally's talent show in Bakersfield. They were big icons in the 1950s. In Bakersfield, Lewis Tally was indisputably the biggest star. He had a television show, recording company, and a music publishing company. Lewis ran his "empire" with his cousin, Fuzzy Owen.

Nothing in the world would have ever made me believe I'd get to meet those guys, much less play music with them, much less employ them.

Lewie was with me until the day he died in 1986, and Fuzzy is my tour manager to this day. Before that job he played steel guitar in my early band after I signed with Tally Records in 1963.

Now, I'll never forget the first time I met Lewie and Fuzzy.

I had hung around the country music clubs of Bakersfield—The Lucky Spot, The Barrel House, Doc's Club, Green Door, Club 409, The Blackboard, High Pockets, and probably one or two more.

Well, I mustered my balls and went to Lewis Tally's studio to play my songs. And he liked them.

I didn't say a word, largely because I couldn't. I was

speechless with gratitude. Then he played them for Fuzzy, who dampened my spirits. He said I sounded too much like Wynn Stewart and Lefty Frizzell, and pointed out that the world already had both.

I continued to watch local television and country music. There was an up-and-coming artist named Buck Owens, who dominated country music in the mid-1960s to early 1970s in a way few artists ever have. He did more to popularize the electric, solid-body guitar sound in country music than anybody. And he and the late Don Rich sang some of the tightest harmony anybody ever has.

In 1952, Buck was a local star in Bakersfield, along with his pretty wife, Bonnie. I'd eventually marry Bonnie myself. Bonnie is my harmony singer who is still with me today. She has been friends with each of my three wives since her, and in the late 1970s and early 1980s she even sang backup for the wife who wanted to be an entertainer.

People used to ask Tex Whitson, my former business manager, if it was awkward for me to have my current wife singing front and center while my ex-wife sang background.

No.

Hell, Bonnie was even a maid-of-honor when I married my third wife.

Tommy Collins, whose real first name is Leonard and about whom I recorded the hit song "Leonard" in 1981, was also a fixture on Bakersfield television in 1953–54.

I'll never forget when I wrote "Leonard." I finished the song and had the bus driver pull to the side of the road. Ronnie Reno held a telephone receiver, and I sang the song to Tommy long distance.

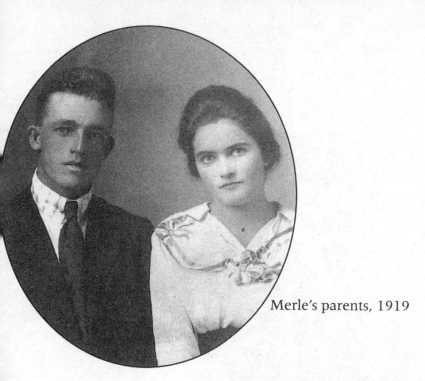

Merle's parents, 1919

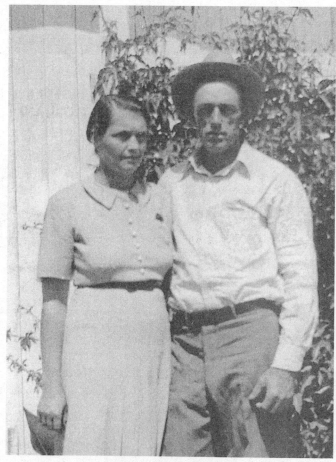

Merle's parents

Merle and his
dad, 1939

Merle with his mom and dad

Merle with his beloved dog Jack

The Haggard family, 1941

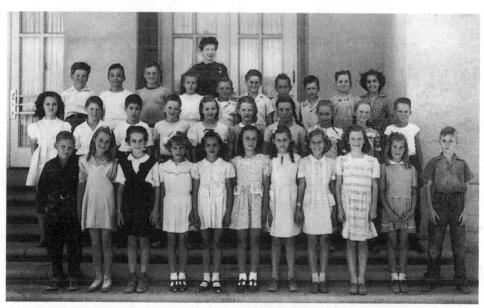

Merle (middle row, far right) with his fourth grade class

With a friend, 1944

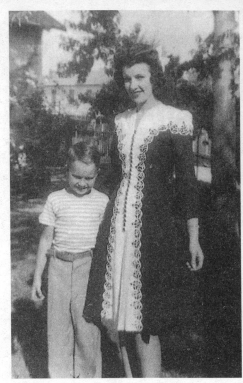

With sister Lillian

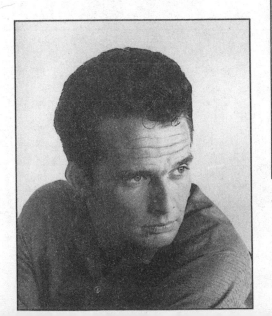

Merle, early Capitol years

Rose "Vegas" Waters

Merle and Ernest Tubb

Merle with four of his
children: Kelli, Marty, Dana,
and Noel

With the kids

Noel, Dana,
Marty, and
Kelli

Playing the guitar, 1973

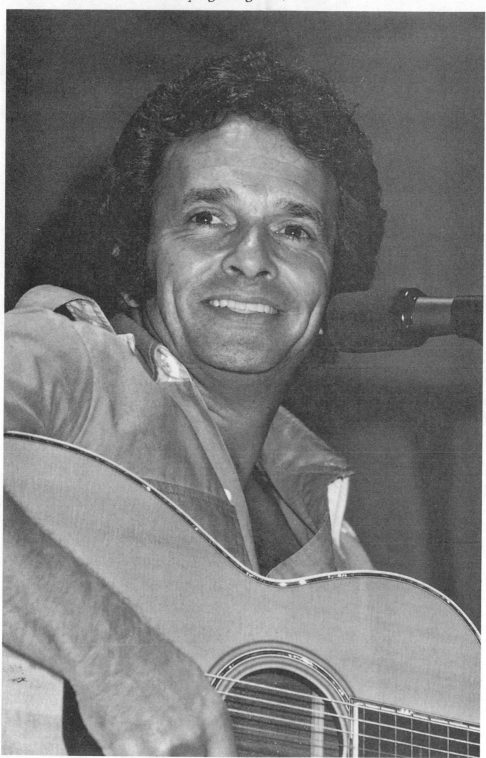

With Fuzzy Owen

With
Jimmy Carter
in 1980

Merle's old band

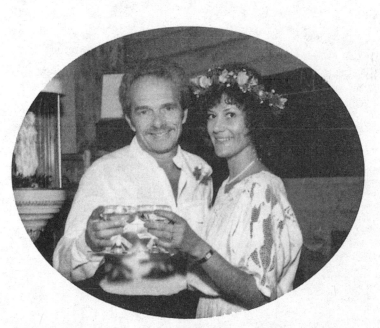

With wife number four, Debbie Parret Haggard, 1985

With wife number two,
Bonnie Owens, in 1999

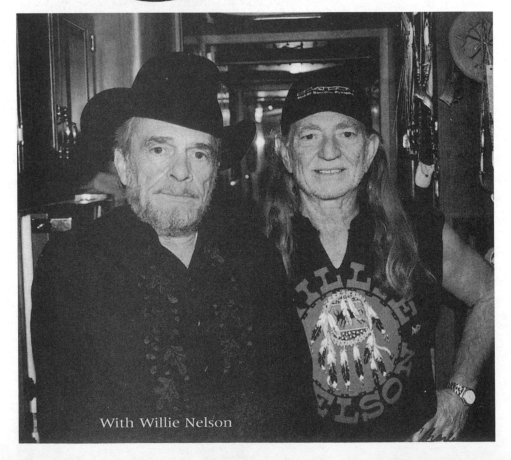

With Willie Nelson

With James Burton,
Elvis Presley's
guitar player,
in 1997

With Bill Monroe

With current wife, Theresa

Merle and Theresa at their wedding

Merle, Theresa, and Rose "Vegas" Waters
at Merle's 60th birthday party

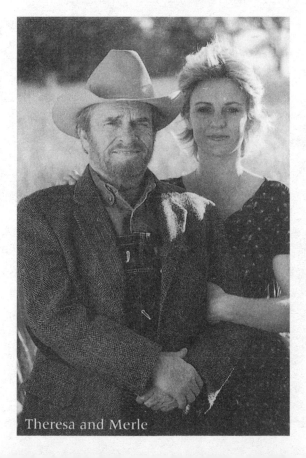

Theresa and Merle

With his children Jenessa and Ben

With Jenessa

With Ben, 1998

With Theresa, Jenessa, Ben, and Smokey the Bear

With Ben in 1998

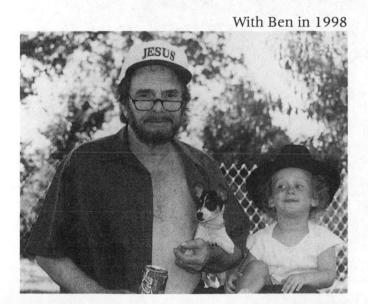

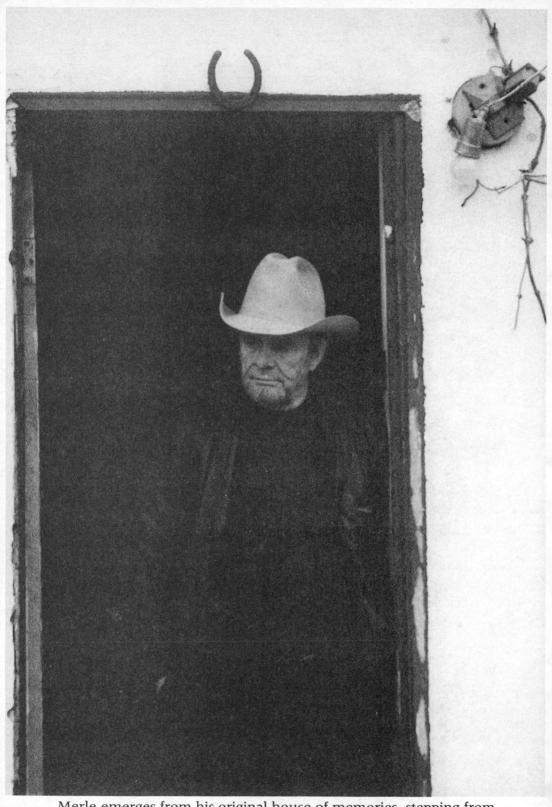

Merle emerges from his original house of memories, stepping from
the converted boxcar that was his boyhood home

MY HOUSE OF MEMORIES

I mentioned earlier that Roy Nichols eventually played lead guitar for me, and in fact he played longer than anyone ever has, before or since. He left my show on February 22, 1987. The first time I ever saw him he was playing for Lefty during one of Lefty's many Bakersfield appearances.

Roy became a guitarist's guitarist. When he was on, no one could touch him. He was as good as Grady Martin or Chet Atkins, although the three had markedly different styles. Roy became the architect of my instrumental sound on my early hits.

Bakersfield was getting quite a reputation for the great country music heard in its bars, and folks who visited California often stopped by the town's honky-tonks to hear the music.

I played guitar as much as I could in Bakersfield bars and sometimes was mistaken for Roy Nichols. What a great compliment.

One of the visitors to Bakersfield was a guy named Jack Tyree. He had a radio show in Springfield, Missouri, home of Red Foley's *Ozark Mountain Jubilee*. Foley's show was eventually on network television and was the springboard for talent such as Molly Bee.

Jack said he was a famous radio personality in Springfield, where he did *The Smilin' Jack Tyree Radio Show*. He asked me to move to Springfield to be a part of his program.

Now, I had never worked that far east. I hated the trip, and I soon hated my stay. So I didn't stay long. I quit after three weeks as a featured singer/guitarist. I was homesick for Bakersfield and for money. After twenty-one days, I was

frowning because Smilin' Jack hadn't paid me a dime. I marched into Jack's office to give him my resignation and to collect my money.

Jack had agreed to pay me $50 a week. He owned me $150. I asked him for it, and he said he'd like to pay me, but he just didn't have the money.

To this day I haven't figured out why some show promoters and others think that paying a musician is optional. They think it's necessary to pay their doctor and their electric bill. But a musician, hey, let him wait for his money or stiff him. Fuzzy Owen collects my performance fee. We don't even drive to a date unless we're paid half our fee in advance. Once we arrive, the promoter often wants us to do the show, saying he can't pay us the second half of what he owes until he counts his box office. Sometimes, an argument follows.

The promoters will sometimes complain about the show and say it was no good, even though it might have prompted two or three standing ovations. Some promoters will say anything to get out of paying or to pay a lesser amount. Fuzzy gives the promoters some yarn. He tells them the stage was too hot and that I nearly fainted just getting through the program. He comes up with all kinds of stories, but he shouldn't have to. We're rightfully owed the money.

We played Colorado City, Colorado, in October 1998, and we were supposed to be paid a percentage of every ticket that was sold. Fine. Then Fuzzy noticed that the promoter had put at least three hundred folding chairs in front of the people who had paid for front-row seats. The front-row people were angry because they couldn't see, and I was unhappy because the

MY HOUSE OF MEMORIES

promoter tried to stiff me out of money from seats he wasn't supposed to sell.

Fuzzy bugged him throughout the program, and we eventually got our money.

I've had forty-one number-one records and played for U.S. presidents. And I *still* have to fight occasionally to get my performance fee. I think most musicians do.

There isn't a singer in the country music industry who can't tell story after story about all the outrageous things he's had to go through, including fistfights and gunplay, just to get the money owed to him.

"I can't pay you," Smilin' Jack continued that day in Springfield. "I ain't got no money."

I was more than fifteen hundred miles from home, broke, and had no funds to get home.

I don't remember how I discovered the location of Smilin' Jack's petty cash. I walked to his desk, then I raised his trouser leg and pulled a wad of bills from his sock. I should have taken it all. Instead, I counted out $150 and threw the remainder on his desk. He didn't say a word. It's a good thing. I would have fed him his bills. He watched in silent disbelief as I walked out of his office.

I rode a Greyhound to Bakersfield, not knowing what my future held and certainly not knowing that one day I'd climb aboard a bus, and still be riding in 1999.

Dean and I were cruising Main Street and looking at girls between stopping for Cokes or sneaking into the back of beer joints. I was seventeen and driving a car that I had bought with a down payment and Mom's co-signature. I had earned

the money inside the potato sheds and was currently working for Geophysical Service, Inc.

Leona Hobbs and her sister, Alice, were fifteen and thirteen, respectively. They didn't look it, especially Alice, who was fully developed by the time she was thirteen.

You wouldn't have thought those girls were sisters, because they didn't look alike. When they told me they were sisters, I thought they were lying. Alice looked like Lauren Bacall. Leona was a gorgeous lady when she was young, but Alice was beautiful.

The first night I met the sisters I went for Alice. I asked the girls if they'd like to go have hamburgers.

Leona said she wanted two hamburgers.

"Two hamburgers?" I said. "I don't know if I've got enough money for everybody to have two hamburgers. Are you the only one who's going to have two?"

We got into a little tiff right there. I guess that, compared with her, I looked rich. Her family never had anything, and mine had very little, but I must have looked like a wealthy kid from across town. I mean, I had that car and a Martin guitar. Her family was musical, and her dad sang like Jimmie Rodgers. I think I reminded her of her dad. For whatever reason, she was attracted to me, and she didn't like it. I think she hated the fact that, from the very beginning, she might have been in love with me. Strangely enough, I hated the fact that I was in love with her. We were not meant for each other.

Leona and I hit it off because we were so wrong for each other. The challenge was on both sides of the road, you

know? She wasn't one to walk away from a challenge, and neither was I. We started arguing right from the beginning, and we argued right up until the last time we saw each other last year.

Leona and I eventually moved in with my brother Lowell and his wife. We lived openly together, right in front of my religious mother, sister, and the decent folks of Bakersfield. Couples live together freely today, but in 1954, couples who shacked up were looked down upon. They were thought to be immoral.

I didn't care what anybody thought about me, and I don't think Leona cared what they thought about her. I couldn't stand to see how our cohabitation was killing my mother. With all of my confinements and all the times I'd run away since my dad had died nine years ago, I figured I owed Mom no more pain. If it hadn't been for Mama's shame, I might never have married Leona Hobbs.

I didn't really propose to Leona. I just mentioned to Lowell that it might be a good idea if Leona and I got married, and she happened to be standing there when I said it. She was, in effect, overhearing a conversation *about* her, not one directed *to* her.

I asked Lowell if he'd take Leona and me to Reno, where we could get a quick wedding, the way you can to this day in Nevada. There's a place in Las Vegas today that is a drive-through wedding chapel. You can drive through and order a marriage license and be pronounced man and wife without even getting out of your car.

Our wedding wasn't quite that easy, but almost. Lowell

and his wife, Fran, drove us to Reno and were our witnesses in a tiny chapel. We were man and wife—or, should I say, man and war.

I worked in the cotton fields, stole a little bit here and there, and shared my loot with Leona's eleven brothers and sisters. I worked in the oil fields, too. Weekends were reserved for my music and for partying.

Leon Copeland and his wife, Mildred, went with Leona and me to play a job Leon had booked. Some people had asked him if he knew a good country band, and he suggested me and some other players. The show didn't pay a thing.

We got to the show, started into our Lefty Frizzell and Hank Williams, and the people began to boo. They started hollering requests for Perry Como and Patti Page cover songs. They didn't want to hear country music at all.

When the people were most unhappy, Leona took it upon herself to take up a collection. We had agreed to play the job for free, but she thought the customers should pay us. I looked up and there was my wife working the room with a plate and taking up an offering.

Leona was pretty, and apparently one old boy thought if he was going to give her some money he ought to get something in return. I don't know. But when the band and I went on break, she came to our table with a plate full of money, and a strong accusation about one contributor. She said he had run his hand up her dress. She pointed him out.

I told her to forget it. After all, the poor bastard was obviously drunk, and he had given us money.

My failure to defend her "honor" outraged her.

Leona jumped up and yelled as loudly as she could for any

man in the place who wanted to run his hand up her dress to come ahead and do it, since her husband, Merle Haggard, obviously didn't care.

"Leona, let's don't make a scene. Anything I do or say is gonna start a fight!"

She wouldn't hush. Something had to be done about the man who had touched her on the "you-know-what."

I got up and slowly strolled over to the table of the man who had degraded my wife.

I politely began to explain the problem and how my wife was probably wrong. But then I politely asked the man, "Would you mind doing me a favor, and apologize to my little old wife?"

"What did she say I did?"

"She claims you ran your hand up her dress," I replied.

As the big man started to rise slowly from his chair, he shouted, "Well your wife is a lying son of a—"

"Bitch" never left his lips. Just like a great t-shot right down the center of the fairway, I connected with a short right. To my surprise, he went ass-over-tea-kettle with his eyes back in his head and landed a few feet away, underneath a couple of round barroom tables.

At that moment a good sized brawl erupted. The women from our table and the women from another table, had started their own fight. They were tearing one another's clothes off and pulling one another's hair.

While I was taking a breath, someone swung at me from behind. He missed and, with a little help from my boot in his ass, he went flying across the room. It was then that I saw the man whom I had knocked to the floor. I knew it was him,

because he was sitting on the floor, wiping his forehead with a wet cloth. I saw my friend Leon walking towards the man on the floor. As the man slowly stood up, I began to wonder what Leon was going to say to him, when I suddenly heard Leon ask, "Are you the man Merle Haggard hit?"

His confused reply is still funny to me.

"Hell, I didn't have time to get his name. I don't know who the fuck hit me!"

"Well, my name is Leon Copeland, and the first guy that hit ya, his name is Merle Haggard."

Then Leon struck him with a wonderful right and knocked him out again.

This all occurred on a music break, during the fifteen minutes when the band is usually shaking hands with the clientele, mingling, and making friends. The style of our music was different right from the very beginning. Even the intermissions assumed their own character.

Some official from the American Legion Hall had found his way over to the microphone and said, "Would the musicians who started this fight, please leave? Your services are no longer needed!"

He repeated again, "Would the musicians please leave!"

He didn't know what had hit him either.

8

"A WORKIN' MAN CAN'T GET NOWHERE TODAY"

I've noticed a difference between male and female fans. The male fans mostly want to know about your music and your background. The female fans often want to know about your music and your ex-wives.

Bonnie Owens, who eventually became my second wife, has worked with me for almost forty years. During that time, she has often been asked, "What was it like to be married to Merle Haggard?" Why do women still ask? We've been divorced for a quarter of a century.

But for those women who want yet more news about the women in my life, I've got another colorful recollection or two about Leona. One of the incidents happened before that brawl she started at the American Legion.

Leon and Mildred Copeland were with Leona and me on this night, too.

Tommy Duncan, the former lead singer for Bob Wills, was playing Hanford, California, in 1956. Will Ray was putting

together a band and called to ask me to play lead guitar. Being asked to play behind Tommy, this legend and one of my true idols, remains one of my greatest professional thrills to this day.

There were about eleven other musicians, and each was worse than I. Tommy knew none of them. He walked over to me after finishing "I'm Drifting into Deep Water."

"Well," he said, "it looks like we've got it to ourselves (meaning the others couldn't play well). Would you mind kicking off these songs for me?"

His request was a compliment that inspired me for years to come. If my career had stopped right there, I could have said I'd played lead guitar behind the best singer to come from the best country band in America during the 1930s through the 1950s.

Leon, Mildred, Leona, and I went to Tommy Duncan's dance. Leona and I had been married about a year. We rode to the dance in Leon's 1951 Ford. Funny what little details we remember.

Bob Wills's band, with whom Tommy used to work, was the best in the history of live radio, I believe. It was a fusion of jazz and country that had a horn section, fiddles, and even a drummer. The rhythm guitarist, Eldon Shamblin, would eventually be called "the greatest rhythm guitarist who ever lived" by *Rolling Stone* twenty-five years before his death in 1998.

I'm bragging on the band because I'm trying to make a point. After having seen Tommy with Wills's outstanding Texas Playboys, it was heartbreaking for me to see him that night in Hanford. He had four mandolins and four guitarists,

My House of Memories

and everybody was playing rhythm. I played lead, but there was no bassist, no drummer, and, of course, no brass or fiddles.

To top it off, Tommy was playing a big room, but he only had about seventy-five people in the audience.

The sight really depressed me. It was kinda like an avid boxing fan having to see Joe Lewis in a wheelchair waiting for tips at a Las Vegas casino not long before his death.

Tommy deserved a whole lot more than to have to sing with those miserable musicians.

So I was distant and thoughtful as I drove Leon's 1951 Ford home that night. Leona, sitting in the front next to me, noticed my silence.

If a woman isn't in the mood to make love, a man is wasting his time, no matter what he tries. She might let him, but she won't enjoy it, and he'll be able to tell.

In the same way, when a man doesn't want to talk, he doesn't want to talk. No amount of probing from a woman is going to make him say a thing. He might break his silence, and if he does, he and his female companion will usually both regret what he says. If she pushes enough, by God, she'll finally get him to say something, even if it's only that he doesn't want to say anything.

I wanted to be left alone and quietly hurt over the plight of Tommy Duncan. Leona wouldn't hush.

"What's the matter with you?" she asked. "Why don't you talk?"

She was driving a hurting man crazy. Some women complain about a man's insensitivity, then turn around and are insensitive. I wanted to knock the shit out of her.

MERLE HAGGARD

So I did, right after she said that Tommy Duncan had no talent, and that's why he had drawn such a small crowd. Her words made me furious and cut me deeply.

I don't advocate domestic violence. But that night in 1956, without even looking up from the highway, I gave Leona Haggard the back of my hand across the mouth.

She didn't hit back. She didn't threaten me. She didn't apologize. She just got out of the car—which was traveling at about sixty miles per hour.

She opened the door and stepped onto the asphalt moving eighty-eight feet per second beneath her. Her door had blown shut as I raised my eyes to the rearview mirror, where I saw Leona bouncing like a rubber ball in a dress.

Until that point, I was convinced there was nothing left for this woman to do that would amaze me. But that night, she did.

I stopped the car and ran back to her.

Here I was trying to check her for broken bones, but I couldn't hold her still because she was jumping around the highway waving the skirt of her dress that she claimed *I* had torn because *she* had jumped out of the car. Leona was a mystery. Maybe that was the attraction. Maybe I just wanted to see what made somebody behave the way she did. Who knows what her hold was, but she had a stranglehold on me.

I'd look forward to getting away from her, then would miss her shortly after I was gone. That's exactly what happened one day when I was an oil field worker down in Santa Paula. Working the oil fields was hard, but it was honest.

Almost any able-bodied man could get an oil field job in

MY HOUSE OF MEMORIES

those days. Oil was pumping from the ground, and our nation did not have the dependence on overseas petroleum that it would develop in the 1960s and 1970s. Since the work was so hard, a lot of guys would work a day or two and quit. On almost any day, you could walk up to a foreman and get a job because there was such a shortage of help.

I had finished the week and collected my paycheck one Friday night when the foreman told me and four other guys from Bakersfield that he wanted us to come in for half a day the next morning. Nothing is more discouraging to a working man than to be told he has to come in on his day off.

I wanted to get home and be with Leona. We'd probably get into a fight, but I knew we'd eventually *get into each other's pants*. Man, I was disappointed that I had to work.

Three of the guys drove all the way to Bakersfield but I determined with Dennis Myers that I'd spend the night in Santa Paula, then make my way home Saturday afternoon. I'd ride back with the three guys who'd be returning in the morning, I thought.

So Dennis and I took a stroll of downtown Santa Paula and bought a little beer and wine. The more I drank, the more I thought about Leona and the good time I wasn't going to have with her tonight. Then my mind ran away with itself, and I began to imagine how she'd behave in my absence. After all, her behavior was outrageous in *my presence*. How did I know she wouldn't be so angry that she'd go out with some other guy?

I began to think more and more about getting home.

As Dennis and I walked past a car lot, I started telling him

about all the cars Dean Roe and I had "borrowed" in our time. He couldn't believe we had taken the vehicles, driven their wheels off of them, and then returned them. Usually.

(As I look back, don't you know a lot of motorists get in their cars and wonder why the ashtray is overflowing and the gasoline tank has less fuel than they remember it had?)

Dennis didn't know whether to believe me.

So I developed a plan. I explained that I'd "borrow" a car off a lot, we'd speed up to Bakersfield, get laid, and be back in time to work on Saturday.

"So what if we're tired or hungover?" I told him. "It's only a half day, and hell, we can stand on our heads that long. Besides, we'll sleep all the way back to Bakersfield when we ride with the other guys tomorrow afternoon."

He went for it.

I told you earlier that I remember a United States where people didn't lock their doors and where they left their keys in their cars. Our country was once that trusting.

I helped destroy a little of that trust.

I looked over a car lot from the sidewalk, and walked up to a 1952 Oldsmobile 88. That was one of the finest and fastest cars this country ever produced. General Motors announced on January 27, 1999, that it would discontinue production of the Olds 88. I hated to hear that. It was like hearing that there would be no more Coca-Cola or light bread.

Back to Santa Paula.

The door to the Olds was unlocked, and the keys were under the floor mat. Pretty cagey hiding place, eh? I don't

know why the owner didn't just tape them to the steering wheel.

I drove the car to a filling station, where I put fuel in the tank and more beer in my belly. Then I started up the two-lane road toward Bakersfield in the "borrowed" car. I'm serious. I had known what it was to steal, and I had known what it was to borrow.

I honestly would have put that car right back where I had found it, if I'd gotten the chance.

I was driving too fast and taking the curves recklessly, when I spotted two semitrailer trucks near the bottom of a mountain. I estimated they were traveling at about seventy-five miles per hour and thought it would be fun to pass them.

Those old Oldsmobiles and Buicks and Cadillacs showed 120 miles per hour on their speedometers. Their big eight-cylinder engines would let the driver "bury the peg," or take the car to its highest speedometer reading.

I passed the two trucks so fast they were little more than a blur. I hadn't really seen a thing. But Dennis had.

It seems a California Highway Patrol car was nestled between the two trucks, trying to trap any nut who might try to pass.

The patrolman pulled me over and asked to see the car's registration. The car was registered, but the registration papers were inside the office at the lot where I had borrowed the vehicle. I tried to make the patrolman believe I *really* planned to return the car at daybreak.

I'll bet he thought he'd heard every excuse in the book.

He took Dennis and me to the Ventura County jail.

Jails didn't have computers in those days, so I don't know how he found out about my record of juvenile delinquency so fast, especially after business hours. I was held, stood trial for car theft, and was sentenced to one year, to be served in that same jailhouse.

I was out in nine months, released three months early for good behavior. I spent my sentence working as the jail's fry cook. Maybe they hated my cooking and let me go just to give the job to some other son of a bitch whose kitchen skills didn't give the jailer heartburn. Who knows?

I had started out from Santa Paula to Bakersfield, and the trip, with my detour through jail, took 270 days. Leona had come to see me in jail, and each time she was larger. She was pregnant with our first child, Dana, whose delivery I missed because I was behind bars on April 1, 1957.

That wouldn't be the only time I let down my four kids by Leona.

We're all creatures of habit, and I was no exception. In 1957 I was twenty years old. I had first run away from home almost ten years earlier. In other words, before I reached the age of majority, I had spent nearly half of my life running away or behind bars. I'm convinced I would have been a career criminal, and I would have had a short career. I would have gotten a life sentence early in life, and died young, if music hadn't saved me.

Before Dana turned one and I turned twenty-one, I was back behind bars. I had started a business of selling scrap iron that was almost legitimate. I mean, I didn't sell anything that people did not first sell as junk. But they sold it to another guy who was also in the scrap iron business.

MY HOUSE OF MEMORIES

He bought the junk, I stole it from him, then I sold it again. This system cut down my overhead while raising my profits. The guy reported me, a cop arrested me, and a judge sentenced me. I was handed ninety days and served five. This time I wasn't released for good behavior. No one had time to evaluate my behavior. I escaped.

It took God seven days to make heaven and earth. It took my guard five days to take his eyes off me. And it took me one second to escape. I faded into the landscape, then ran like hell.

I hadn't planned the escape, and now that I was on the lam, I realized I hadn't planned where I'd go. I knew I couldn't go home. The cops would be expecting me to go straight to my wife and baby.

So I went north to Utah. I was guilty of escaping from jail and of abandoning my new baby.

> *I was born the running kind*
> *With leaving always on my mind . . .*

I wrote those lyrics in minutes. I spent years living them.

I bummed around the Northwest, one step ahead of the law. A warrant for my arrest was issued. Law enforcement personnel take an unusual attitude toward an escape warrant. They want the subject more passionately than they want other kinds of criminals. I think that's because the escape artist makes them look foolish, or so they believe. I wasn't trying to make anyone look foolish. The cops didn't need to take my flight personally. Some of them were good ole boys, and I had nothing against them.

By this time I'd developed a sixth sense about the close-

ness of the law. I always seemed to know when they were about to catch up with me, so I'd run again. I might work a day or two, but then I'd be off. Employers weren't as strict about social security numbers and withholding taxes in those days. A man could get a job doing unskilled labor without having to answer too many questions. A lot of employers asked your name and accepted any name you gave.

"You can run, but you can't hide," the old saying goes. I know it to be true. And the running becomes physically, emotionally, and psychologically exhausting. You wonder about the folks at home, then feel guilty about not being there, so you try to stop wondering.

"You can't 'think' your way back home," you tell yourself.

There was a guy in Oklahoma who broke out of the state penitentiary several times in the 1970s. His name was Rex Brinlee, and he was doing life for murdering a schoolteacher. There are two or three sets of eighteen-foot-high walls around the prison in McAlester. Their tops are covered with barbed wire. There are guards with high-powered rifles on top of those walls.

Yet the walls were transparent to Brinlee. He became kind of a folk hero to some people, who actually pulled for him when he was on the run. Maybe they just wanted to see someone beat the system.

The last time he was arrested he'd been running for about nine days. Highway patrolmen, SWAT teams, aerial surveillance, and all the rest produced nothing. Someone saw him shopping at a grocery store, tired, dirty, and probably tick-infested from living in the woods.

They saw a cop just walk up to him in the grocery store,

and Brinlee went along with no resistance, as if to say, "What took you so long to find me?"

A lot of folks wanted Brinlee to put up a big fight—to be a modern Clyde Barrow and go out in a blaze of glory. There's no glory in being on the run, no matter how you go out. Brinlee found being outside the walls, when he was still wanted inside, his worst nightmare. People couldn't understand his surrendering so easily. But I can.

Johnny Cash did a concert at the prison sometime in the 1970s, and in front of all the other prisoners he asked Brinlee to stand up.

A short, stocky, and tired man rose to his feet. Nobody applauded, and the other prisoners fell quiet. Who knows what they were thinking?

"Thanks for standing," Cash told Brinlee. "I've been reading about you in every state I've been in. I just wanted to see what you looked like."

Brinlee eased back into his seat. The show, and his sentence, went on.

I don't remember how they finally got me on that particular escape rap. But they did, and I was hatefully glad to see them.

That night, I slept on a hard and cold mattress behind bars. But I didn't have to think once about which way to run next, as there was nowhere to go.

I don't know why, but I got an early out on that conviction for good behavior. I don't recall how long the sentence was, but I was out in a matter of months. Prison guards, at least in those days, didn't like an inmate if they felt they weren't making him miserable. If he kept his mouth shut and went

along with the program, they were ready to replace him with some poor bastard they could persecute.

I hadn't been back with Leona very long before she announced she was pregnant again.

Life with her was unsettling. That's the most polite way I can find to say that I was miserable. I wasn't ready for marriage, much less fatherhood, then more fatherhood.

I wanted to go, and then, as now, I pretty much did as I wanted. I heard about a new oil field in New Mexico and knew they'd be hiring hands. Bob Teague, Dean Roe, and I agreed we should all go pick up a few bucks while the oil was flowing. Geology wasn't as sophisticated then. No one knew how long a well would produce.

So Dean, Bob, and I took off for New Mexico. I told Leona I'd send home money for the babies just as soon as I made some and told her there was no way I could make any in Bakersfield. She got mad, of course, but I think she secretly understood that with my reputation and work history, there was not exactly a surplus of employers who wanted to hire me in my hometown.

Now I had a new problem. I needed seed money to get to New Mexico so I could make money to send to my family. And I needed it quickly. Desperate men do desperate things. And they do familiar things.

I stole the money to get out of town.

I went to a Shell gasoline station where I had once worked. I had been unfairly fired. I knew the attendant would secure the place for the night with a giant padlock. I stole one just like it, then drove to the station. While the attendant was filling my car, I replaced the old lock with the

My House of Memories

new one. I even smeared grease on the new lock so it would look like the original.

That night, the attendant closed the new lock, not knowing I had the key.

I found my old Shell uniform and approached the place with my key. A cop drove past. I waved at him. He waved back. In the darkness, about all he could see was the familiar uniform he'd seen many times during daylight. He naturally thought I was locking up. I let him pass, entered the station, and emptied the cash register.

See what I was saying earlier about a more innocent America? Merchants actually left cash in the register overnight as recently as the 1950s. They don't even use cash registers today, and most don't have a safe on the premises. The receipts are deposited in the bank each night. There is no way anybody except a very talented thief can get past all the computerized security systems.

I had the cash register's contents in my hand and the uniform off by back in a matter of seconds. The next morning we used most of the loot to put a down payment on a car owned by a dealer who'd never see any of us, or the car, again. Credit was a lot easier to get in those days, too.

When we got to New Mexico, the oil field was still producing, but there were no jobs. They had all been filled. Bob and Dean Roe went east, to Texas I think, and I headed west just because I wanted to get warm. It was really cold in December of 1957 in New Mexico, and having been raised in California, I hated cold weather.

I did a three-way split with Bob and Dean Roe of the $36 we had remaining.

MERLE HAGGARD

I hitchhiked toward California and was picked up by a man driving a load of Christmas trees, and later by three drunken Indians who demanded that I drink their whiskey. I could feel the familiar sense of hostility that might have left me dead in the desert. But they wanted to sing, and when they heard my renditions of Lefty Frizzell songs, *my ass was saved.*

I also spent a little time walking cold and windy highways on my lonely way back home. It's hell to be hungry and cold and looking at a string of blinking Christmas lights around a frosty window. The people inside look warm and secure, while you feel as frigid and as empty as you are. Loneliness is awful anytime of year. To be lonely, as well as alone, is hell at Christmastime.

I later hopped a freight train, and was down to my last dime, literally, when I called Mama.

There was no point in calling Leona. I knew she had no money. I hadn't sent her any, but then, I hadn't earned any. And I saw no reason to mention the seed money I'd stolen. That had faded fast, like every dream I'd had for changing my life.

9

★★★★★★★★★★★★★★★

"THINGS AREN'T FUNNY ANYMORE"

"If We Make It Through December" was a number-one song for me for four weeks in December 1973. It's about a man who loses his job at a factory, is broke, and wants Christmas to be the happy time it won't be for his little girl. The song was inspired by Roy Nichols, who had been divorced at least five times around the time of Christmas. One day I asked how his marriage was going, and his reply was, "It'll be fine if we make it through December."

I took an idea about breaking up a family and changed it to keeping one together. When I wrote the song, perhaps my subconscious mind was flashing back to December 1957.

Dana was a one-year-old, and my second child, Marty, hadn't been born. Having one baby and another on the way should have made for happy holiday spirits, but there is no joy in poverty at any time of year.

What was I going to do? No Bakersfield employer was going to hire me. Employers wanted résumés and letters of

recommendation from job applicants. What could I put on my résumé? If I listed all the jobs I'd had, they'd want to know why a twenty-year-old had lost so many. Companies were also doing background checks by then. There was the little matter of my criminal record, which would have been very discouraging to any prospective employer.

One night shortly before Christmas, my friend Mickey came to visit Leona and me. We had enough money to feed all of us and the baby and for Mickey and me to get drunk on cheap wine. Real drunk and real cheap.

We talked about the frustration of our situations and the hopelessness of an honest man trying to make an honest living doing honest work. It was especially outrageous to think that two dishonest men could make an honest living.

I was the first to suggest burglary.

I told Mickey about Freddy G's, a restaurant owned by Dean Roe's cousin. It had come to that. I was planning to rob the relatives of one of my best friends. Mickey and I, by then, had probably drunk four or five bottles of courage. Years later, I said that most men in San Quentin got there on a wine drunk.

I told Leona to pack up the baby. Mickey and I were tired of being poor. I took my pregnant wife and our one-year-old into the December night with a drunken friend to rob a restaurant.

I thought I had waited until a late hour. Time flies when you're having fun, is another old saying I've found to be true. Time drags when you're worried. It must have been dragging for me. The time was not the wee hours of the morning, as I had thought.

My House of Memories

It was ten P.M. I was seconds away from breaking in the back door of a restaurant that was open for business.

Drunks don't realize how noisy they are, and I was probably less than quiet as I removed the screen door. When I had difficulty, I simply tore the door from its hinges. It probably sounded like an explosion inside the cafe.

Then I produced a claw hammer and began to pry at the main door. I should have just opened it. It wasn't locked.

I discovered that when the owner opened it, recognized me, and casually asked, "Why don't you boys come around to the front door like everybody else?"

Damn it, I was trying to rob the man secretly, and he was openly inviting me inside.

I wonder if he even knew what we were doing? He actually may have been perplexed about why we'd struggle to get into a cafe through the kitchen as opposed to walking through the holiday-decorated front door.

I should have made a joke about being too drunk to tell the difference. I should have told him this was the front door if you approached the restaurant walking backwards. I should have done anything except what I did.

I took off like Jesse Owens.

The owner stood in bewilderment as we ran to our car and burned rubber getting away. I wonder what he said when he called the police? Probably something like, "You're not going to believe this, but Merle Haggard just tried to break into my restaurant while it's wide open for business."

When I was unexpectedly greeted, Mickey and I turned and ran. The baby and Leona were waiting in the backseat. We leapt into the car and sped away with the lights out. At

the first stop sign, we were suddenly met by the California Highway Patrol, who flipped his red lights on us simply because we didn't have our front head lights on. There hadn't been enough time for the restaurateur to call anybody—you just simply can't drive with your lights out. But after they stopped us, they began to find incriminating evidence.

I had burglary tools and a check protector between my feet on the front floorboard. The cops had me, and all the evidence they needed, right there in the car. Back at the crime scene, they had an eyewitness who knew me by name!

Leona and the baby were wrapped in blankets in the backseat. I looked at them as I saw the cops approaching our stopped vehicle. I saw fear on her face, and guns in the cops' hands.

I had gone out to get enough money to finance our Christmas. Now, not only money would be missing at Christmas. So would I.

"I got to run, babe," I said to Leona.

My words were unnecessary. She knew. I assured her the cops wouldn't hurt a pregnant woman with a baby. I pulled off my boots, rolled out the door, and hit the ground in my sock-clad feet. I got to the railroad tracks and could have hopped a freight. Hell, I was so good at it, I could have done it with one leg tied behind me. But there was no train in sight.

I spent the night in jail. I realized that out of all the times I'd been behind bars, this was my first Christmas-season stay.

Christmas is a time for family—not confinement. Lying on my bunk, hearing the distant echo of a Christmas carol on

some transistor radio, I was incredibly depressed. I think you can imagine what an understatement that is.

The next morning I went before a former probation officer from the California Youth Authority. I'd like to say he remembered me from my youth, but that sounds silly, as I was still *in* my youth.

I was later taken to the sergeant at the booking desk. A few of the cops passing by called me by name. I did the same to them. Looking back, maybe I should have applied for a job as a cop. I knew a lot of men on the force and could have showed them how burglars and escape artists outsmart them, though I don't think they would have taken my application seriously.

The sergeant put his hand in the small of my back and began to escort me down a hallway. I remember looking at his face a final time, and I recall how he looked at me but didn't seem to see me. His eyes were vacant. As I neared other cops in the hall, they also avoided eye contact.

Then I felt the sergeant's hand slip from my back. I could still hear his footsteps behind me. He said nothing, and the other cops didn't look my way.

It was almost as if they *wanted* me to run. I had embarrassed law enforcement statewide. Maybe they were looking for an excuse to put a permanent stop to the embarrassment. Maybe they were trying to set me up on a repeat offender charge for my multiple escapes. Maybe they even wanted to gun me down. I'll never know.

The sergeant and I walked past the front door, then I realized the only footsteps I heard were my own. Had he dropped

back a few steps? I didn't dare look around. I was looking at the front door through my side vision.

I just kept walking, and gradually bent my path. I walked out of the front door of the Bakersfield jail in broad daylight.

I could lie to you and tell you some story out of a Zorro film about leaping from one piece of furniture to another until I found my freedom. But I did what I had done before. I just faded into my surroundings. I was not the first to do it, and others did it long after me.

That's about the best way I can explain my talent for escape. I just felt as if I could walk away, and so I did.

And I did it again on December 24, 1957, as I slipped through the crowded hallways of the Bakersfield jail and out the front door.

The Bakersfield police chief was humiliated and mad. Real mad. And he announced on television that none of the city cops would be allowed time off for Christmas until I was back in custody. The chief said he was tired of my escapes around the state, and that I had escaped my last time. He would not rest, he vowed, until I was behind bars. My God, he made me sound like public-enemy number one. Leon Copeland remembered that, as we recalled old times in October 1998.

There is some humor to this yarn, which ends with my most heartbreaking escape of all. I'm glad Leon and I can laugh about it today. Nothing about the following story brought a smile when it happened.

Leon was working for Barber Pontiac Co., painting cars as his day job. It was his main job, too, as he didn't get much work as a musician, especially after we were thrown out of the American Legion Hall for brawling. Wonder if we got a

MY HOUSE OF MEMORIES

bad reputation? Anyhow, Leon was a little peeved at me over that free-for-all because I had asked if I could borrow his white suit. He let me, and the drunk I fought poured coffee all over it when I briefly took the jacket off. Leon said the suit looked as if it had been used to mop up the stuff.

Leon wasn't one to hold a grudge, and his anger had dissipated after I had joined him in knocking the guy on his ass. Leon was the first one I thought of when I split from jail the day before Christmas 1957.

I went down to 24th Street to his body shop, about nine blocks from the jail. I made my way through the confused cops by wearing a disguise. I shed the jail shirt and wore only a white cotton T-shirt. Pretty convincing during freezing weather, eh? Well, it gets better. Remember the beanie hat Spanky wore in the *Little Rascals*? Somehow I got hold of one of those hats. Leon was spray-painting a car when his fellow workers happened to look up at a TV screen just in time to see my picture. It was announced that I was wanted dead or alive.

The next thing Leon saw was me creeping into the body shop, wearing the cotton T-shirt and the beanie on my head. He remembers the beanie had a plastic propeller that twirled. Now, I ask you, does that sound like something a criminal would wear? Did Bakersfield law enforcement have no sense of humor?

I let my eyes focus in the half darkness of the body shop. Even during the day, most of the illumination was from those bright lights they put in front of painted cars to speed their drying. I noticed that everybody was looking at the guy in the T-shirt and beanie with the twirling propeller.

Hadn't these guys ever seen Spanky?

Leon spoke before I could. He had an obvious question.

"What are you doing here? You're supposed to be in jail."

"I know," I said. "I escaped."

"The whole town knows," Leon said. "Your picture is on television."

Leon went to talk to his boss.

"Wasn't that your buddy's face on the TV a while ago?" his boss asked.

"Yes, it was," Leon said nervously.

"Well," said the boss, "so he escaped. I wonder where he went."

"Well," Leon said, fidgeting, "he's standing right over there. That's him with the propeller."

"Get him out of here!" the boss yelled. I guess he had read about the liabilities of harboring a fugitive. "He can't stay here!"

Leon drove me to the Lame Duck, a little motel. He gave me five dollars, and told me to keep the shades pulled. I asked him to get Leona, and I paced until he returned with my wife and Dana, my daughter.

He left us there, a family of three, in a run-down motel in suburban Bakersfield a few hours before dark. Leona and I should have made passionate love until midnight, but all the problems would not allow our minds to go there. We kept the blinds pulled, for fear of calling attention to myself.

Leon returned with some bread and bologna for our Christmas Eve dinner. When Leon took off again, I didn't expect him to return. He had a steady job and a wife. He couldn't afford to be hanging out with the target of a city-

wide manhunt. He could have been popped on some kind of accessory charge. He had aided and abetted a criminal by driving me to the motel, but he didn't see me as a criminal. He saw me as a friend in a jam.

As Leon pulled into his driveway at his house, a squad car pulled in front of him and another pulled behind. Leon's boss had told the cops that Leon had left with Merle Haggard. I don't know why Leon was never charged with anything.

The policemen took Leon to jail and told him he was going to be just like the cops: He, too, would not spend Christmas at home until I was in custody.

"I don't know where the hell he's at," Leon told them.

The police chief told Leon that he was going to ruin the Christmas holiday for all of the police force and their families if he didn't blow the whistle on me. Leon stayed with his story nonetheless. Four cops were grilling him about my hiding place, and finally a detective came into the room.

"I'll tell you what," he said. "We got a little box here that will tell us if you're telling the truth. Would you be willing to let us attach that box to you?"

It was Leon's first time to hear about a lie detector test.

I had taken off from the motel not long after nightfall. Leona understood that I couldn't stay. There was just too much heat.

I had gotten a ride to Lamont, about twenty-five miles away. I went to the home of Uncle George and Aunt Flora and shouldn't have. They acted strangely. Uneasy. I realized later that they loved me, but people don't want to be around someone who might be followed by cops with drawn pistols

and shotguns. That night, my cousin Bob asked me to leave, saying that my arrest at his parent's house could cause them real embarrassment.

Bob was about to take me elsewhere when Lomer, another relative, pulled into the driveway. I guess he thought I might go to my aunt and uncle's house, because I had spent so much time there as a kid. I'd have given anything for one more innocent family gathering right then, with no pressure from the police.

Lomer said he'd just been stopped at a roadblock. His car had been searched, along with every other driver's. Then he said something that chilled me to the core.

Remember, as outrageous as I was, I didn't consider myself a criminal. I just thought a lot of laws were a joke, and I was always ready for a good laugh. I was twenty years old and still out to have a good time—no more. What else was an unemployed and broke man to do? Often, I was simply trying to make the best of a bad situation. Lomer's announcement damaged my optimism.

He had heard a bulletin on his car radio. The Bakersfield Police Department had issued its officers a shoot-on-sight order for me.

I asked Lomer Boatman for a final favor, and told him I'd understand if he didn't grant it. I had seen my wife for what I was sure was going to be the last time for a long time. Now, I wanted to see Lowell.

I don't know why this flight was so special to me. I'd been on the run many times, as you know, but I had an uneasiness that I couldn't pinpoint.

Lomer took me to see Lowell, against his better judgment.

"You shouldn't go there," he said. "That's one of the first places the cops started watching, I'm sure."

I may have gotten into the trunk or hunkered down in the seat. Lomer avoided the roadblock he'd negotiated earlier and delivered me to Panama Lane, where Lowell lived.

As I approached my brother's house, I noticed all the Christmas decorations in the neighborhood. Behind the windows, framed with lights, were happy families.

I knocked on Lowell's door and he opened. I sat down heavily inside. I was breathing hard. I wanted to relax and catch the spirit of a loving home—anybody's home—on Christmas Eve.

A cop charged through the front door and another through the back. The one from the front had a shotgun. At that range, he wouldn't have wounded me. He would have cut me in two.

The cop's name was Tommy Overstreet.

As Overstreet started to put the cuffs on me, I asked him if I might have a swig from the bottle of whiskey that sat on a table. At first he was reluctant and asked why he should allow any privileges to a man who'd run the legs off his fellow officers for the past thirty-six hours. But his hardness softened, maybe because of the Christmas season and he granted my wish, and I took my swig. Then I took another.

I awakened Christmas morning with as much of a hangover as I could muster in the short time I had to drink. My head had felt worse. My heart never had. Broke, away from my family, unemployed, and in jail on Christmas morning.

Pain was the least of my problems.

MERLE HAGGARD

I was sent to Chino Guidance Center, where I would subsequently undergo formal sentencing. Chino was a holding area as well as a medium-security prison on one side and a facility for criminals charged with more serious offenses on the other. It was a step up from some of the jails and rehabilitation centers where I'd been intermittently housed during the past few years.

I did seven weeks with no real problems. I grew weary of all the testing, but it was better than breaking rocks, and I was eating and sleeping regularly. After the tests were evaluated, I would be sentenced and probably get credit for time served at Chino.

I figured I'd be sentenced to some minimum-security prison and probably get out in a short time due to good behavior in the wake of a nonviolent crime—attempted breaking and entering and escape.

I didn't realize that the California Corrections Department was tired of Merle Haggard and his antics. Maybe I was having fun, but they sure weren't.

I understood that my assignment to another facility would come during the night, written on a sheet of paper that would be slipped between the bars of my cell. I decided not to sleep, but to wait for the paper. Since I'd already done those seven weeks, and had done so well, I thought they might add a year, maybe two, but no more, including my stay at Chino.

I heard the guard's footsteps coming down the hall and saw him slip the paper between the bars, just as I'd been told he would. I was nonchalant about picking it up. I talked to another inmate about music for a few minutes. While I was

in Chino, one of the great pop songs of the century had been written by an inmate, incarcerated at Chino Men's Facility. That pop song was "Unchained Melody." There wasn't a lot of good things to remember in Chino.

I pulled the paper from the bars, let my eyes focus on the letters, and said out loud that there had been a mistake.

"Hey, there's been a mistake," I said more loudly, after the guard. He was long gone and wouldn't have cared anyhow.

The Department of Corrections that I had embarrassed at every opportunity had struck back with its heaviest blow. It didn't get any heavier, not in California, not in the United States.

"Merle Haggard," it said. "Destination: San Quentin."

10

"I TURNED TWENTY-ONE IN PRISON DOING LIFE WITHOUT PAROLE . . ."
(From "Mama Tried")

My first thought about San Quentin was that Red Williams was an inmate. Someone had told me he thought I was a snitch.

"I'm going to have to go up there and deal with that," I told myself.

Red, a guy named Roy, and I had been on the lam together in earlier years. Red was given the stiffest sentence and was sent to a tougher institution because of his age. He was sixteen, and I was fourteen. I was surprised, but he thought I had snitched on him to cut some kind of deal for myself. Not true.

I thought about Red during the fourteen-hour ride in a corrections bus. You still see them from time to time in California. Bars run up and down in the windows. Guys inside sit two-by-two, shackled together.

That's the way it was when other prisoners and I rode on old California 99 on the way from Chino in Southern California, north through Bakersfield on the way to San Quentin.

121

MERLE HAGGARD

It was a gloomy day in March 1958 as I rode handcuffed to another guy. I didn't talk until we went through Bakersfield. He didn't either. I finally asked why he was going to the joint.

"L and L," he said.

"What's L and L?" I asked.

"Lewd and lascivious conduct."

"Is that a penitentiary offense now?" I asked. "What the hell did you do?"

"They claimed I was pissing off my back porch."

"Aw, come on now, nothing else?" I asked.

"That's it."

"Is this your first time in the joint?" I asked.

"I am a repeat offender," he replied.

"What did you do the first time?" I asked.

"The same thing."

"Was it the same back porch?"

The conversation went down hill from there. I don't remember talking to him the rest of the trip.

The bus went through all the little towns where I'd grown up—Fresno, Modesto, and others. This sounds like "Route 66," Nat King Cole's old song. I could have written a song about this trip, but songwriting wasn't the thought of the day.

We stopped at a restaurant to eat, but my handcuffs were never removed. I had one hand free for my spoon.

Today, as you drive through California, you see several prisons. They're not an unusual sight. Back then, there were five famous prisons in the nation. Folsom, Alcatraz, Sing-Sing, Joliet, and San Quentin—the most famous of them all.

My House of Memories

It was beginning to get dark as the bus pulled up after the five-hundred-mile trip. We looked up at this enormous penitentiary with lights and armed guards. The place spread everywhere; I couldn't take it all in from inside the bus.

It was about ten-thirty at night. We sat in the bus until eleven o'clock, conjuring up all the terrible things that come to mind when you're waiting to be admitted to prison.

When I went inside, I didn't know one block from another. I found out later they had brought us by the North Block across the Big Yard underneath the canopy. In the East Block, on the left, some of the guys were still awake. They looked at the block through different tiers. Some whistled at us. That was scary for a pretty, young twenty-year-old boy. I felt that's how they saw me.

If anybody had looked at me cross-eyed I'd have probably smacked him. I knew from the juvenile joints what had to be done to keep people from making my life miserable. I usually had to fight as soon as I walked inside a joint. Somebody would challenge me to see who I was, what I was made of, and all of that.

I mustered in and was taken to my first cell. Five hundred men were housed inside 250 cells that were smaller than those other jails. I'd never seen cells that small. And in my young years, I had seen a lot cells. When I finally got to a cell I remember thinking, "They've got to be kidding, this is not the real deal."

So I asked my cell partner.

"Is this a holding area?" I asked.

"No," he said. "This is it."

The cell was the width of a bunk plus the span of a shoul-

der. There was space for a toilet and a sink. It must have been nine by five feet.

The mustering hadn't been as tough as I had thought. They looked up our assholes and deloused us.

The next morning I ran into Delbert Smart, an old friend from Bakersfield, who had told everybody I was coming and that I sang like Lefty Frizzell. He and I eventually became cellmates.

It was Tuesday.

"Has anybody seen Red Williams?" I asked a group of men.

"I don't know," someone answered. "Somebody said he's hot at you."

"That's what I heard," I said.

I didn't see Red the rest of the week because he was working. He sent me a note on Friday evening, saying he wanted to meet the next day on the football field. It had been five years since I'd seen him, plenty of time for his anger to build.

He, Roy, and I had started running together when I was on escape from another place. We stole a car in Bakersfield and got caught in Las Vegas. We did a month in Las Vegas County Jail, then we were taken to Carson City, Nevada, where they charged us with violating the Dire Act for taking a stolen car across state lines. Red went to the penitentiary in El Reno, Oklahoma, for three years, while Roy and I went back to the California Youth Authority—because of our age difference, we were released to California authorities. But again Red didn't know about the age difference, so he thought I had snitched on him.

The trip to San Quentin and going inside were as frighten-

ing as you might imagine. All I could hope for was that I didn't run into anybody who wanted to take advantage of me. I tried to be invisible, to slip through the cracks. In prison, you do your own time. You don't infringe on other people's personal lives or ask questions or borrow candy or cigarettes. You never know what else may be going on in an inmate's life. Some guy may have just found out his boy on the outside is dying of cancer, or something just as bad. You say something to that guy, and he's liable to kill you before he realizes it.

Back to Red Williams. I met him on Saturday.

I had liked him a lot, so it hurt my feelings when I found out he thought I had snitched on him. I wasn't afraid of Red, but I knew that if there were a fight, I probably wouldn't win it. I was going to get my ass kicked over something I didn't do. I went to the football field with that attitude.

I told him two or three things, and he just started laughing.

"You little punk," he said, and laughed. "Give me a hug."

We never fought. In fact, I believe he would have fought for me.

Red died of a drug overdose in Las Vegas two or three years ago. Nobody in his family or on his job knew he used heroin. He'd been out of the criminal life for twenty-five years.

I made friends with everybody in San Quentin. I don't think I had any enemies. But I couldn't play music in the prison band for two years because I was on close custody, thanks to my escape record. That meant I was locked up after four o'clock each day.

Delbert fought for two years to get me off close custody. Finally, I was reclassified down to medium security, which meant I could play the warden's show once a week.

People have asked if I got anything beneficial out of San Quentin. San Quentin was as beneficial to me as the army is for some people. I was twenty and full of piss and vinegar, with no intention of doing anything right. If there is divine intervention, God intervened in my life and threw me in prison. I think to slow me down.

I was in San Quentin because I had been convicted as a habitual criminal for escapes that were mostly a joke to me. It's not that I expected the state to give me a medal, but I sure didn't expect to be in San Quentin! What did I expect, that they would simply say "boys will be boys"? It's hard to remember what you were thinking when the thoughts were so long ago and so wrong.

Sometimes, when I lay in my bunk, I could hear men crying out in pain as they were beaten by other inmates and guards, or gang raped. In the evening, there was a period called the music hour. More than half of the convicts in the south block were like me—they wanted to be musicians. And during that hour, you could hear saxophones, guitars, banjos, and verbal fights and misunderstandings along with several instruments I couldn't define. One time I remember hearing a black man and a Mexican fellow promise to kill each other the next day. The music and the noise were forgettable. The black man was murdered the next morning.

There was a hospital inside San Quentin, but all the beds were taken. One time, I nearly died of pneumonia that fol-

lowed a bout of the flu. I wasn't alone. Prisoners waited on prisoners. Tough men became soft and tender. There were no nurses. The guards didn't care. It was only men helping each other. I remember thinking I was going to die in San Quentin. It was three months before I could straighten up from my pneumonia crouch.

Some of the inmates with jobs were able to walk around, and some spoke to me through the bars. When they asked how I was doing, I told them I was really sick. They knew I was telling the truth.

It's not smart to try to bullshit inside the joint. You'd better tell it like it is. And if you make a commitment, you'd better keep it. Men have died in prison because they couldn't pay back a carton of borrowed cigarettes.

I knew the prisoner's unwritten code when I arrived. I was a habitual criminal, remember.

Maybe that's why I had so much trouble fitting into the country music community in Nashville. I was a creature of honest habit, and the music business is filled with dishonest people. Lying is the order of the day. Honesty, any honesty, is painful to most of the men and women who run the music business. There are a few exceptions, of course.

I love the music. I hate most of the business. And the sissies who think they're smart because they've made a fortune lying and swindling in the music industry wouldn't last a day in prison. Not a day.

No one ever told me how much time I'd receive in sentencing. Imagine living in that hell and not knowing when you're going to get out. That was clearly a violation of my civil rights, but I hadn't even heard of civil rights in 1958.

Whiners don't last long in the joint. Everybody has his own misery. Nobody wants to hear about anyone else's.

San Quentin housed about 5,000 men most of the time. No telling how many hundreds of thousands had come and gone. On the day I arrived, it had been 4,745 days since a prisoner had escaped.

I heard about violence and saw some, too. I saw a black man burned to death on a ladder. The five-hundred-gallon vat of starch he was checking boiled over on him, burning his black skin completely white. By the time an ambulance arrived, he had died several deaths. It was the most horrible thing I saw in San Quentin or in my life.

I also remember two guys who got into an argument from their cells. Remember the black man and the Mexican fellow threatening each other above the music? One was on the third tier and the other on the fifth. They couldn't see each other, but they exchanged cell numbers.

Each had knives the next morning when they made it to the rotunda. The black made a pass of his blade at the Mexican. The Mexican allowed the blade to strike his mid-section, because there were magazines under his shirt. The Mexican didn't get cut. The black was thrown out of position. Then the Mexican killed him.

Some kind of rehabilitation.

Sure, you could learn a trade in the joint, if you could take your focus off staying alive long enough to concentrate on your craft. The basic pay was three dollars a month, and you could climb the income ladder to eighteen dollars a month.

Why the hell work? I had five jobs at San Quentin and didn't do well with any of them. I eventually did my best

My House of Memories

work by doing nothing at all. My true talent was escaping, but I had tried not to fantasize about it in San Quentin. I didn't know exactly how much time I had to go, but I knew I didn't get life, and I knew I was young enough to start over after I'd served my time. I didn't want to blow it by escaping, getting caught, and seeing another fifteen years added, or seeing any chance for parole denied.

I took a new job to give San Quentin another try. I worked in the prison laundry sorting the dirty, sweaty socks of men who didn't always bathe. I developed a fungus from handling the filthy clothes. First, it began to eat at my skin. Soon, it was eating right through my fingernails. Do you know how sensitive the skin is under your fingernails?

I asked the guards to send me to the prison infirmary. One suggested I treat myself by pissing on my fingers.

I was trying, I was really trying to adjust to that hell called prison life. They treated men like I wouldn't treat a snake. The guards saw no reason to be decent. What were we going to do—escape? No one had done that in thirteen years.

A guy named Sam and I became cellmates. He worked in the furniture factory with Jimmy Hendricks, whose nickname was Rabbit. Nicknames are common in the joint.

Rabbit, a bank robber, was doing two five-to-life sentences that were running consecutively, not concurrently. If sentences run concurrently, no matter how many you have, they all count as one.

So this guy was going to do at least ten years, probably more, before he came up for parole, which would likely be denied the first time. Much of that depended on the guards, anyhow. If they didn't like you, they'd put you on report for

a violation you didn't commit. Whose word was the parole board going to take, the guards' or a convicted criminal's?

Sam and Rabbit planned an escape. Because of my reputation for going over walls, they said they'd be glad to have me in on it. Maybe they thought I'd add a little prestige to their breakout. My escaping would make San Quentin look even more foolish. It would mean the place couldn't even hold a guy everyone knew might well make an escape attempt.

It was never in my mind to escape with Rabbit.

I took the invitation as a compliment, but I never took it seriously. I wanted to get away from prisons forever by legally walking out the front door. Prison had finally made a believer out of me.

But I have to say that Sam and Rabbit came up with a good scheme. Sam, a carpenter, was helping to build a desk that would be shipped to a judge in San Francisco. The plan was to pack Rabbit and me inside. No guard was dumb enough to tear apart a desk custom made for a judge. The judge might want to know who had messed with his furniture, and the guard might be reduced to mowing the grass.

Sam said he'd pack us in just before he drove in the last nail. He'd leave it loose enough for us to push our way out once we were on the outside.

There was a catch. Because we'd be the first escapees in thirteen years, we'd be the subjects of a nationwide manhunt. The warden and governor would see to that. There is no way they'd have their corrections department embarrassed in front of the world.

So Rabbit vowed that once he got beyond the walls he'd do anything, anything, to keep from coming back. I knew

what he meant and he was talking about holding court in the streets.

He reminded Sam that I was only twenty years old, young enough to start over with my life. He stressed that if I behaved, I could get out before too long. He'd be at least forty before he got out. Who'd hire a forty-year-old man with "penitentiary" listed on his résumé? Rabbit had nothing to lose. I had everything to gain.

I was included in the plan all along, but Rabbit had advised me to stay. I think he wanted me to critique his plan, knowing of my experience.

I was supposed to have all night before the escape attempt to give Sam an answer to give to Rabbit. Sam walked by my cell at sunrise.

"Are you in or out?" he asked.

"I ain't goin' Sam," I said. I didn't tell him that I had never taken his offer seriously. I didn't want them to think I didn't appreciate their considering me.

Sam said I had made the right decision. See how prisoners think? They gave me an opportunity they advised me not to take. It's a world of confused thinking where a man lives by his wits, or he doesn't live long. Let me say again that I'd like to see a few lying music business executives and lawyers I know try to make it inside the joint.

Shortly after I told Sam no, I watched inmates load the heavy desk onto a truck. They grunted, thinking the desk was made from solid oak. It was, with some added pounds from a hidden human being.

You've heard about people being married for so long, and bonding so closely, they can communicate without speaking?

Prisoners are like that, minus the romance. They are so confined for so long under so much oppression, they often know what each other is thinking without speaking a word.

By four P.M., everybody in the joint knew something was wrong, and nobody had said a thing. At last, the whispers started.

The body count was wrong.

We used to love that. For thirteen years, whenever the count had been wrong, it had been because the guards were too stupid to perform basic arithmetic. Everybody was laughing at the guards once again. They'd get they're asses chewed by the warden for the false alarm. A famous journalist of the 1940s, Walter Winchell, once said, "If you want to see the scum of the earth, come to San Quentin at four in the afternoon and watch the guards change shift." Walter was a man after my own heart.

They didn't let us eat that night until seven P.M. They held us in our cells. By the time they fed us that fodder they called food, the mess hall was one big celebration. The whole prison knew someone had made it over the wall. Only two of us, at that moment, knew who it was.

Some of the prisoners had transistor radios. They tuned the radios to the same station and played them loudly so every prisoner could hear.

"Jimmy Hendricks has been identified as the first man to escape from San Quentin in thirteen years," the newscaster said. The warden and prison officials, he said, were bewildered as to how it had been done.

The entire population exploded with cheering.

Once again, I saw firsthand the rage of corrections officials

when a man under their guard gets away. This was the first time I'd seen it when the target of their anger wasn't me. I was really enjoying this. For an instant, prison was fun. I still wished I was on the outside, but I was glad I hadn't escaped. I was aware of the pressure Rabbit was under; I had been there. And I knew they'd get him, just like they got me.

There were broadcast updates about the missing prisoner every day for a week. Inmate morale had never been higher. It was as if we were factory workers supporting our hometown boy on the front lines during war.

One man had taken on the entire system, and at the moment, he was winning. I knew he'd eventually lose, but I never said that out loud. Somebody might have thought I was taking the warden's side.

Rabbit soon became old news, and newscasters stopped mentioning his name.

Then one day regular programming was interrupted for a bulletin. A man thought to be Jimmy Hendricks had shot and killed a California highway patrolman who had stopped him for a routine violation. I remember thinking I hoped the innocent policeman died quickly. It was then that I knew for sure why I didn't go. I think I knew someone would have to die. And I didn't want blood on my hands.

The next day we heard on the news that authorities had him surrounded at a motel near San Jose. Quickly evaluating the odds, Rabbit must've given up. He was returned to San Quentin, for escaping, and an additional charge of first-degree murder. The state of California discontinued the electric chair by 1958. It had been replaced by cyanide.

People ask me all the time about my standout memory. I

can talk about the night I swept the Country Music Association Awards. I can talk about performing for U.S. presidents.

I have no memory more vivid than seeing Jimmy "Rabbit" Hendricks led back and forth from his death row cell to the administration department where he met with the public defenders who were trying to commute his sentence. We all knew their efforts were in vain. A cop killer must die.

Rabbit was wrong, really wrong to kill someone. And he would now pay with his own life.

They put Rabbit in a box about half the size of my tiny cell. They made him live in that closet for a few days before his death. He had a commode. No bed. No blanket. Nothing.

Every so often a guard taunted him, I was told. I'm sure they did.

I didn't sleep the night before Rabbit's execution. Instead, I played out his execution in my mind.

Three men who probably didn't even look him in the eye would push a button, but neither of the three would know which button actually dropped the sack of cyanide into a bucket. The fall would tear the sack, and the fumes would rise upward into the nostrils of Jimmy "Rabbit" Hendricks.

Eventually he would have to draw a breath. It would be his last. And so it was.

There was a custom at San Quentin. A puff of smoke was released from a stack the instant a condemned man died. It was usually at ten-thirty in the morning.

A lot of the men stopped for a moment out of respect for the man whose body would leave in a pine box. I knew his soul was free.

11

"BRANDED MAN"

I'd been in the joint for eighteen months before my first parole hearing. I got the results the same way I got my San Quentin sentencing: Someone put a note between the bars of my cell. Why didn't anyone have the courage to tell me to my face what I already knew—that my first parole request had been denied. What a word, denied.

I wished I hadn't even gone before the board, but I had no choice. Maybe I should have told them I liked being a ward of the state. Then they probably would have paroled me just to make me unhappy.

I lived largely for visitation privileges. Leona came to see me and brought the kids. Mama, Lowell, Lillian, and a few others, came, too. It was hard to see Leona and not be able to touch her. Eventually, she stopped coming. Some time after that, she stopped writing.

I soon found out why. It seems my wife was going to be blessed with a third child. But there had been no sexual visi-

135

tation between Leona and me. She was pregnant by someone I didn't know, and I wasn't entirely sure of her whereabouts.

Someone once said the worst sickness in the world is homesickness. Homesickness is especially painful when you don't know the location of your home, which in my case was a wife and my two children.

Work was the best escape I knew, except maybe for alcohol, so I decided to combine them. I'd go to work making alcoholic drinks. Whiskey was out of the question. I didn't have the ingredients, and I didn't have the time to let the stuff age.

But I could make beer! All the ingredients were in the prison kitchen, including yeast. Needless to say, I didn't embark on my new venture with the blessing of Warden Dickson.

I made the brew from ingredients taken in the kitchen and let my brew age in used milk cartons. A good carton of beer usually takes about eight or nine days to mature. Selling the stuff earned me a whole lot more than the eighteen-dollar monthly maximum pay San Quentin was offering. My customers walked around the prison yard freely drinking the beer out of the milk cartons. Some got plastered in front of the guards. My homemade beer was a lot more stout than the store-bought variety, and it smelled stronger, and it tasted good, too.

The guards detected the odor of alcohol on one or two prisoners, who could have squealed about where they got the stuff. But they wouldn't rat on me. First of all, that would have broken the prisoners' code of silence. Second, the

guards would have shut down my operation, and the squealer would have faced the anger of my other customers—some of whom were pretty strong old boys.

So nobody got me busted. I did that all by myself, by falling into the urinal. I went into the toilet area at about one o'clock in the afternoon. There was a gable off the building inside Upper Yard, just off to the right when you came up to the lower yard. There were steps, and on the right there was a big rest room. It was a horrible place.

Forty to fifty men were usually out there crowfooting (straddling) the toilets because they didn't want to sit down on the nasty things.

I staggered over to the urinal, drunk. I've been drunk six or seven times in my adult life, and this was one of them. I couldn't hold things together. I dropped my cigarettes in the urinal, and when I went to retrieve them, I moved too fast for my condition. I wound up head first in the urinal.

Everybody in the whole rest room laughed. The guards heard the laughter and here they came. And there I was in the urinal. They threw down on me (raised their weapons) just like they'd throw down on someone in the street. The guards were the goon squad, men who'd whip someone just to stay in practice.

Members of the goon squad didn't have the nerve to whip anybody on a one-to-one so they'd get together and do it. Some of the prisoners probably needed their asses whipped and so did the goon squad.

I looked up from the urinal and saw that one of these guys had a gun on me.

"Get up and get out of there, spraddle-legged!" he said.

The next thing I knew it was the next day. I don't think they whipped me, but I was hurting all over.

I got seven days in solitary confinement because I was drunk in the yard. I don't think they knew I'd been selling beer.

There was no bed inside solitary. The only furnishings were a cement slab (for a bed) and a Bible. They laid a mattress on the slab. They jerked the mattress every morning at five o'clock and gave it back at nine in the evening. There were no windows. In the daytime, I read the Bible; at night, I used it for a pillow.

My first night I had no clothes except for cotton pajama bottoms. I lay on my bare back. That's hard and cold in my climate, at any time of year. The second day I was given a scratchy wool blanket.

I was twenty-one years old.

Through the air vent in the wall I could hear Caryl Chessman, a convicted serial rapist who'd been on death row for more than ten years, exhausting one appeal after another. His cell was next to mine. The first thing I ever heard—or, rather, overheard—him say was that he'd gotten a life insurance policy through the mail.

He exclaimed, "Somebody must've signed him up as a joke, or made a bet whether or not I'd get a stay."

I talked to Chessman six or seven times during my seven days in isolation. Mostly I tried to cheer him up. I was there simply suffering a hangover. I was a young screw-up.

I was very respectful to him. He never saw my face and I never saw his. But we kept talking through the air vent.

My House of Memories

I've read stories about how those seven days on the shelf were the turning point of my life. They were not. Those seven days just dried me out. I had been living pretty high in the yard, getting away with making beer, and I had plenty of money. I was self-supporting. My mother didn't have to send me money. I used my own currency to buy a Martin guitar with fifteen cartons of cigarettes.

I wasn't scheduled for another parole board hearing for a while. When I did appear before the panel, my drunkenness in the yard would hurt my chances of getting released. So I had to do something to impress the board.

I volunteered for the toughest job in the place, working inside the textile mill. Since I was graded on each day's performance, I worked my ass off. I earned a few "ones," the top grade given. Mostly I earned "twos," still pretty impressive.

I could do anything I made up my mind to do, I had decided. And had made up my mind to get out of San Quentin by way of the textile mill or any other legal route. I didn't know what life on the outside would hold, but I knew I had no life on the inside.

By now, it was the spring of 1960—May 2, to be exact. I know because that was the day I saw the smoke rise from the chimney for the second time.

Caryl Chessman died vowing he didn't commit the crimes for which he was being executed.

A man who's about to face his maker wants to confess his sins and seek forgiveness. He doesn't leave this world lying. Chessman wrote letters to various people before he was killed. He wrote none apologizing to his victims' survivors. Does that say anything?

MERLE HAGGARD

Then the spell was broken. On a hillside outside the prison, a group of people had gathered to sing gospel songs. Many were protesting capital punishment in general; others were protesting Chessman's pending execution. Others just came to sing to a dead man walking to his grave.

> *I recall last Sunday morning, a choir from off the street*
> *Came in to sing a few old gospel songs*

The lines are from "Sing Me Back Home," the song, as I mentioned earlier, was partially inspired by Rabbit before his execution. Chessman was an inspiration, too. The night before Chessman's death, the prison fell quiet. For the second time in my life, I heard deafening silence. It's incredible how five-thousand inmates can show a silence that borders on reverence.

The warden gave the order for Chessman's execution at 10:03 A.M. That afternoon, a dispatch came from the governor's office that would have given Chessman a stay of execution. By then, his body was probably already in Frisco.

I had a few experiences in prison that helped me become a better man. One was the Johnny Cash show I mentioned earlier. His voice was shot because he and Luther Perkins, his guitarist, and Marshall Grant, his bass player, had supposedly partied in San Francisco all night before the show. Cash brought down the house nonetheless. I referred to that concert when I did Cash's TV show eight years later. Johnny didn't have that many hits by 1960, but he had "I Walk the Line," "Ballad of a Teenage Queen," "Guess Things Happen That Way," "Don't Take Your Guns to Town," and the two

every prisoner identified with, "I Got Stripes" and "Folsom Prison Blues."

He sang a lot of other tunes, too, and was good even though his voice was gone. The men responded to Johnny Cash more than they did to the strippers who danced on that New Year's Day show. Can you believe that? Most men in prison think about women more than anything else, and there they were digging that old bad country music more than the naked girls.

A second good experience also came in connection with the Cash concert. I met Stu Carnell, then Cash's manager, who later became a big booking agent and one of the people who unofficially controlled Reno, Las Vegas, and Lake Tahoe. Stu, for whom I would eventually work, is someone who stands out in my memory to this day, many years after his death.

Stu was one of those charismatic people everybody likes. Yet his heart was bigger than his personality.

He had power over folks in the gambling industry. They did what he asked. He was well-connected.

I remember once in the 1970s, the band and I were play-ing Las Vegas, which is not the most exciting place to work. What do you do after the show? You can gamble and lose, as I did scores of times to the eventual tune of hundreds of thousands of dollars. At the end of my extended engage-ments, I wound up owing the casino more than it had paid me to perform. Or you can womanize all night. I did that, too. But each pastime becomes boring after a while. Stu was always a good source of diversion. He knew how to liven things up by doing something crazy.

MERLE HAGGARD

In those days, we did two shows a night in Lake Tahoe at Harrah's. Stu and I had just walked into the room, and I heard Stu at one end of the elaborate suite, taking messages from the lady at the front desk. Suddenly, his voice rose, "Barney." And he repeated the name at least four times, as he picked up several more messages. Messages of this type usually went straight into the trash can. I head Stu say, "I'm gonna see what Barney wants."

"Hello, is this Barney," Stu asked and then continued, "Barney, this is Stu Carnell with Merle Haggard . . . Carnell . . . C.A.R.N.E.L.L . . . What is it you want with Mr. Haggard? . . . That'll be fine . . . I'll tell you what to do, Barney . . . You be at the Tahoe airport in the afternoon at two minutes to two . . . No, goddamnit . . . Two minutes to two . . . In the afternoon . . . Don't be late . . . There'll be two men in black to meet you . . . Bye-eee."

The next day, after considerable preparation, Stu Carnell and Ronnie Reno were the men in the black, and they both arrived at the airport with pistols that just allowed the green butts to be seen. They looked like something out of a CIA spy movie.

During the hours between the time Barney called and his arrival precisely at two minutes to two o'clock, even more preparation took place. The Star Suite at Harrah's was so big it consisted of two levels. There was a nine foot white grand piano, a 35mm screen that dropped down out of the wall, three bedrooms with Jacuzzis in each, and the suite's staff often numbered as many as ten. The scheme was to make Barney think that my life was controlled by the Mafia.

When he arrived at the airport that afternoon, the men in

MY HOUSE OF MEMORIES

black blindfolded him to the service elevator back in the kitchen area of Harrah's Tahoe Casino. Stu and Ronnie and Barney soon arrived on the fifteenth floor. The Star Suite was on the sixteenth floor, only one floor short of their destination. It must've seemed like a holding room or a lobby for someone waiting permission to be invited upstairs.

As the men in black waited for the call, more arranging was being done, sort of like blocking for a movie. My good friend Dean Holloway was to play the part of the chairman. What a performance he gave!

But before we get ahead of ourselves, we're still on the fifteenth floor with Barney. In that room, I had stored twenty-four dozen salamanders for a fishing trip we were going to take as soon as the gig was over. Before Stu and Ronnie had left to pick up Barney, they had placed one of the gnarley-looking creatures in a clear glass of water in the center of the coffee table.

As they waited for the call from upstairs, Barney casually pointed to the salamander and asked, "What is that?"

"That's a goddamn salamander. They sometimes take men out in the desert here in Nevada and tie 'em to the ground and let them fuckers eat their eyeballs out. But that's only when someone gets annoyed. Don't worry about it."

"That's really heavy, man." Barney said.

It was then, I think, that we found out that Barney had just been released on parole for shooting, but not killing, nine policemen. What a dude to be pulling tricks on!

The phone rang. Stu answered and then said, "We can go up now."

When Stu and Ronnie walked in with this guy, there was

a swarm of activity going on in my duplex suite that Cecil B. DeMille would've enjoyed directing. Phones were ringing off the hook in every room, girls were running about in all different methods of service, and one call came from the president, Nixon, I think. Our friend Barney stood there, bug-eyed and totally bewildered.

Dean, in his role as chairman, had fifty people waiting on him. And not a single thing they could do would please him. Suddenly, Barney asked, "Isn't that Merle over there?"

I looked up sheepishly, shushed him, and then invited him to sit quickly beside me.

It was about that time that the old man from the mountains, Dean Harrington, a heavy-equipment owner from Los Angeles, burst through the door and said, "Boss, this is all I could gather up today." And he threw down a wad of money that amounted to $50,000 in one-hundred-dollar bills.

"Where's the rest you owe me?" Holloway demanded.

Harrington, a man who looked like Charles Bronson, sheepishly apologized for coming up short, and he stood back like a security guard at attention.

It was then that Barney got fed up, stood abruptly to his feet, and said, "Fuck all this shit. I just came to interview this guy." He gestured to me.

With a fist seven inches wide, Harrington stepped right in front of Barney, and in a nasal tone he said, "One more outburst like that, motherfucker, I'll have to thump you."

Barney immediately sat down to listen to me. I could tell he was more than just a little nervous, he was scared. He asked me questions, and I soon gave him an account of how I came under the control of the Mafia, which satisfied his

request for the interview. I told him I had been picking cotton alongside the highway when Mr. Holloway had gotten into a car crash. A wreck so bad that his car burst into flames, and before I knew it, I had pulled him from the burning car and had saved his life.

As Barney scribbled it all down, he kept repeating, "This is heavy."

The real funny part about it is that this guy was on his first assignment—just out of prison himself. He was someone very hard to shock, but our master of ceremonies, Stu Carnell, managed to pull it off. The man was taken back the same way he came, blindfolded and returned to the Tahoe airport. Stu's only comment was, "Really should've had the cameras rolling."

Merriment like that was still a long way off in 1960 when Leona came to see me in San Quentin after the birth of her third child. She wanted to know when I'd go before the parole board again; I just wanted to know when I'd get out. Then finally, it was time for another hearing.

I went before the same bloodless old farts who looked as if they'd been embalmed while breathing. I wonder what those humorless dorks did for a good time? It looked as if a smile might crack their faces.

I could hear the paper rattle as they passed my evaluation among them. To my delight, it mentioned the great job I'd been doing in the textile mill.

They couldn't believe the turnaround I had made. Of course, they couldn't tell me whether or not I was going to be paroled or denied during the meeting. The little game of

the onion skin paper that came at mail time would inform me of their decision. It read: *Two years, nine months, inside the wall. Twenty-seven months on parole times set at five years.* Calculating my time served. I began to count on my fingers that meant in sixty-two days I would walk the streets: November 3, 1960. Only the best sexual experience in my life could rival that moment of jubilance.

The night before I was discharged, I laid down, but it was fruitless. I couldn't sleep. I was too excited. Sleep never came that night.

I had my last breakfast at San Quentin with eight of the closest friends I'd made there. And let me tell you, you make friends in prison. There is so much time to talk, and so little to talk about, except what you remember from the outside. So I knew each friend's background inside and out.

That last meal was the first time I'd seen a group of prisoners cry tears of joy. I was going to miss these guys.

I told them that someday I'd come back as a recording artist and do a concert, and years later I did. I even walked through San Quentin, and took the late Eldon Shamblin, who was in my band at the time, to my old cell.

He couldn't believe how tiny and cramped it was.

"I don't know how you stood it," he said.

"Neither do I," I replied.

I walked out of San Quentin, the day of my release, wearing paper shoes. One by one, I passed through each gate. I stood before the looming bars, and a guard in a tower pressed a button that opened each. I had heard from a small speaker above my head an old familiar sound—the clear ringing sound of a Martin guitar that belonged to Hank Snow. He

MY HOUSE OF MEMORIES

was singing a song that raises goose bumps to this day. As I stepped from inside and over the threshold to freedom, Hank was singing *"In the Dodge City yards of the Santa Fe stood a train made up for the east. And the engineer with his oil and waste was grooming the great iron beast."* I've tried many times to record that song, "Hobo Jack's Last Ride," but I've never been able to measure that sound I heard that morning. Maybe my ears were keener then.

I had played the scene a thousand times in my mind. During her last visit, Leona had made a promise that we'd make the marriage work when I was released. She, and our children, were supposed to pick me up. I would run into their waiting arms, and we'd start the rest of our lives.

All of that works in a Hollywood movie. It was nonexistent that November day outside San Quentin.

I had gone to the end of the sidewalk. Still no one. It was an unexpected and uneasy feeling, as if I were in open-air isolation. The only thing missing was the walls.

I preferred the open-air type. I would have preferred it more if I hadn't been isolated—if Leona had been there, as she had promised. Coming home to no one after all that time, all that anticipation.

Then I heard a voice.

I told this story when I videotaped *On the Record* with Ralph Emery in January 1998, but I'll tell it again here. The woman, whomever she was, deserves the telling.

She was sitting at the curb in a luxury sedan. The woman was well-dressed and just looked rich, the way some folks do. She looked like Joanne Woodward.

"Need a ride?" she said.

"Huh?" I said to myself and then to her.

Bending over, I peered inside the car, which smelled of fine leather and sweet perfume.

"Get in," she said. "I'll take you where you need to go—the bus station?"

How did she know?

The woman told me right off that her intentions were honorable. She said she was transporting me because she did that every Tuesday, when convicts are released.

"My husband and children don't know that I do this," she said. "They'd have a fit. They'd be so worried."

She said not one ex-convict had harmed her and that each had been appreciative.

And so we rode, me in an ill-fitting suit and $15 in severance pay from San Quentin and Ms. Woodward in her fancy clothes and dark sedan.

I stepped out of the car and thanked her. I told her what a wonderful thing she was doing. And I told her how pretty she was. I sometimes go over this memory in my mind, and wonder if she was an angel sent to keep me from going crazy.

12

★★★★★★★★★★★★★★★★★★

"SING A SAD SONG"

I got off the bus in Bakersfield and focused on nothing. Three years is long enough to notice the changes. Businesses had come and gone, although there weren't the fast-food restaurants that have since overrun Bakersfield and most other American cities. All the labor camps were gone, later inspiring the song "They're Tearing the Labor Camps Down." The good times and laughter that had been as much a part of Bakersfield for me as its streets were also gone.

"You can go back, but you can never return" someone once said of hometowns. I found that to be true. Although Bakersfield had changed, perhaps I had changed more. Time, particularly time spent behind bars, transforms a man.

Along with fast times, I associated family life with Bakersfield. I had a wife and family there. Leona had failed to show up for my release from prison, claiming she'd had car trouble.

I was sure that she, my brother Lowell, Mama, and my kids would all be a part of a welcoming party. If they had

wanted to see me as much as I wanted to see them, they would have been there.

But no one was. When I got off the bus, all I saw were unfamiliar faces. Bus stations are lonely, whether you're arriving or departing. They always seem to have high ceilings that amplify the footsteps of people who are traveling but whose lives are going nowhere.

My luggage consisted of a battered bag not much larger than a woman's purse and an empty vodka bottle. The alcohol and the bus ticket had put a serious dent in the $15 I'd left prison with.

When I eventually ran into Lowell in the station, our reunion was awkward. I would have been ill at ease had I been gone anywhere for that long, but I was especially uncomfortable since I was coming home broke and just out of prison. My having been in the joint made a lot of people, including my brother, uneasy in my presence.

Lowell took me to Mama's, where I ate from her bountiful table. Everything was cooked just right.

I didn't see Leona at first. It wouldn't have been hard for her to figure I'd be staying with Mama or Lowell, but she came to neither place.

Leona may or may not have wanted me back as a husband, but she needed a breadwinner. Maybe that's why she decided to give the marriage another go.

I went to work for Lowell, earning $80 a week digging ditches. Eighty dollars a week was a vast improvement over the $18 a month at San Quentin, although I could have earned $80 a week and more off my beer concession before the prison officials shut it down.

My House of Memories

I had been working for Lowell for about two months. Saturdays were my day off, a chance to play music at the house. I had borrowed an old Webcore wire recorder and was fooling around recording and sort of appraising what chance I might have in doing so professionally when the unthinkable happened. A knock came on the door. A stranger. Slim. Cowboy boots. A cordial gentleman, who said, "My name is Jack Collier. Are you Merle Haggard?"

My thoughts raced through all the things he might be and all of the things he wasn't. I knew he wasn't a parole officer or a cop. So I answered him politely, "I'm Merle Haggard. What can I do for you?"

He said, "Well, we've got a band and our frontman, the singer, had to take another job. And I heard that you were a frontman and singer."

"Where in the hell did you hear that?"

I invited him inside, and as he walked through the door, he asked, "Well, are ya?"

I said, "There's something about your nature or something that you've said that tells me you've done time." I fired that question at him before I answered his.

He kinda grinned and said, "Yeah, but are you a frontman?"

"Well, that's debatable," I said. "I sing a little bit. And I'm interested in a job playing guitar, but people don't usually come by your house offering the job you want."

"Well, how good do you sing? And what style of guitar do you play?" He asked.

"I just do single string lead. How 'bout you? Are you a guitar player?"

"Yeah," he said. "I play Merle Travis/Chet Atkins style."

"Well, shit. That oughta work," I said.

"Well, are you interested?" he asked.

"Of course, I'm interested," I said.

"Well, let me hear you sing something," he said.

I had just put down "Nobody Knows But Me," an old Jimmie Rodgers tune, on the old borrowed Webcore. I said, "Here. Let me play something I just recorded."

I flipped on the old wire recorder, and as he listened, his mouth dropped open. And he looked at me with doubt in his eyes and said, "That's not you. That's Lefty Frizzell."

So I reached over and repeated the performance for him. Jack acted like he couldn't believe his discovery, but he couldn't have been any more surprised than I was with his offering me a job.

We started playing four nights a week at the little joint called High Pockets. The band consisted of Jack Collier on lead guitar, Sonny O'Brian on drums, Jody Cornelius on steel, and myself on the rhythm guitar, and as they wanted, I was fronting the band—not necessarily exactly what I wanted. But no one else in the band ever talked on the mike. And their singing was out of the question, so that was left up to me.

I don't think they placed much importance on my guitar playing, but I did. That little gig was the beginning. And it went all the way from that to where I am today. And by the way, that little skinny cowboy named Jack Collier, who came to my door that day with a job, I don't think he knew what he was starting. I was right about his prison record. Jack also said he recognized something familiar in my personality. One

of the greatest friendships I ever developed in my life came about over the years with Jack.

Leona and I were at the Rainbow Gardens one night when I was asked to fill in for the regular house singer, Johnny Barnett.

I jumped at the chance, thrilled at the opportunity. I was also excited about playing in a band with steel guitarist Fuzzy Owen, the guy from Tally Records who had once indicated my music wasn't as good as I thought. I knew he was still a big shot at Tally, and I thought my being around him could help my chances of getting a record deal. He could put me right next to Lewis Tally himself, and Lewis was a big star in Bakersfield in 1960. He had his own local television show, owned a restaurant, was host at a Saturday night dance over in Fresno, and, as I've said, owned his own record label. He looked and could sing like Hank Williams. Lewis, years later, worked (not as a musician) for me until he died.

The Blackboard was the most popular nightclub in town; the Rainbow Gardens was the most popular dance hall, and no one at either place had heard about the singer at High Pockets yet.

One Tuesday night, Leona and myself and her sister Allison happened to be passing the Rainbow Gardens on Union Avenue.

Leona said, "Look, they're having a talent show at the Rainbow."

Leona quickly turned to her sister and, with mischief in her face, said, "Why don't we enter my husband?"

The next thing I knew I was on stage once again at the Rainbow Gardens. I didn't win the contest. I placed second. I

sang "Cigarette" and "Coffee Blues," and some dingbat laid on his back and played "Fireball Mail" on the dobro. People went crazy, because he had acted crazy, and he won first prize. I got a good lesson in showmanship that night, but I also got noticed by the musicians in the band backing up the talent show. They were all players I had seen on television for years. I was in the midst of the big time.

Jelly Sanders, fiddle and guitar player, walked over to me following my performance and said, "Do you play an instrument?"

I said, "Yeah, I play guitar. And I currently play four nights a week over at a little place called High Pockets."

He didn't pay much attention to my four-night gig and went directly to what was on his mind. He said, "You know, the Lucky Spot is looking for a relief singer and rhythm guitar player. Johnny Barrett wants some time off." He added, "You know Johnny?"

I nodded my head as if I did. I really didn't. I had only heard of him.

"Why don't you come over tomorrow night and try out?" Jelly said.

"Who else is in the band," I asked.

"Well, on the nights that you play, if you get the job, it'll be myself on fiddle and guitar, Fuzzy Owen will be band leader—he plays steel. And Mel King on drums."

Like a poker player with a good hand, I tried not to look too excited. It wasn't long after that that Merle Haggard was well known in Bakersfield, California. Let me say, the reputation of the town pertaining to music was very clannish. And the big leaguers did not accept newcomers lightly. But in my case, they seemed to make an exception.

MY HOUSE OF MEMORIES

Bill Woods wanted me at the Blackboard. Lewis Tally wanted me to play guitar for him. All of a sudden everybody wanted Merle Haggard. The unexpected, the unbelievable, the dream, the chance was all happening. And they didn't seem to care where I'd been. Only what I could do.

We both did something even more outrageous in the turbulent country of Ireland that I'll tell you about later.

Lewis had an eye for the ladies, as did almost everyone in my organization during the 1970s and '80s. One day, Lewis was screwing a girl on my houseboat on Lake Shasta and died while making love to her. Evidently, Lewis had been fishing at the time of his death and had taken a moment to satisfy his girlfriend. After he was gone, someone reeled in his line, and at the end was the hook with a weiner.

I don't think he'd really been fishing at all, considering the bait he was using. I think he had been soaking his worm.

Back to Bakersfield.

I went to work at the Lucky Spot two nights a week and played four nights at High Pockets. I quit digging ditches for Lowell. Then, through Lewis, I got a Sunday night job at another club. I was now working seven nights a week doing what I love most of all—making music.

I developed a following while playing those joints in the 1960s. I think that's why Buck Owens called me. Buck was a big star, thanks to "Under Your Spell Again," "Above and Beyond," "Excuse Me (I Think I've Got a Heartache)," "Act Naturally," and others. His biggest hits—such as "Love's Gonna Live Here," "My Heart Skips a Beat," and "Together Again"—were yet to come.

He asked me to go on tour as a replacement for his bass player who had quit unexpectedly. When I told Buck I didn't

know how to play bass, he told me to fake it. I thought I might learn something from him, so I took the job.

I was earning $150 a week with my seven-day schedule. My work with Buck, which required me to drive a camper that we had borrowed from cousin Herb Henson hundreds a miles each day, paid $75 a week. The way Buck saw it, it was worth $75 a week in lost income just to play with him.

I was with Buck only two weeks, but long enough to come up with "Buckaroos," which is still his band. Had I known about the pay, I might have stayed home. Nonetheless, I'm glad I went.

First, I found out what it was like to sing before several thousand people. We were playing a Milwaukee baseball stadium when Buck broke a guitar string and turned to me and said, "Sing something." I was only eighteen months out of prison and green as a gourd.

"What do I do?" I thought frantically.

George Jones's recording of "She Thinks I Still Care" was the number-one country song in the nation. I did it—unrehearsed—and got a standing ovation, all these thousands of people went to their feet.

I'd been at a local radio station when George Jones and George Riddle, his tenor singer, walked in with the record. Jones handed it to Bill Woods, who was on the air. "Sometimes You Just Can't Win" was on the other side. I remember.

"Man, that's the best damn record I ever heard in my life," I thought.

I had met George Jones earlier, when he was playing the Blackboard. He had heard me singing and got drunk and wouldn't come on stage. He's been my biggest fan ever since.

"Who is that guy singing out there?" Jones had asked Don Markham, my saxophone player of many years, who was playing the Blackboard in 1962.

"That's just somebody who works here," Markham said.

"That's the best singing I ever heard in my life," Jones said. "I ain't going out there."

When I got the standing ovation in Milwaukee, Buck was jealous, and it showed. He was the star and never got a reception like that.

After the show, Jim Reeves, the program's headliner, approached me. Reeves had the smoothest voice in country music history; his tone was pure velvet. Man, I loved his voice. Little did I know that night how short a time I'd know him; he died in a plane crash later that year.

"My God," he said to me. "I've never heard a performance like that in my life. That's the best job of singing I've ever heard."

Talk about a thrill! That was quite a compliment, coming from Jim Reeves.

It was one thing to play for drunks in the clubs of Bakersfield, and quite another to play for several thousands at a concert. You can be a seasoned performer in the nightclubs, but have your nerves fall apart and be totally inadequate in front of a sober audience of that magnitude. Stage fright under those conditions would happen many times over the years.

People who come regularly to see the same guy and hear the same songs really like his stuff. Their feedback is encouraging. I've played dates, such as those at the White House,

where nobody in the room knew my material. I much prefer playing for people who know, and love, my music.

I met a man once, after I'd left the Bakersfield nightclubs, whose identity I'll conceal. I eventually hired this guy for a key administrative position after my national recording career got going. I trusted him like a brother.

He told me he was an orphan. Since my father had died when I was nine, I could identify with him. Years later, I found out that he had lied to me. No matter what he did to me financially, nothing affected me more than finding out that he had lied to me about his childhood, because that's why I had hired him. I held a grudge for many years, but I've forgiven him in my heart. I'm sure he's sorry he blew the chance of his life. End of subject.

My music career continued to progress in the early 1960s. I landed a job on Cousin Herb Henson's television show. That's where I met Bonnie Owens, who became my second wife and sings harmony on my touring show to this day.

By now I was playing clubs seven days or nights a week and playing Cousin Herb's every Monday. Suddenly people in Bakersfield didn't treat me like Merle Haggard, the ex-con. I confess I enjoyed my new status. No amount of money could have lured me back to crime.

Leona and I may have gotten along better during that period than any other. You can't fight with a woman if you don't see her. And all I did was work and sleep. There wasn't time for arguments. Of course, she complained about me being gone all the time. But I was pumping more money into our household than I ever had.

MY HOUSE OF MEMORIES

Esquire once quoted Willie Nelson saying that the greatest aphrodisiac for women is money. A lot of feminists are going to take issue with that statement. I know Leona enjoyed our substantial cash flow, and I don't fault her for it. God knows, she stuck with me during plenty of lean times; she was entitled to whatever I could provide.

When my daughter Kelli was born, it did little to improve the quality of my married life. Leona and I weren't fighting as much as we once did. But then, we weren't doing anything as much as we once did. It's been said that the opposite of love isn't hate, it's indifference. We were becoming more and more indifferent.

My old running buddy Dean Roe surprised me by dropping by the house one day. He wanted to go to Las Vegas, and I did, too. I left Leona a note telling her where I'd gone.

I knew that Wynn Stewart was playing Vegas, and I wanted to hear him. He was a hot property in those days, with hits such as "Wishful Thinking," "Wrong Company" (a duet with Jan Howard), and "Big, Big, Love." He would not record his biggest hit, "It's Such a Pretty World Today," until 1967.

Roy Nichols, who was playing lead guitar with Wynn, asked me to sit in. I couldn't imagine it.

"I can't play alongside Ralph Mooney and with players this good," I insisted to Roy. He didn't want to hear it. He just wanted to get off the stage.

Years later, Mooney worked for me before he went with Waylon Jennings. We were on the road one time when he decided, while drunk, he wanted to go home, because he missed his wife. He went to the bus and started it without

letting the air brakes properly fill. When he stepped on the brakes, he almost drove the bus through a hotel lobby.

I knew I sang better than I played, so I did a couple of vocals when I noticed Wynn in the audience that night in Vegas. When I finished my set, Wynn asked if I'd been working anywhere. I told him about the California clubs and Cousin Herb's.

Then Wynn offered me a job replacing Bobby Austin, his band leader, who was leaving the show. I'd play bass, sing harmony, and open the shows for Wynn. When I told him I wasn't much of a bass player, he said, "Don't worry about it, we'll teach you." And then he added, "Man, I've been looking all over the country for somebody to replace Bobby. Came home and found him on his own bandstand. You're it, son. You gotta do it for me." The thrill of this moment will stay with me forever. What a thrill. And what a great man.

Wynn offered me $250 a week, more money than I'd ever earned, or ever imagined I'd earn. I jumped at the job. The job jumped back.

I touched earlier on the fondness I had for gambling. It surfaced early when I began playing Vegas. I gambled away my pay, and then some. The job was the best I'd ever had. But except for prison, the environment was the most self-destructive I'd ever entered.

After a year of the most enjoyable experience with music I ever had, I had to quit Wynn Stewart and go back to Bakersfield, where slot machines weren't as plentiful as cigarette machines. In those days, my working a casino was as bad an idea as a drunk working in a tavern.

Earlier I mentioned how everyone remembers where they were when some famous events occurred. I can also tell you

MY HOUSE OF MEMORIES

exactly where I was and what I was doing the first time I heard my first record on the radio. I had just relocated in Bakersfield after the financial disaster of Las Vegas and was again working at the Blackboard.

I had gotten off work at the Blackboard Club one night, and "Sing a Sad Song," recorded on Tally Records, was playing on the AM dial. I had been scanning the dial, hoping to hear the song, knowing it had been sent to various country music stations. People had told me they'd heard it on the air.

"And here we have a new kid from Bakersfield, down around Bill Woods/Buck Owens country. Here's Merle Haggard, with a brand-new song called 'Sing a Sad Song.' "

The song was the best thing to come out of my brief time in Las Vegas. Wynn Stewart had written the tune and planned to make it his next single. I asked him one night standing on stage with the curtains pulled, "Wynn Stewart would you make me a star?"

Wynn paused and looked at the floor a moment and replied, "Why, of course I would."

"Well, can you do it?" I asked.

"What do you mean?" he asked.

"Let me do 'Sing a Sad Song,' " I said.

Wynn Stewart had great plans for the song, but he said "It's yours."

Wynn Stewart is gone today. I'll always be grateful for his unselfish decision. What a gift. What a gift.

It was released three days after Christmas in 1963 and appeared at number nineteen on the *Billboard* survey. The song was by no means a monster, as it only appeared on the charts for three weeks. But it was my first chart record.

I suppose this is as good a place as any for me to fully

answer a question I'm often asked: How do I feel about modern country music?

Some music that's being played today is okay. But how long has it been since you've heard a song that just rattled your cage? How long has it been since you thought, "This will be another 'Amazing Grace' or 'Faded Love'?" There was a time when one of those came along every year.

Why have the good songs stopped?

I think it's the mentality of the radio programming, which is not set up to rock the emotions of the listeners. There was a time when the song had to explain everything. Today, it takes a camera, a scriptwriter, and a bunch of technicians to explain it in a video.

It's ridiculous. Nothing is left to the imagination. I don't think anything is more boring than perfection. Perfection is achieved almost every day on soap operas, which have the most beautiful people leading the most beautiful lives.

Today, we have people sitting out there, slumped over and looking at a computer and talking to somebody about something that doesn't matter and calling it work.

That's how I feel.

Anyhow, the strength of "Sing a Sad Song" could have enabled me to return to Vegas, but that would have been a mistake, since I would have resumed my old gambling habits. Leona, the kids, and I had lived in a three-bedroom apartment. They stayed home at night while I played the Las Vegas Nashville Nevada Club, made good money, and spent it on gambling.

The experience I gained in Vegas had been valuable. I had never before played for celebrities. Jim Reeves and Patsy Cline were in the audience one night.

MY HOUSE OF MEMORIES

Can you imagine? Patsy had recorded "Walking After Midnight," "Crazy," "Sweet Dreams," and others.

Playing an international venue like Vegas had also significantly reduced my stage fright. But I couldn't stay because of the temptation to gamble. Not only would I spend all of my earnings and all I could borrow, I'd then call Mom with a lie about having been robbed, and she'd wire rent and grocery money. And I'd gamble that away, too.

Gambling has been a weakness of mine off and on all my adult life. Ronnie Reno reminded me recently of how, when I played Vegas in the 1980s, I hired someone to look after my keno cards day and night. *Time* reported that I once lost $80,000 in a blackjack game.

As "Sing a Sad Song" began to catch on, I began to worry about my history as an ex-convict. How would my career be affected when folks found out that I'd been in the joint? And how would they find out? Would a reporter break the story? Would someone who'd known me in prison be sitting in an audience and tell everyone in the room that he'd met me in the joint? Would the disc jockeys stop playing my record, and any that were to come?

Under the terms of my parole, I wasn't supposed to play in bars. So I told band leaders not to mention my name when they called me to the microphone. There were a lot of reasons, to my way of thinking, to keep quiet about prison.

I did get permission to go out of state. I think the California parole officer saw that I had possibility. Or maybe California was glad to get rid of a troublemaker like me. Or maybe there was divine intervention.

Whatever, I didn't want my past to follow me into the

limelight. Leaving my parole officer in California was won-derful. And the first real sense of freedom in my adult life. I must've been twenty-five. Living with the knowledge that the secret might come out some day, Johnny Cash and June Carter would solve the problem I worried about. Sometimes it's great to have intelligent friends who really care.

I was invited to do Johnny's weekly, and I might say very successful, national television show. It would be my first appearance in front of this great nation.

John said, "Merle, let me tell them where you've been."

"You mean prison?" I said. "John I'm afraid it would kill my entire career."

"Merle, they're going to find out anyway. Some tabloid will break the news and they'll do it in such a way that it will hurt you. But if you let me tell them in my way, they'll love you like we do. And no one will ever be able to harm you with it," John said.

That night Cash introduced me like nobody else can. And like he predicted, the truth set me free.

13

★ ★ ★ ★ ★ ★ ★ ★ ★ ★ ★ ★ ★ ★ ★ ★ ★

"DEALING WITH THE DEVIL"

The worst insult you can give a doctor is to call him a quack. The worst insult you can give a lawyer is to call him a shyster. The worst insult you can give a recording artist is to call him a flash in the pan.

I'd had "Sing a Sad Song," my one and only hit. It never approached number one, and it didn't make me a household name. But people in the music business read *Billboard* the way church folks claim to read the Bible. I had made enough waves with "Sad Song" to ensure I got airplay on the second record.

The second song had to be stout, or I'd probably never get airplay on my third release, assuming there *was* a third release. I was under pressure. I still feel that kind of pressure today. You're only as good as your last record, the way a fighter is only as good as his last fight.

I collaborated with Red Simpson and wrote "You Don't Have Very Far to Go." He walked into the Lucky Spot and leaned on the rail around the bandstand.

"If you're trying to break my heart, you don't have very far to go," he yelled. "Write it, and I'll give you half (ownership)."

I did and he did. Bonnie Owens helped write the song, but she didn't get her name on it.

"Heart" was intended to be the A side of the record. The B side, entitled "Sam Hill," was written by Tommy Collins from Oklahoma.

As it turned out, "Sam Hill" was on the charts for five weeks, peaking at number forty-five after its June 6, 1964, release. I'm glad "Sam Hill" wasn't a big hit. I didn't much like the song and had it been a giant hit I would have hated to have sung it for the next fifty years. Let me just say it was written by a great friend and a good writer, but just not my favorite Tommy Collins song. I've since recorded other songs I don't like, such as "If We're Not Back in Love by Monday." That one rose to number two for two weeks in 1977, but its melody sounded too much like "If We Make It Through December," which was number one for four weeks in 1973.

The tunes were so similar that I'd start into "Monday," and the band would mistake it for "December" and play the wrong song. I quit doing "Monday" completely.

Nobody was mistaking me for Elvis, but I'd made *Billboard* twice with two consecutive releases in 1963 and 1964.

Did I mention that my fourth child was born about this time? You can see where my priorities once lay. I regret daily that my music career was often more important to me than family in those early days.

Including Leona's child, we had five youngsters at home in the mid-1960s. We were a seven-member household the

head of which had one objective—to explode onto the music scene.

As I mentioned earlier, I wasn't overly concerned about becoming a star. I just wanted to be sure I was entrenched enough to make a living picking and singing for the rest of my life. I didn't ever want to go back to manual labor, and I *knew* I was never going back to prison. I would have taken honest work at the smallest salary before I would have broken any laws that might have sent me back to the joint. I had finally been away from the rut I was in long enough to sincerely change. I was no longer an outlaw. Funny, that's what they call me in country music—The Outlaw.

When you're trying to make it in the music business, you're always looking for a hit song. After you become established, the songwriters start looking for you. People want you to cut their tunes.

The good news is that it makes the search for songs easier. The bad news is that most of the songs are no good.

I was playing a club in Sacramento one time when Lowell was living there. After the show one night, Lowell told me this lady named Liz Anderson had said she had some songs. She and her husband wanted us to come to their house, where she would cook breakfast and play songs.

"Lowell," I said, "everybody in the world has got songs. What's the odds of them having a hit?"

"The odds ain't very good," he said. "But it's a free breakfast."

Against my better judgment, I went. Well, Liz got on this funny sounding pump organ while the bacon was frying and began playing some great songs. She played "My Friends Are

Gonna Be Strangers" first. Then she played "The Worst Is Yet to Come," "Our Hearts Are Holding Hands," and "Just Between the Two of Us."

I took three and said I'd cut all of them.

"Strangers," released on January 2, 1965, went to number four. It was the biggest hit I'd had so far and inspired the name of my band, The Strangers.

Liz later gave me a song called "Fugitive." It was released on December 17, 1966, and became my first number-one song.

In 1998, Capitol Records released a boxed set of my work recorded from 1964 through 1994. It was called *Down Every Road*, the first line from "Fugitive." "Fugitive" became my first signature song. Everyone will always associate "Folsom Prison Blues" with Johnny Cash, and "Devil Woman" with Marty Robbins. They'll always associate "Fugitive" with me. I'll always perform it, and I'll always take pride in it as my first chart topper. Thank you, Liz and Casey.

I was no longer the "kid from Bakersfield." I was Merle Haggard. The disc jockeys, and more important the fans, knew my name.

I caught songwriting fever.

Bonnie Owens was dating Fuzzy Owen at the time. The three of us were infected with tunes. I'd get an idea, and Bonnie would write down the words as fast as I could recite them. Sometimes we'd sit up all night. She later talked about how much fun it was during our innocent and learning days. I know what she means.

When I was offered a deal at Capitol, I took Fuzzy and Lewis Tally with me as part of my organization. Fuzzy played

steel for a while but was eventually replaced by Ralph Moo-
ney. Fuzzy then became my tour manager, a job he holds to
this day.

I've already told you about Lewis and how he was my util-
ity infielder until his death. Those guys believed in me when
no one else had. I had left their tiny label, but I wasn't about
to leave them. Fuzzy Owen and Bonnie Owens are still with
me. They made every date I played in 1999.

In the mid-1960s, I came off a tour I had played with
Hank Snow, Waylon Jennings, and Bobby Bare. Bare had
recorded "Shame on Me" and in 1963 had cut a song that
would remain his biggest hit, Mel Tillis's "Detroit City." Way-
lon had signed with RCA because Bare had caught his act
in Phoenix and had touted him to Chet Atkins, then RCA's
president and chief producer. Waylon, in 1965, came up with
"Stop the World (and Let Me Off)," and his career was under
way.

Fuzzy and Bonnie picked me up at Los Angeles Interna-
tional Airport at the end of the tour, and we drove to Bakers-
field. I couldn't wait to get to the house and see Leona and
the kids. Our house may not have been a mansion by a lot of
folks' standards, but compared with the dumps where Leona
and I had lived, it was Hearst Castle. I bolted in the door,
pumped with enthusiasm at the momentum my career had
acquired.

The house was empty. Not only was it empty, it was a
wreck. Debris and filthy diapers were everywhere. There was
no sign of life, only signs of where life had been.

My wife had obviously left me and taken the children.
Why? Why now? Why, after all of those years of struggling

and fighting for and with each other, had she suddenly departed when things were going our way? Was she someone who couldn't handle success, or, more precisely, was she someone who couldn't handle *my* success? I mean, my God, she knew what I was doing was for *us*. She had made me more furious than anyone ever had, but I wasn't about to leave someone who had stood by me during bad times.

I asked Fuzzy to drive me to Leona's mother's house. Actually, I demanded that he take me. I was rude as only a young, hot-tempered kid from the streets could be. But Fuzzy was my friend, and he'd seen my tirades before. He accepted me as I was, temper and all. Besides, he knew my fit that day wasn't directed at Bonnie or him.

I was right. Leona was at her mother's house, our car parked in the driveway. When Bonnie and Fuzzy saw the car, they didn't want me to go inside. They were afraid I'd fight again with Leona. I assured them I was only going inside for my car keys, not for Leona. And I meant it.

As I walked past my parked car, I happened to look inside. The interior had been destroyed. The dash was caved in, and much of the instrument panel was lying on the floor. Glass was everywhere. Someone had undergone a hell of a fight in the car, or it had been vandalized. I didn't know which.

I only knew I had worked long and hard for that used car and that I had left it in Leona's care while I worked some more. It was a pretty 1950 Chevy, turquoise and white. The best I ever owned in my life. What had happened to the most valuable material possession we owned? And why had she let it happen?

MY HOUSE OF MEMORIES

I bolted into the house, where Leona was standing with a man I didn't know. He was as big as an oak tree with arms. He looked like a Native American.

I forced myself to remain calm. I simply asked for the keys to our car. She threw them at me.

I let that slide. I picked them up and started for the door, still composed.

Then she made a reference to her "boyfriend." The word "boyfriend" in connection with a man's wife strikes an emotional chord. I don't want anybody claiming my wife has a boyfriend.

In this case, Leona herself had referred to that bruiser as her boyfriend. Rage overtook me. A tired and jealous man, hearing a wife with a history of cheating talk about her current affair, will lose control. I'm not excusing my behavior, just explaining it.

I whirled around and went for Leona's throat. In seconds, I was choking her. I told you earlier that had it not been for music, I might have spent my life locked behind bars. That day, I could have earned myself a return trip to San Quentin, where I could have wound up like Rabbit or Caryl Chessman. And at that moment, I fully intended to.

I had wrapped my hands around her throat, and I could not seem to remove them. I choked her until she was gagging.

Her big boyfriend did nothing. A man can tell when another man is furious and when he is actually out of his mind. If I'd been him, I wouldn't have messed with me either. I was so far gone that I wouldn't have felt any pain he

inflicted, and I'd have come back on him like a buzz saw. The only thought on my mind was this woman will never damage another human's life.

Fuzzy and Bonnie intervened, though, pulling until they finally broke my viselike hold. Leona, now blue, lay collapsed on the floor. She was alive, but in the space of those moments, my love for her had died.

I picked up my kids at the baby-sitter's home and took them to Mama's. I knew I hadn't seen the last of Leona. Nobody takes an ass-whipping like that without some kind of retaliation. She not only had a temper, she could hold a grudge. And she could hold her own with any man I've ever met. Toe to toe. She had attacked me before for something I'd done hours or even days earlier, and I knew that eventually she'd come looking for me and her kids.

She wouldn't have a hard time finding us. She knew I'd be close to my kids, and I figured she'd think I'd likely be at Mama's.

Instead, she went to Bonnie's house, which is where I'd gone. Why would she do that? She had often accused me of trying to start a relationship with Bonnie, but she had also accused me of fooling around with lots of women. She was jealous of Bonnie, because Bonnie was a part of my show. Forget that, Fuzzy and Bonnie were a couple in those days.

Leona took off from Bonnie's, and I eventually settled down—again. Leona Hobbs Haggard sent my blood pressure so high, I might have had a stroke had I stayed with her.

As I began to settle, Bonnie began to tell me her troubles. Now that was a switch. I was accustomed to her helping me with my life and didn't give much thought to hers. Why

should I? She had Fuzzy, and they seemed happy. It's not like she needed a friend in me. I needed one in her. Or so I thought.

Bonnie was convinced Fuzzy was seeing another woman. I assured her she was wrong. She insisted she was right, and now, more than thirty-five years later, that other woman is still married to Fuzzy Owen. Neither Bonnie nor I, nor Fuzzy himself for that matter, could have predicted that back then.

Fuzzy and Bonnie continued to date, but I found myself becoming increasingly drawn to Bonnie. I didn't tell Fuzzy in so many words, but I suspect he knew. I think Bonnie also began to suspect what was going on. How do women know a man is interested before he is even sure himself?

Since I wasn't on tour, I didn't need a harmony singer or band, but Bonnie needed work. She thought I had the hots for her, and she thought that Fuzzy was cheating on her. So she said good-bye to both of us and took a job in Alaska. She was gone for months.

They say absence makes the heart grow fonder. That's a worn-out phrase that wouldn't be worn-out if it weren't true.

I went to the Barrell House, where Fuzzy was working in a band between tours with me. I told him I wanted Bonnie's number, and he gave it to me. I returned later and asked to borrow some money.

Then I used the money I had borrowed from Fuzzy to fly to Alaska to see his girlfriend. Let me publicly apologize to my good friend Fuzzy, because I must admit, my intentions weren't honorable. Bonnie sensed that when I had called and said I wanted to work Alaska. I said her having an in there could help me get exposure for the records we were working.

MERLE HAGGARD

She saw through it, although the part about needing to work Alaska was true. She indicated she thought I was coming to romance her. She told me not to bother coming at all. Trouble is, when she told me that, I was already between planes in Seattle.

Bonnie met me when I got off the plane in Fairbanks. As we rode to the place where she worked, there was tension between us that hadn't been there earlier. I don't think she appreciated the false pretense under which I'd come to Alaska. As I say, I wanted to get a job, but I also came after Bonnie.

I was wise enough to take it slowly. I knew if I hit on her she'd turn me down and would probably be so pissed she wouldn't work in my show when I started touring again.

Bonnie introduced me to her boss, who assured me of temporary employment as a singer. At the end of the night, Bonnie and I went to our separate rooms.

I lay in bed and thought about her. I called her room and asked, "Are you still awake?"

"Well I am now," she said.

"I'm coming over," I said. "To your room."

It must've been 3:00 in the morning. When she met me at the door, she was gorgeous.

Once I went inside, she walked to the window. The moonlight was the only light in the room. I was still standing by the door. The moon was like a spotlight. Her beauty radiated. She said, "Why are you here? Why are you doing this?"

"Bonnie," I said. "I'm in love with you."

The things that happened next, those beautiful things will die with Bonnie and me. It is my favorite memory and I wrote

about it. And there'll be more songs written about that night, but only she and I will truly know where the inspiration came from.

In the spring of 1965, Leona Hobbs Haggard gave me a divorce and custody of the children. On June 28, 1965, Bonnie Owens, the former wife of Buck Owens and former girlfriend of Fuzzy Owen, married me.

Meanwhile, Bonnie and I were more effective as a songwriting team than ever. She'd suggest where I might change a song's arrangement, or another verse, or another repeat of the chorus. There is a certain satisfaction a man gets from working with the woman he loves, who was brilliant and had a formal education, to boot.

Buck Trent, the famous banjo player who owns a theater in Branson, Missouri, has a work tape of Bonnie and me when I wrote "Today I Started Loving You Again." Songs you hear on the radio are called master recordings. They're preceded by demos, or demonstration tapes. And those are preceded by work tapes.

Trent has played the tape for friends who've told me it was thrilling for them to listen to the birth of a song that has been recorded by more than four hundred artists, the most recorded song I ever wrote. I'd like to tell you now the story behind the song some people refer to as my best.

It came about following a ninety-three-day tour throughout Texas and Oklahoma with absolutely no nights off. With a five-day break, before continuing another forty-five consecutive days throughout the same area, we flew to California for a moments' rest and a visit with the children. In the midst of Los Angeles International Airport, I took a deep breath and

thought about my own feelings maybe for the first time in three months. I looked at Bonnie and saw the exhaustion all over her face. She stared back, like people do when you look directly into their eyes. And I said, "You know what?"

And she said, "No. What?"

"Today I started loving you again," I said.

We both heard what had been said, and our professional ears heard it, too. But the song wouldn't be born until three weeks later, following a long four-hour dance at Dewey's Long Horn in Dallas that we did anything. I had undressed and climbed into bed and asked Bonnie if she would go get me a hamburger and bring it back to me, because I was simply too tired to go anywhere and eat.

When she came back, with a brown paper sack filled with hamburgers, I had a paper with the words to "Today I Started Loving You Again" written all over it.

I was seated in the middle of the bed in my shorts, cross-legged with the guitar in my lap, and I said, "Bonnie, sit down and listen to this."

She listened and was speechless. The reason I only have 25 percent ownership today is not important, but it makes more money than all the other songs put together. I gave Bonnie half of it because she inspired it.

Thanks, Bonnie.

Bonnie and I were married for ten years, during which she remained my best friend, professional collaborator, and backup and harmony singer. I cheated on her, and she knew it.

In March 1999, Norman Hamlett, my steel guitar player of about thirty-five years, was telling Tom Carter how the

band and I would sit around in jam sessions on the bus until Bonnie got sleepy and went to her room. Then I'd quickly break up the session so that I could get with some gal who was waiting for me.

I don't know why I went through that charade. Bonnie had been around the business and me. She had seen me cheat on Leona, and she had seen other guys in my band cheat on their wives. Bonnie and I even had an agreement. She said she knew I would never change, that I'd never be faithful to one woman.

But, she asked, please don't flaunt your encounters so that I look foolish. I didn't flaunt them. And what happened on the road stayed on the road. I loved Bonnie very much.

There was another reason it was dumb for me to try to fool Bonnie. She always seemed to know who I wanted anyhow. She knew my taste in women, and a woman can sense when another woman is on the make. If a gal came to a show with the intention of being with me afterwards, Bonnie always picked up on it.

I've changed a lot.

Bonnie Owens helped me raise my four children by Leona as if they were her own. She was an excellent mother and homemaker. I mean, I was a provider, but she gave the love and attention I often did not.

Today, I involve myself in the lives of my children by Theresa. Any man can sire a child; a real man is a father and daddy. I try to do that with Jenessa and Ben, and I cherish my time with them.

Jenessa is as smart as a whip and will grow up to be anything she wants to be. She radiates self-confidence. When

she was seven, if a telephone caller to my home asked who was speaking, she told him in crisp and confident words.

"Jenessa Haggard," she'd say. "And who is this, please?"

Her mother has helped her a lot with her manners.

Ben has his dad's directness. He asks or says exactly what's on his mind. He also seems to have an attraction to the opposite sex.

When he was six, he asked a girl to marry him. She said yes, and he was happy. The next day he was moping and wouldn't share his pain with anyone. Finally, he confessed to his sister that his fiancée had broken off their engagement while they were in the sandbox.

On November 18, 1968, Capitol released "Sing Me Back Home," a song that was on the charts for several weeks in *Billboard* and spent more than one week as number one. I knew it was going to be a barn burner for my publisher, which, at that time, was Blue Book Music, a company owned by Buck Owens.

I had made a lot of money and had adjusted well. Prosperity set well with me. But one time, I needed fifteen thousand dollars, since I owed five grand to some heavyweight Vegas gamblers. So I went to Buck to get an advance because he was publishing my songs at the time.

I asked for fifteen thousand.

After roaring with laughter, he said there was no way he could pay such a sizable advance and that he was not a loan company. We argued back and forth, but he said he wouldn't budge unless I sold him half the song.

I needed the money and got it, while he got half of my

song, which is based on my experiences in San Quentin. Buck earned his half of the money just by sitting behind a desk. I earned my half from having sat behind bars.

Days later I learned that while he was turning me down over the fifteen grand, in his desk drawer in front of him was a publisher's check for thirty-five thousand dollars for "Sing Me Back Home." I had been taken. I later sued and got back the other half of the song.

In March 1999, I returned to Bakersfield for my first hometown show in years. Buck's nightclub, called Crystal Palace, was open the same Monday night as my show. The club is hardly ever open on Monday, at least not with name entertainment, I'm told.

Well, Buck presented Asleep at the Wheel and even gave away free tickets. My seats were priced at thirty dollars each, and Buck's free show hurt my gate. He didn't make any money off his box office, he just hurt mine.

Buck wasn't the first or the last to show me that the music business is more business than music—and that the business isn't always pretty.

14

"FROM NOW ON, ALL MY FRIENDS ARE GONNA BE STRANGERS"

I worked with some lousy house bands during the early 1960s, despite my hits. Billy Parker, the disc jockey at KVOO in Tulsa, where Bob Wills did his radio show—has talked about playing with house bands after he left the Ernest Tubb show. Some were so bad, he said, they actually played in one key while he sang in another, but he pressed forward.

I didn't experience that, but I worked with plenty of musicians who had day jobs and probably still have them, if they're still alive.

Now, a singer's most significant milestone is getting a recording contract. The second most significant is getting his own band.

The first person I hired was Roy Nichols. I drafted Roy in Las Vegas when he left Wynn Stewart's show. Wynn paid him $250 a week. I paid him $125.

Roy had three conditions for taking the job.

"I don't drive, I carry my own amplifier, and I want to

181

know where my fucking bed is every night." He said he would sleep anywhere, even on top of instruments, as long as the resting place was his alone and as long has he could go there whenever he wasn't playing.

He is unquestionably one of the greatest guitar players in the world and definitely the greatest I've ever known closely. Until the late eighties, every successful country singer had a signature instrumental sound. Roy created mine. And Roy was my idol, right alongside Lefty Frizzel, Bob Wills, Jimmy Rodgers, and Grady Martin.

You have no idea what an honor it was for me, from that day until illness forced his retirement, to work with Roy Nichols. He mastered his craft the way Jimmy Stewart and John Wayne mastered theirs. Ironically, I met both the late Jimmy Stewart and John Wayne, and I met them on the same day. I can truthfully say I was more impressed meeting Roy Nichols.

I've never known anyone I misunderstood so much. I've been all over the world with the man. I still don't know, much less understand, him.

He is a gentleman. Yet when Dolly Parton got on my bus once, he asked her if she was ill.

"Why?" she asked.

"Because of that swelling in your chest," he said.

"Would your mama be proud of you?" Dolly retorted.

Roy shouldn't have said that. It was rude. Dolly grew weary of breast jokes many years ago, I'm sure.

Roy once played guitar in Buck Owens's studio during a recording session. At the end of the session, he and Buck had words. As Buck left the studio, Roy hurled Buck's own solid-

body Fender Telecaster guitar at Buck. A solid-body Fender is a weapon. A man could use it to row a broken-down motorboat carrying four passengers. He could hit a hog in the head with the guitar and kill it. If that guitar, at that velocity, had hit Buck in the back of the head, it might have killed him. If it had hit his spine, it could have crippled him. Instead, it hit the door, after Buck went through it. If you'll look closely on Tommy Collins's boxed set where there is a photograph of that famous white guitar, you'll see the scar on the back from its slam against the door.

In March 1999, I played Bakersfield for the first time in many years.

Roy came to the show. Because of his stroke, he sat in the wings in a wheelchair. The weather was unseasonably cold; it had even snowed earlier in the day between Bakersfield and Los Angeles. My band and I just got through before state troopers closed the interstate. Roy wore a leather coat and knit socks that night. He shivered outside my bus in his wheelchair as people walked by him, not knowing he was a legend, a musician's musician. I stepped off my bus and bent at the waist to put my face next to his. His friends and relatives wanted pictures of us.

I've done benefit concerts for Roy, and I'm going to record an album whose proceeds will partially go to him. But no matter what I do, I'll never repay his contributions to my career.

Roy is absolutely honest and unpretentious. He says exactly what he thinks, or he says nothing at all. That's why he declined to be interviewed for this book, I think. I put out the word that I wanted people to be totally honest. A lot of

them had to say some negative things. That was fine with me. But Roy would rather remain silent than say anything negative about our years together. And believe me, he wasn't always happy with me.

Roy won't tolerate a lie. If you tell a story about something that happened years go and put some gingerbread to it, Roy will correct you.

He has his own sense of fairness. Notice I didn't say justice. That's usually determined in a courtroom, and goes to the guy with the best lawyer. Roy believes in frontline fairness. He could never be a politician. He just isn't crooked enough.

I remember when we were young, when Roy worked on Bakersfield television with Lewis Tally and others I've mentioned. They had a high profile around town. They did the television show in the daytime, played nightclubs until closing time, and then met with other musicians, including me, at the Rancho Motel for breakfast.

One time Lewis and Roy pulled up to the motel about 3:30 A.M. with a girl between them. They were dog drunk. Each was taking belts out of a pint bottle they were passing between them. I don't know if they included the girl.

Lewis, for no apparent reason, took a long swig, lowered the bottle, then slammed it against the side of Roy's head. Roy could have gotten out of the car. He even could have called the police. Instead, his reflexes kicked in.

Roy hit Lewis squarely in the mouth, where Lewis was sucking a stogie. Fire and ashes went everywhere. The crowd that quickly gathered could see the two-man free-for-all going on in the car. But the doors were locked and the win-

MY HOUSE OF MEMORIES

dows were up, so no one could break up the clash. The girl just sat there and screamed. And somewhere in the midst of it all, the girl disappeared.

Roy was a good guitarist, and he knew it. Hell, we all knew it. So he got away with a lot of stuff. He is an alcoholic who doesn't drink. He fell off the wagon one night at the Hollywood Bowl—or was it the Amphitheater? It was fourteen years between drinks, I might add.

A famous rock 'n' roll guitarist who has toured and played with all of the greats, including Elvis, apparently wanted Roy's job. It appears the guitarist intentionally got Roy drunk. I knew it as soon as I stepped into the wings and Roy wasn't on stage.

"What are you doing here?" I asked. "Why aren't you out there?"

He told me he'd been drinking.

"Go on out, and I'll deal around you," I said. "Swing Doors" was the first song. Roy's last note on the song was a low F note on the bass string. On the last beat of the song, he started unwinding the bass string and increasing his volume at the same time. It sounded like a big elephant fart spiraling from a great height toward the ground. When he twisted the strings all the way down, the crowd was obviously not impressed. I shot a glance at Norman; he turned to Roy. It could be heard all over the amphitheater even in his quiet voice, as he said, "Roy, it doesn't look like you're doing any good here, you might as well go on to the back."

It was an important job for me, as much of the important press was there, including the *Los Angeles Times*, Roy made a fool of himself that night. He didn't finish the show, and the

band felt for him. Nobody wanted to see that happen. Especially us.

Roy sat his guitar back in the rack, got up, and made his slow walk off stage. And the audience's silence held. The awkward moment was everywhere. There were great guitarists there. Movie stars were there. But mainly his family was there. The embarrassment had to be overwhelming for Roy, especially when he sobered up.

We did one song without a lead guitar player, when someone brought a note out on the stage. It was from the guitar player who got Roy drunk, offering to fill in. I looked to the left and to the right, searching for his face. When I found it, I said into the microphone, "That's all right, we'll get by. Thanks anyway." I wanted to flip him the bird. I'm not sure if I did or not. That night we all saw a star fall in Hollywood. It was sort of downhill for Roy after that. Let me say today, we enjoy a closer relationship than we ever had on the bandstand. He's still my favorite.

My drummer in the first Strangers band was Helen "Peaches" Price, who today works in the water department of a Nashville suburb.

Peaches took no abuse from anyone.

Peaches and I once played a six-week date at Genova's, a strip club in Kansas City, Missouri. We played sets between the dancers' routines.

She got mad at me because I slept with a stripper.

I told her it was none of her business, that she wasn't giving me any sex. And besides, I had bought her a new set of tires as pay for the job. Can you imagine trying to hire a musician today for such a wage?

MY HOUSE OF MEMORIES

"You act like a goddamn wife," I told her, "bitching about me and these girls. You don't have no hold on me."

But she never got off of me about my doing the horizontal bop with those strippers.

I played rhythm guitar in the first Strangers, and Jerry Ward played bass guitar. Bonnie sang backup, as she still does.

At first, we traveled in a station wagon and pulled a trailer.

I was doing a show one night in rural Oklahoma, a band member recently remembered, and I could see from the stage that Bonnie was in trouble outside. A guy had backed her against the trailer and claimed he was going "to screw Bonnie Owens."

I didn't stop the show. I let the band take an extended instrumental break, walked through the club's back door, and put a pistol in the guy's face. He went away, and the show went on.

There are thousands of stories about life on the road. Some of the incidents are harmless. Norman Hamlett, for example, loves popcorn. Once, some guys in the band filled his bunk with so much popcorn that he couldn't get into it.

Johnny Cash, while high on pills years ago, wanted a hot-dog. So he built a fire on the floor of a limousine out of ice cream sticks and cooked one. And he told a man to change all the tires on his limousine. The man went back and looked at the tires and said, "Why would you want me to do that? They look fine to me."

Cash reached over the middle of the limo seat, grabbed a long .44 pistol with one hand and opened the door with the

other. As he walked around the limo, he, one by one, blew out all the tires, stuck his .44 in the front of his pants and said, "Now they're not all fine! Are they?"

George Jones used to be quite notorious for doing exactly what he wanted to do when he wanted to do it. Some say he was influenced by drugs. I say his actions were more likely incited by the executive assholes in what we call the "music industry" and the greedy promoters who overworked him.

He also leaned heavily on alcohol and cocaine, facts he has discussed openly. He was supposedly sober for about ten years. As I write these words in the spring of 1999, he's been released from a Nashville hospital after a car wreck that ruptured his spleen and liver and caused other injuries. For days, it was thought he would not live. After the wreck, it was disclosed that a bottle of vodka was found under the passenger seat of his car at the time of the wreck.

On May 12, 1999, Jones held a press conference and confessed it was true. He said he had won his fight against alcohol for ten years but had fallen off the wagon when he had his wreck. A judge ordered the sixty-seven-year-old man into a rehab center. I wish him the best. I personally think he made these admissions under duress. Remember, he was talking on a cell phone. No one in the communications industry would want George Jones killed because of a cell phone. Think about that friends and neighbors. I don't think George was drinking.

George Marriott ran errands and attended to my personal needs for many years. Biff Adams, my former drummer and bus driver, always disliked him. Biff gave George hell no matter what George did.

George got tired of Biff. So George claims he did the following. I didn't see it and Biff never mentioned it. George was "unusual" enough to do something like this, and besides, true or not, it's a yarn worth the telling.

One day, unbeknownst to Biff, George drilled a hole through the steel bottom of Biff's bunk. Then George climbed into the bunk beneath Biff. When Biff went to sleep, George says he jabbed Biff hard in the butt with a long knitting needle. Biff groaned in his sleep but didn't wake up.

George says he lay there silently until Biff fell back into a deep sleep. Then George jabbed him hard again in the butt. This continued off and on, all night.

The next day, Biff was exhausted from not having slept well, but he didn't know why. He also reportedly had a very sore butt.

He was scheduled to drive the bus.

"I don't think I can drive today," Biff reportedly said. "Something has come over my ass."

Like I said, people who live on the road have their own way of dealing with stress.

In 1966, I bought a house in the canyon outside Bakersfield that became famous. An enormous scale-model railroad ran through my house so I could feed my fascination for trains. It has 750 feet of double mainline track. A lot of magazines carried stories about it.

That same year, when I was twenty-nine, I was riding a horse on my property, and it threw me. I broke my back. I crawled for perhaps one hundred yards on my belly through weeds and underbrush.

MERLE HAGGARD

I wish there was more to that story, but that's about it. The doctors misdiagnosed me for five months, during which my back began to heal improperly. I'm lucky they didn't have to break it again.

I worked shows the entire time. I was actually relieved to learn that my pain stemmed from a broken bone. I had no idea what was wrong with me, and when you're carrying that much pain for that long with no idea of the cause, it's frustrating.

The hit records were coming consistently by the late 1960s. That's one of the reasons it's hard to achieve longevity in the music business. People get to expect great product from a recording artist. If he doesn't give it to them, he'll fall fast. An artist can record twenty number-one songs, then record a couple that fail to work, and his record label will start whispering about dropping him. That has happened to some of my friends.

In 1968, I had a number-one record for two weeks with "The Legend of Bonnie and Clyde." The song was a hit, I know, because of the runaway success of the movie *Bonnie and Clyde,* starring Warren Beatty and Faye Dunaway. Faye called one night to say how much she enjoyed my song, and, as she spoke, I could hear music in the background. The song was "Today I Started Loving You Again."

Faye played the part of Bonnie Parker so masterfully that people think of Faye when they think of Bonnie. Faye is a doll, and the real Parker was not. I'll bet a lot of folks would be disillusioned if they could turn back the clock and meet the real thing, snaggleteeth and all.

There was something magical for me, during my early

recording career, about getting a call from the star of one of the most popular movies of the decade and one of the best films of all times.

Another standout memory comes from a year earlier. I was at Nashville's old Ryman Auditorium, rehearsing for an evening show—the Kraft Music Hall, I believe. A man walked up to me, his pace was slow and his shoulders slightly slumped, but the smile on Bob Wills's face was still radiant.

I'd met him a few times and once threw a party for his original Texas Playboys and him at my home. We even put up a sign in front of the house that said Bob Wills and the Playboys would play together live for the last time.

On that day at the Ryman, he and his guitar player, Tag Lambert, approached with little fanfare. Bob slapped my cheek in an affectionate manner.

"I don't have the full band anymore," he said, as if I didn't know that the greatest and largest Western swing band in history had disbanded.

"It's just Tag and me now. We travel around the country, and we don't pay much attention to the new music—that is, until your music comes on. And then we turn up the radio. I prayed that you'd be number one, and you're on the top five. So part of my prayers have been answered already."

Bob was referring to my current record having risen to number five. Hearing those words after being physically touched by the master's hand is one of my favorite memories.

Once I had a hit record entitled "My Favorite Memory of All." That song applies in many ways to Bob Wills and his words to me that day.

March 25, 1972, saw the release of "Grandma Harp," a

tune that became my twelfth number-one song. My sister, Lillian, later recalled how I had phoned her in the middle of the night for details I needed to write a song about my maternal grandmother. Lillian, who's a bit more proper than me, wasn't amused when I woke her up with questions that could have held until morning. I think she thought I'd been drinking a little.

Four days before the release of "Grandma Harp," I received an official document from the State of California. I had had no dealing with state government since I was released from San Quentin twelve years earlier, when I was still married to Leona Hobbs Haggard.

But there it was: California Governor Ronald Reagan had granted me a full and unconditional pardon. Every felony and misdemeanor was expunged from my record. I was no longer ex-convict Merle Haggard. I was Citizen Haggard. I had outlived my past.

I later appeared on a television show with Reagan, a GOP fund-raiser. A lot of Democrats didn't think that someone who sang for a workingman's rights, as I had, should try to help a Republican win office. I don't judge a man by his politics, any more than I judge him by his color. Reagan helped me in a way no one else had and no one else could. So when he called on me, his friend, for a favor, I was there—will be again should he need me. I was glad to oblige.

I involved myself with the Republicans again in 1973 when I played the White House at the invitation of the late Pat Nixon. She wanted me for her birthday party. She owned every recording I had ever made, I was told by the president.

MY HOUSE OF MEMORIES

And that great president was kind enough to admit his love for my music.

My big song, "Okie From Muskogee," was being understood and accepted in different ways, so I was not surprised when I was invited to appear on the *Smothers Brothers Comedy Hour*, a program that was eventually canceled for its left-wing humor. On the *Smothers Brothers Comedy Hour* I sang the song on a stool, surrounded by little American flags. The hippie movement was pretty strong in those days, and protesting the war in Vietnam was a way of life on virtually all college campuses. My song denied drug use (marijuana) and supported respect for the college dean. They didn't know how to take it. Was I nervous? They just didn't know. It was proestablishment. Mrs. Nixon was a champion of law, order, and regimentation.

I asked how the band and I should dress to play the White House and was told to wear the same clothes we would wear on stage anywhere. So the band wore powder blue polyester, a popular fabric of the day, and I wore an open shirt with a cowboy hat.

When I stepped off the airplane in Washington, a gust of wind hit my $1,000 Stetson, sending it rolling down the runway through grease and muck. Didn't matter. I wore it that night to perform for the president at his black-tie affair. Because it was St. Patrick's Day, the president's own tie was green.

I had a hard time with the crowd. No one in the place applauded until the president did. It was kinda like being in a room with the Mafia. No one does anything until the don does it first. Nixon wasn't too thrilled with our early songs,

but then he loosened up when we did the Jimmy Rodgers classic "California Blues." Perhaps that's because he was from California. I didn't expect the crowd to be as receptive as a Texas honky-tonk's, but I didn't expect them to be embalmed either.

Later, I learned why things had been a little subdued. Earlier that day, Nixon had learned that the press had become aware of his participation in the Watergate burglary cover-up. There was a party after our show, but Nixon didn't stay long and we didn't see him again.

I'll give him credit, though. Despite his troubles, which, of course, ultimately led to his resignation, he took the time to learn the names of everyone in my touring organization. I was very impressed by Nixon's graciousness.

Finally, since I mentioned my broken back, I want to stress that some things that happen can haunt you for a lifetime.

Rose Waters, my business manager, and I were in San Diego in 1998, years after my fall from the horse, and my back was killing me. I was on the bus with Theresa, who looked especially sexy in a pair of short shorts. She is a dish.

Didn't matter. I couldn't have done anything sexual if I'd wanted to. My back was out that day, as it often is, so I asked Rose to find someone to give me a massage. I thought she'd call someone with medical credentials. Instead, she came up with a woman who worked in a massage parlor, I guess.

This woman weighed about three hundred pounds, Rose estimated. Here I had traveled a thousand miles on a bus, my back was killing me, and a woman too fat to get easily

through the bus door was going to manhandle my spine. Life on the road.

I started to speak to her, but didn't get the chance.

"Now look here," she said. "I don't care who you are, you're going to get a massage and nothing else. I mean nothing else!"

She was implying that I wanted a sexual favor while my foxy wife was sitting right there. I couldn't believe my eyes or ears.

"Here," I said, and I handed her a hundred-dollar bill. I went to bed and didn't watch her leave the bus.

15

* * * * * * * * * * * * * * *

"ALWAYS WANTING YOU"

When Charlie Duke, John Young, and Ken Mattingly flew to the moon and back in April 1972 on the Apollo 16 mission, they took my music to play in the cockpit. That was a real honor, to put it mildly.

The closest I ever came to outer space was in 1964, when I was the copilot of a small aircraft coming out of Vandenberg Air Force Base in California. I'd just gotten clearance to fly and was told by the tower to "go on home, Mr. Haggard." Actually, I was en route from Lompoc, California, to Bakersfield.

I dozed off but was awakened by a brilliant light through the rear window of the Cessna 206. The entire cockpit was brighter than the desert at noon. The source of light was far behind us but kept getting closer and brighter. It eventually soared over the top of our little aircraft.

We radioed the Vandenberg Tower.

"Hey, did you guys see something?" the pilot asked.

The air traffic controller said nothing.

"Well, did you pick up anything on radar?" the pilot pressed. "Something just flew over our heads."

"We can't disclose information of that type," a voice finally said.

If they had not picked up anything on radar, they would have said so. Because they declined to give information tells me we were not up there alone.

I don't know what to make of that story, except that it's one of hundreds of unexplainable things that have happened in my life.

In 1974, Bonnie Owens temporarily left my touring show again. It was the first of many steps she'd take before easing away from me professionally and then personally in a departure that resulted in divorce. She was flat burned out. The road is a killer. There's no measuring the emotional toll it takes on a man or woman.

I never ceased to be amazed at people who think show business is a glamorous life. What the hell is glamorous about being cooped inside two hundred square feet of bus space with nine or ten people? I have my own bus today, but I'm usually accompanied by three to five people on it. My buses travel in a convoy. There's my bus, the band bus, and the crew (sound technicians) bus. We also have an eighteen-wheeler to haul concessions.

You have to eat when everybody else eats, even if you're not hungry. The road manager schedules the dining stops. You don't have time to drive into the city to look for fine restaurants. It's mostly truck stops and grease.

MY HOUSE OF MEMORIES

All of this is done daily and on deadline during concert tours. Get to the next town in time to play it, and get back on the bus to get to the next town in time to play it. The pressure is always there. You can't just roll into a city and do a show. It takes about four hours to set up equipment and do a sound check. It takes about three hours to tear down the equipment and load the concessions, which also have to be set up at the next venue.

Bonnie got her fill. She decided to stay home with the kids we'd each had by previous marriages. We never had a child together.

A year after first leaving my show, Bonnie sued me for legal separation, then eventually for divorce.

I hired Louise Mandrell for one year, but Louise had her own career aspirations. There were other girl singers. There was Cheryl Rogers and Donna Faye and one or two more.

I thought about other girl singers, and so did members of the band. Ronnie Reno was the first to suggest the woman who eventually became my third wife. I think her recollections of her years with me, as a singer or as a wife, are not overly fond. I asked Tom Carter to interview her for this book. I thought she should have an opportunity to tell her side. She agreed to do the interview, then told Carter she had changed her mind. My recollections of the marriage aren't too fond either. And since she didn't accept my offer to tell her side, I've chosen not to mention her name. I've just given her a number, as you know from these pages. And I also give her a debt of gratitude. I can't thank her enough for divorcing me.

Do I think she ever loved me?

No. But her family did. And I love them.

Merle Haggard

I want to talk a little about Dolly Parton because some folks still link me with her. In a book I wrote almost eighteen years ago, I mentioned that I'd had a crush on Dolly. Eighteen years is a long time. Yet when I did an interview with my old friend Ralph Emery in January 1988, he asked me many questions about my former interest in Dolly. I think it's awfully old news. Ralph always does a good job researching for interviews.

So, because I know some folks would want to read about it, I asked Carter to call Dolly to see what she had to say about us and our supposed affair in the 1970s. Following are some remarks from the highest-profile woman in country music and one of the most celebrated in the history of show business.

Dolly told Carter that she had loved me, but never romantically, and had no idea that I was once in love with her.

Maybe I wasn't, but I sure thought I was.

Who wouldn't have been?

Dolly has the magnetism of a woman coupled with the charm of a child. I'll always have a soft spot in my heart for her. And she knows it.

"I didn't realize it [the crush] was to that extent, or I would've probably done something about it," she said. "I'd at least've flirted a little more or something. I'd at least've made it worth his while."

* * *

It wasn't easy for future wife number three in the early days as a part of my show. I can make an analogy that, ironically, pertains to Dolly.

Maybe I was no longer in love with wife number three,

but I wanted to be in love with somebody. One-night stands get old quick. It's always dangerous. I wanted someone not just for genuine lovemaking between the sheets but someone who was also a friend—a best friend. I wanted a soul mate. I wanted someone who cared about me for me and didn't care that I sold millions of records and made millions of dollars.

I made a resolution. I'd stay away from women in the music business.

So I married Debbie Parret.

Debbie Parret took care of my clothes and my boots. And she took care of me—for which I will always be indebted. And she will always be family. And God bless her little son, Darren.

We were married, she remembers, at seven A.M. by the pool at the house I had bought for wife number three. Wonder why we had the ceremony so early? It was because we wanted to start a new life at the dawn of a new day. And we both agreed the morning was the most suitable time for our wedding. When Debbie threw her bouquet, my son's girl-friend caught it. The girlfriend had a baby later that day.

I missed the birth because I was somewhere probably getting high celebrating my marriage, but Debbie doesn't think she was with me. I'm not sure. We had our honeymoon later that night somewhere in California, but Debbie can't remember the town and neither can I. She says we argued.

I knew about an hour after the wedding it was a mistake. I loved Debbie. And I was sexually attracted to her, but we were not meant to be together as man and wife. I think she felt the same way. So when people ask how long we were married I often say for an hour.

MERLE HAGGARD

When Carter asked Debbie how long we were married, she said for a day. Legally, it was about six years.

Debbie and Theresa are good friends. When I recorded a gospel album last summer, they sang background. Debbie, who lives about twenty miles from my ranch in Palo Cedro, regularly comes to the house for dinner and talk. She often watches our kids, and they couldn't be in better hands.

Debbie never remarried but has one child who she says is her reason for living.

She's a good gal. I used to wish we had fallen in love before we got married. We're lucky the marriage and divorce didn't ruin our friendship.

Debbie had been the maid at times when wife number three was still around. Debbie jokes that she ducked right along with the wife when I threw things at her. Debbie quit her job after a year and a half.

In 1983, when wife number three took off for good, Debbie came back to work at my house. I had taught her to cook the foods I like, and she went on the road with me. That was right before our marriage. I traveled alone, except for Debbie and the bus driver, and she cooked for us in the microwave.

Then Debbie and I shacked up during the winter of 1983 on my houseboat. We were married later.

A year later, I was dating a girl named Sabrina somewhat regularly, and then the next year I began to see the woman who is wife number five—the true love of my life—the last wife I'll ever have.

I can't remember the year Debbie and I got divorced. The decree is in a pile of records somewhere, but I don't see why

MY HOUSE OF MEMORIES

the exact date is important. I don't know why we stayed married for so long after I was dating all those other women, who of course, knew I was married to Debbie.

I'll tell you something else about Debbie. She is a master negotiator. I didn't bother to pay income taxes for three years during our marriage. I negotiated an "offer and compromise" with the Internal Revenue Service and eventually worked off the debt.

Because we had filed joint returns, Debbie was liable for $400,070. That's a sizable debt when you clean houseboats and later work as a doctor's receptionist.

A lot of folks, myself included, urged her to get a good tax lawyer. Know what she did? Debbie went to the IRS and negotiated a settlement herself. She got off the hook by paying $1,200. I've had some of the best tax lawyers in the world. They've never done that well for me. Maybe I should hire Debbie to represent me.

I guess Debbie helped me the most during the death of my mother, Flossie. We had just pulled into a town in Arizona, perhaps Phoenix, for a show when we got a call letting us know that Mom was dying in a medical facility in California. I canceled the show, and Debbie went with me to Mom's bedside.

Some of the last words my mother ever spoke, from her deathbed, were to Debbie.

"Take good care of him," Mom said.

Debbie promised she would.

I stayed with Mom until she breathed her last, and then I closed her eyes. A woman who walked with the pride of a

princess, though dressed in humble cotton, lay gaunt, her glowing radiance lost to death. I closed my mama's hungry eyes.

"Well, she's gone," I told Debbie, as I boarded the bus.

Mom had been a mother figure to my lifetime friend Dean Roe Holloway, who was then my bus driver. He cried like a wounded animal—for hours. Me—I was too numb to exhibit emotion. A man can hurt too badly to cry. Tears would come in their own time. He took my mother's death harder than anyone. His honesty and his rebellious attitudes toward things that I hate brings him the closest to me. A man after my own heart. It's hard for me to select a best friend from the many friends I've been lucky to have. But if I had to select just one, it would be Dean Roe Holloway.

Dean Roe drove us to the funeral. Mom had written her own obituary. I later learned that she had even written her life story, in longhand.

Ralph Emery read part of Mom's own story at the funeral.

On behalf of myself and my mother, I must publicly thank Ralph for flying across the country and doing that for my mother and my family. Thank you, Ralph.

Mom was gone, marriage number four was nearing its end, and the tour and this outrageous thing called my life went on.

I had cut an album two years earlier composed entirely of Mom's favorite gospel songs. It was called *For the Mama Who Tried,* the title a play off my early hit, "Mama Tried." It includes such standards as "Precious Memories," "Where No One Stands Alone," "In the Garden," "Why Me Lord?," and others. I love those songs as much as Mom did. I can't

My House of Memories

describe the comfort they've given me. I haven't listened to that album in years.

But someday, I'll sing each song again and again—as a duet—with Mom. It will mark my first time to sing with a choir. Mama will thrill at the harmony of angels.

16

"I TAKE A LOT OF PRIDE
IN WHAT I AM"

The funny thing about show business is that when you're struggling, nobody wants anything to do with you. People will give you their business card, then not take your call. When you're hot, everybody wants a piece of you.

In the mid-1970s, I was even asked to do a movie with Andy Griffith, whose *Andy Griffith Show* is in reruns to this day. I'll never forget an incident that happened when Andy, who starred in the show, was at a Hollywood party. He saw a powerful director there and chatted with the guy about the brilliance of Don Knotts, Andy's costar in the TV series. This big-shot director went on and on about the hilarity of Don Knotts.

"And Andy," the director said, "you did something with Don didn't you?"

The man was serious.

See why I don't like the people who run show business? They may know something about business, but nothing

207

about show. Posing that question to Andy was like asking Santa Claus if he had anything to do with Christmas.

I would assume there are millions of Andy Griffith fans who would love to say they've been fortunate enough to spend three weeks in a cab of an old pickup truck in the state of Colorado visiting Andy. He told me everything about how they made the series, how each actor wrote his own part, once the premise of the story was decided, and who would be the actors necessary for the script, such as if the story was about Otis, they might not need Floyd or Goober. Or if it was about Aunt Bee having to leave town they might not use someone else who was a regular. But someone who was always necessary until the time he left the show was Don Knotts. I quizzed him about everyone. I bugged him. I was a fan. I still am. And I'll bug him again if I get a chance. God bless him.

Marc Oswald, president of entertainment marketing and special events for TBA Entertainment Corporation, was once my booking agent. Marc was the brains behind my 1999 album, *Merle Haggard: For the Record,* and the pay-per-view television concert by the same name.

He's doing better now financially than he did when he rode my bus from show to show to be sure things went right on the dates he'd booked.

A booking agent can be a touring singer's best friend. He books a date months in advance and ensures that everything arranged actually transpires the night of the show. There must be enough dressing rooms, commodes, food for the

band, sound technicians, and more. A booking agent—that is, the responsible agent—is like a travel agent with a client roster of one.

I've had some doozies.

People frequently ask how I relax. The answer is I make more music. But I also love to fish, especially with Theresa, and before the children were born naked in the moonlight.

I wasn't with Theresa early one evening in the 1980s when Tuffy, my dog at the time, and I went out on Lake Shasta in a bass boat. I was fishing a cove with plastic worms.

The silence was broken by a noise as loud as a hundred tornadoes, or as loud as a hundred freight trains. It didn't build, it exploded. I instantly thought someone had thrown a case of dynamite into the lake and that I'd be killed.

Here's what happened:

The bottom of Lake Shasta is covered with pine trees. A tree that was perhaps 110 feet tall was released by nature from the bottom of the lake. It shot upward, gathering speed as it rose. It exploded through the water's surface, climbed about three hundred feet into the air, and broke into three pieces.

Millions of gallons of water flew from its branches.

The tree shattered when it at last landed on the surface, and then the lake was suddenly silent. Deafeningly silent.

You read about people who die mysteriously on lakes. Had that waterlogged tree fallen on me, I would have been found floating in the water, the debris long gone—if there was anything left of me. No one would have known how I had died.

I didn't realize at the time how close I'd come to doing just that. That's just one more brush with death that occurred inexplicably in my life.

I was playing Harrah's Club in Lake Tahoe, probably the most uptown venue a country star could play in the 1970s, with the exception of Carnegie Hall. I had played Carnegie Hall, also, when I was back east.

I was introduced, walked on stage, and the audience applauded as if it were asleep. I was doing an unusual show for a group of promoters, executives, and high rollers. And people like Glen Campbell, Carroll O'Connor, and Bill Cosby were in the audience, seated with these big shots that Harrah's was trying to impress. There were many other entertainers as well. I was doing my first song when someone in the crowd stopped the show.

"Hey, what is wrong with you people?" a voice yelled. I put my hand above my eyes to shield them from the spotlight. The faceless voice continued to rant.

"This is the greatest country singer since Hank Williams. You act like he's a goddamn local act. You need to be bawled out, and I'm a little short nigger son-of-a-bitch willing to do it. Now try it again, Haggard. Walk off stage, and come back and see if they can show a little respect."

I did, and the place went apeshit. They had taken orders from Sammy Davis, Jr., who was standing atop a round cocktail table.

Bob Eubanks, host of television's *Newlywed Game*, was the only concert promoter I worked with for eight years. He financed every show I played, and he sometimes sold them

to independent promoters around the country. Sometimes he copromoted dates. Other times, he kept the box office entirely for himself. My point is that he had a financial interest in each of my shows for almost a decade. I'm proud to say that we never had a cross word during all that time.

I'm also proud to say he made money on most of my shows. He often says the hardest problem he had was getting me to do the one-hour show I was usually contracted to do.

He eventually sat an oven timer on stage and set it for eleven. When the big hand reached twelve, I was supposed to come off, as if I were a roast ready to come out of the oven. There were a lot of nights, especially when I was married to my third wife, that I didn't feel like doing a whole hour, because she had made life so tough, I'd often lose my voice from having screamed at her. Anyway, I'd leave the stage with that stupid timer still ticking.

The fans couldn't see the timer.

There were times when Eubanks would dog me when I was short, but only thanked me when I went overtime. Isn't that the way it goes.

Eubanks introduced me to Carlton Haney, the seasoned concert promoter.

I agreed to play a bluegrass festival for Carlton, but only if he told no one I was on the bill. I just wanted to sit in with some musician friends without a lot of advance fuss.

Carlton promised he wouldn't advertise my upcoming appearance, and again he was told that if he did, I wouldn't do the show. He said he understood.

I was on my way to the show when I heard a big radio commercial urging people to buy their tickets to see Merle

Haggard in concert. That really pissed me off, and I refused to do the show.

Carlton said or did something funny, so I forgave him, and did his show after all. He made a lot of money by advertising my appearance. Had I known he was going to do that, I would have charged him.

Shortly afterward, Carlton called my Bakersfield office to express an interest in booking more dates for me. I'd played many for him previously. Everybody knew I was still upset with Carlton and refused to sell him any dates. So Carlton told Betty Azavedo, my office manager at the time, that I was a son of a bitch, not knowing that Betty was recording the conversation.

When Betty told me what Carlton had called me, I listened to the recorded message over and over again, and his very words were these, "You tell that son of a bitch, if he doesn't play that show in Philadelphia, I'll sue him for all the money he'll ever make in his life." I played it over and over again until I finally worked up a good mad and called him personally.

"Carlton, did you call me a son of a bitch?" I asked.

"No sir, Mr. Haggard," Carlton said. "I didn't call you no son of a bitch."

"Carlton, I've got it right here on a tape recorder," I told him. "I can hear you calling me a son of a bitch."

"Merle Haggard," Carlton said, in a thick southern drawl, "if that tape says anything except what I say, then the damn tape is lyin'."

How can you stay mad at that sort of mentality? But it's a whole lot funnier now than it was then.

He was serious.

My House of Memories

A lot of people ask how I write songs, and where the inspiration comes from. I have no formula for creating songs and I get inspiration from different places. I'm not trying to avoid a complicated answer, just giving an honest one.

Eubanks reminded me recently of a song I wrote just before my breakup with Bonnie Owens. He swears I was most creative when I was having woman troubles.

Eubanks was boring me to death at a business meeting, and he could tell it. He was overorganized. He wanted too many meetings too often. Eubanks was a one-man military infantry, and a world champion bulldogger, recognized by the rodeo world. A lot of people don't know that. Anyway, I'd much rather have been somewhere fishing, making music, or making love.

Eubanks, nonetheless, was holding court—going on and on about something—when I said, "Hold everything!"

"What?" he said abruptly.

I didn't know until years later that he was mildly agitated. I guess he'd put a lot of planning into what he thought was an important meeting. He probably thought I had my priorities wrong in wanting to leave, but I was going somewhere to make music. Music was, after all, the reason all of us were there.

Then Eubanks asked some kind of question. Instead of an answer, all I gave him was a blank stare, he said years later. He thinks I wasn't paying attention. He's probably right. In fact he's dead on the money. I wasn't. If I'd been used to wasting my time in meetings of that type, none of them would have anything to meet about.

"I've had this melody in my head all morning," I told him.

"What?" he said again, still disbelieving that I would suddenly walk out.

I came back in ten minutes with "Everybody's Had the Blues Sometimes." The song went to number one on June 30, 1972.

I don't like to talk much about my songwriting because I have no formula. I have a gift, and it came from a higher power. I have used and abused the gift, but it miraculously remains intact. There are obviously some things that God wanted me to say in song. And so I have.

Sometimes the songs are drawn from personal experience or observation. In fact, that's the case most of the time.

It's certainly the case with a song I wrote in the mid-1980s while playing Reno. Freddy Powers was playing the different lounges in town, including the El Dorado Hotel, which had a bubbling lobby fountain that flowed with free champagne. It never stopped, and people could hold a glass under its cascade whenever they wanted.

Freddy later told me the fountain was permanently turned off because so many winos wandered in and hung around the fountain till they stopped it up. So they shut it off for good. One transient wino actually died in the midst of the drought.

One of the guys who partook actually had a steady job. In fact, he became a fixture in Reno. The place ran wide open twenty-four hours a day, as it still does, and this solitary wino earned coins by sweeping cigarette butts off the sidewalks.

His first name was Jimmy; nobody knew his last name. All the Reno regulars called him "Jimmy the Broom."

On New Year's Eve 1985, Rick Nelson died in an airplane

crash. The Reno news reported that same night that Jimmy the Broom was dead. His death was as mysterious as his background.

Some said he came to Reno to forget a woman. He began to drink, and then he drank some more. The story goes that he died drunk and alone.

The date of his death is chiseled on his grave marker, financed by the county. Someone even paid for a nice funeral, attended by the Reno regulars. No birthdate or last name are on his grave marker, as neither are known. The inscription simply says, HERE LIES "JIMMY THE BROOM."

And so I put the story into a song, recorded as a duet with Willie Nelson and released in September 1986, on our *Seashores of Old Mexico* album.

After that, even more people in Reno claimed to have known the man, and his story became legend. The song promoted the saga from coast to coast.

"Jimmy the Broom," who lived in relative anonymity, became famous in death. I felt good about that.

A lot of people passed through my band in those days. The band grew to thirteen pieces, became the hottest one on the circuit, and seemingly every good musician wanted to play with us.

Ronnie Reno brought Jimmy Tittle, who today works Nashville nightclubs, to play bass guitar for me. I met him at my home in Bakersfield.

I bring up Tittle only because he personified the personality type of the typical "Stranger" in those days. Playing in my band wasn't just a job, it was also a lifestyle. A fast lifestyle.

Tittle fit right in because I thought he had the potential to

become a great player. And he was hired for no other reason. Even Tittle probably doesn't know that.

Tittle, like so many talented guys who went through our organization, roared onto the scene and limped out. He got— and lost—the job because of substance abuse, he figures.

Tittle recently recounted how Norm Hamlett, my steel guitarist and band leader, called him in Nashville to tell him his services were no longer needed. I was looking for someone who lived on the West Coast, Tittle was told. He knew where he lived had nothing to do with his dismissal.

I was in Nashville for whatever reason, passing through I think. Someone on my bus said, "This is the day they expected you to come by at CBS. They've got a bunch of songs they want you to hear."

"Is this Thursday?" I asked. "Do I get fucked in the ass and have to sign autographs, also?"

We were parked in my forty-foot coach somewhere on one of the few level places in Nashville. Ray Benson had spotted us and was standing in the doorway when I said, "What's the chance of you running me down to the CBS office?"

Ray said, "The chances are pretty damn good, Haggard, come get in the car."

We arrived at the old CBS office, Ray and I meet our record executive in the parking lot as he pulled in at the same time we did. The three of us started up the stairs to his presidential office when he casually remarked, "Well, I still don't like 'Kern River.' "

The executive had a bad leg, so he was in the lead on the walk up the stairs. I was climbing the stairs and Ray Benson was right behind me. "Kern River" was my current number-

one single at the time. I said in response, "I believe that's about three times you told me that, Dick."

Just as he reached the top of the stairs, he said in retaliation, "No it's more like five times."

The door opened into the room of songwriters prepared to sing their greatest work. Just as the anger hit the top of my head, we entered the room. You must visualize a room filled with innocent songwriters who hadn't heard the conversation on the way up the stairs. They only heard what I'm about to repeat.

"Then I'm about five times overdue from telling you to go screw yourself." My voice was still at a calm but obviously angry tone; the volume, however, would quickly get louder.

I said, "Is that your chair over there you son of a bitch? Isn't that the one Johnny Cash built? And aren't you the stupid son of a bitch who dropped him from the label last week? Where does a coldhearted bastard like you come from? How do you get the authority to drop Johnny Cash? Where do you get that much ignorance? Where in God's name are you from? Where were you raised?"

He said, "I'm an Ohio farm boy."

"Not good enough, you sorry son of a bitch," I said. Then added, "Go over there and pick up one of those guitars. Show me a chicken claw D. Sing me your latest song. You sorry bastard."

And for the first time, I became conscious of the people in the room. I had forgotten there were actually other people there. And for half a second, by the awareness of their presence, my anger was interrupted.

Then it was back to the asshole again.

"You know, I'd tie one hand behind my back and get in the middle of the floor on my knees and whip your gimp-legged ass, but I'm afraid you'd cry, snivel."

Throughout this barrage of profanity, he kept repeating, "You're the best in the world." He was totally composed and unaffected by my attack.

Ray Benson was white as a sheet. No one, not even Leona Hobbs, before or since, has ever made me that mad. To this day, my blood pressure rises when I tell the story.

I found out on the way back to the bus why there was so much fear in the face of big Roy Benson. He said, "Hag, I don't think you know this, but we just signed to sleep with CBS. Our first LP is coming out Monday."

I stayed on that guy's label until 1989, then left for Curb Records and another bullshitting music executive. He told me how much he was going to promote my albums. He told me how hard the label was going to work to publicize Merle Haggard's work. He told me a lot of things.

None of it ever happened.

Veteran country singers complain that contemporary radio won't play their new releases, and that's true. My own label wouldn't give them songs to play, so we'll never know if that pertained to me or not.

There is nothing more frustrating than to be a recording artist who isn't recording or who, if he is, isn't getting his recordings released. The DJs in the world lost track of me because there was nothing new to play. Patty Hearst could've been on Curb. For that matter, Amelia Earhart may be there now. And Jesse James could've hid out there for a hundred

years. The man should've been president. He's the greatest politician I've ever known. And don't we all love politicians?

And so, after forty-one number-one songs, the streak stopped, thanks to two indifferent record executives. I had a number-one song, "Twinkle, Twinkle Lucky Star," in 1989, my last number-one tune to this day. I rose to number four in 1989 with "A Better Love Next Time," my last significant hit.

Can I still make hit records? I don't say "Watch me." I merely say "Let me." Not that I didn't make records that might've been hits during this period. I did. But they were never released. Some CDs didn't even have covers on them. They looked like tombstones rather than CDs.

Let me say something here. To be played as much as I have in America and to find fault with it would not only seem to be stupid and unaware, but disrespectful, to say the least. And ungrateful. I'm hoping for more airplay next year, and the years after that. But I'm not bitching. My airplay ain't been that bad.

People have asked which of all of the thousands of shows I've done was my best. I can't name the best, but I can remember one of the worst. It happened in Liverpool in front of all kinds of major press.

It had been a tough tour. I hardly ever took uppers, but I was tired and asked some of the guys if anybody had anything that could help me a little bit. Somebody handed over half of what I thought was a "benny" (benzedrine). That was the extent of my body's exhausted condition—half of one pill

would get me through two shows, and I'd wind up wishing I hadn't taken it because I wouldn't be able to come down.

So I took this pill, and what was it? LSD. I went bananas. I thought I could see through my third wife's face.

This happened at three in the afternoon. The terror continued that evening. I had never experienced anything like it. They say if you tell somebody he's on LSD his trip is good. They didn't tell me. I thought the building was forty feet high.

I got terribly cold, and they had to wrap me in blankets and anything else they could find. My mind was playing tricks on me, and I still had to do a show. All I remember is getting to the microphone.

After the show, Red Lane grabbed me. We pulled around the corner away from the show. We headed into a dark diner.

I was opening the car door when I heard a man say, "Get 'em!" I could hear animals running toward me. I figured they were German shepherds and they were. I couldn't see them. I remember thinking, "My timing is pretty good. When the dogs get to the right place, I'm putting my cowboy boot right down their esophaguses."

They got within inches of me but evidently sensed what I was going to do. They stopped short.

"Can't you guys read?" some guy said.

"How the hell can we read?" I said. "We can't even see you."

"This is a no-parking zone," he said.

"Call your damned animals off, and we'll get out of here," I said. "But if they move, you'll carry one away. I'll kill him."

My House of Memories

That was the end of the evening of what was probably the worst show of my career.

I roared right through the 1980s, running and drugging the nights away, making bad decisions while under the influence of various substances. The nonstop marathon of miles, music, and mayhem were taking their emotional and financial toll.

I made bad business decisions. And, as I said earlier, I had too often trusted the untrustworthy.

I had a credit card that allowed me to charge $50,000 a month for diesel fuel to run my buses. It was frequently spent to the limit, so my drivers would be scrambling for cash to buy fuel at three A.M. at some snowy, windswept truck stop. Some of my employees were apparently using the cards to fill their private vehicles.

The pressures of past debts and the pressure of new ones were overtaking me. After I signed the deal with a record company that didn't promote me, the royalties from record sales and radio airplay dropped off, seriously reducing my income. I had earned maybe a hundred million dollars in twenty-five years.

By 1990, I was practically broke.

Bankruptcy was never part of my personal vocabulary. But I was beginning to hear it more and more from those who were close to me.

It had all been happy-go-lucky fun. Suddenly, things weren't funny anymore.

17

"THAT'S THE WAY LOVE GOES"

"**M**iracles occur in the strangest of places," Willie Nelson once wrote.

I can testify to that. I was playing the Silverthorn Resort in 1984 when Clint Strong, then my guitar player, met Theresa. For some unremembered reason, I called Clint Strong's house and asked him to come down to my boat. He said, "Hey man, I got a new girlfriend. Don't be messing with her."

When they walked on board my boat, our eyes met, our eyes locked, and we both began to burn. And for a long stare, several beats actually, Debbie Parret and Clint Strong were alone in the room. It was not my plan to steal anybody's woman—I already had one. But something happened that day out of everybody's control.

Theresa got permission to come on the road with us. My first night on the tour was in Las Vegas. Between the time I met her, and the time it took to drive to Las Vegas, she'd been on the band bus with Clint. I thought it strange that I was

223

bothered by her being on the band bus with Clint. The first show of the evening was under way, and I was behind the curtain preparing to walk out on the stage when I saw her standing in the wings. Man did she look great. And she was quiet, too—didn't have a lot to say. I knew she was attracted to me, also. Suddenly I was overwhelmed by her. And in the darkness of the back stage area, and during the loudness of the music, I came up on her from behind and handed her my key.

"This is the key to my room. Take it. Sometime before the show's over, you go to my room and stay there. And don't let nobody in there but me," I said to her, and then I walked onto the stage.

When the show was over, Clint was asking, "Anybody seen Theresa?"

Nobody replied.

"I think she went gambling, Clint," I told him.

Waiting for me in the room was certainly a gamble. I was very much married. Or at least that's what she thought. When I finally made it to the room, Theresa said, "What about Clint? And what about Debbie?"

"What about him? You want to be with him?" I asked and then added, "It's your choice."

She looked at me and said, "I think I found a place I want to be."

"That sounds like a song," I said.

Before we knew it, someone was beating on the door. It was that irate guitar player, Clint Strong.

"Hey, is Theresa in there?" Clint yelled, sounding exactly like Gomer Pyle. "Hey. Let me in, man."

"Get the hell away from my door or I'll call the damn

My House of Memories

security," I said. "The lady's where she wants to be. Go about your business. Leave us alone."

"Well, hey man. That really sucks," Clint said.

Things get gray after that, like it does when things go good. Pain is hard to remember. And so is ecstasy. If we could think of it vividly enough, we wouldn't want to experience it again. Words always fall short in describing beauty of this magnitude.

I think we fell in love that day on the boat, but I fought my own emotions all the way. I would not accept it. At my age, it wasn't an easy thing to have happen. Who needs love this late in the game? She was young. Real young. Said she didn't want children. I didn't believe her. I tried every mental game in the world to make her unattractive. I started to try to find traits of her character in women I hated. I invited her to leave on many occasions, convinced I didn't need any of it, or any of her. She refused.

Finally, one day I made a believer out of her, and she left. Then I couldn't believe that she was gone. Out of my life. So I looked for her, but couldn't find her. I drove all over town. And suddenly I felt the tinge of fear. Had I chased away what I'd been looking for all my life? She was gone for six days, and six nights. I searched all of Northern California and half of Oregon, and still I couldn't find her. I was crazy.

I knew what she was driving, because I had given her the pickup. I gave it to her because it was so easy to see. I guess I subconsciously wanted to keep track of her. The pickup was ugly. She was pretty. And suddenly there she was just to the right of the road that leads to Digger Bay Resort—right where we'd met several times before. She knew I'd look for her

there. She already knew a lot of things about me. She did something that no one has ever been able to do. She predicted the time and location of my unpredictable whereabouts six days in advance—without absolutely any help or assistance from anyone.

I think before we spoke those thoughts crossed through my mind, but there wasn't a lot of talk for several minutes anyway. I came back to conscious reality, slowly. I knew I was in trouble. I couldn't be without this woman. And I was still afraid to tell her the truth. Whatever lies I had used to convince her that I wasn't interested all went out the window when she saw how happy I was to see her.

We have a family now, and we'll celebrate our anniversary every September 11. We have two beautiful children, and a couple of hundred acres of great bass fishing. I don't remember how long we've been married. It doesn't really matter when you've committed to forever.

When Theresa reads accounts of my outrageous behavior, she throws down the articles without finishing.

"I don't read that junk!" she says. "That's not the Merle Haggard I know!"

In the fall of 1998 a tabloid published accusations by one of my children by my first marriage. He said that I had been an unfit father. His contentions were shattering, and many were simply unbelievable. For instance, he said that I put him in a bathtub and let live fish nibble on him. Trouble is, he would have been fourteen or fifteen years old when that happened. I think a kid that old would have just gotten out of the tub.

MY HOUSE OF MEMORIES

"I wouldn't read that stuff," Theresa said. "The Merle Haggard I know is the perfect father."

I know I wasn't always. I was absent during my first four children's upbringing. I've already said how much I regret that. One of my daughters, during the 1997 "Tribute to Merle Haggard" that aired on the Nashville Network, said I had trouble expressing my feelings. She said I never told her I loved her, but that I often picked up a guitar and sang a song to her to that effect.

Well, I'm telling her, and all my children, right here, in my own words, in black and white: I love you, and I regret my part of the wrongs. Forgiveness for old transgressions is the desire of the day. Loving each other is the desire for forever. God help us help each other.

Theresa thinks I focus intensely on my two children by her—Jenessa, nine, and Ben, seven—because of remorse for my previous failures. She's probably right.

Today, our four-member family begins each day in private prayer. Later in the day, we pray as a family, we pray before meals, and we study the Bible—Theresa, our two children, and me.

People who haven't been around me in years wouldn't know me. I spend my days chasing bass with my family, not chasing women with my buddies.

The change is that radical. It wasn't that abrupt.

Before we were married, Theresa and I lived on my houseboat for five years, carefree and free-spirited. The published accounts about our drug abuse are true. I said early in this book that I reluctantly confess these things about myself,

knowing my children will read them. I believe my kids know I wouldn't lie to them. Therefore, they'll know I'm telling them the truth when I say no good can come from the use of illegal drugs. As I said earlier, they don't need to learn from their mistakes; they can learn from mine.

I'll never forget one time in 1986 when Theresa and I simply wanted to get away from the rat race. We rented a limo to take us from Los Angeles to Long Beach to see Rose Waters, who at that time was just a good friend, not a trusted employee.

It's a forty-five-minute drive from Los Angeles to Long Beach. The trip took nine hours.

Theresa and I didn't really mind, as we were feeling no pain and in no hurry. We had wanted to be alone anyhow. But the driving finally became a little boring. So I called Rose.

"Where are you?" she asked.

I didn't know.

"I can see big mountains," I told her.

"Then you're going the wrong way," Rose said. "There ain't no mountains between Los Angeles and Long Beach to speak of."

Rose told me to tell the driver he was lost, and I told her I couldn't. The limousine service had sent a driver who didn't speak English.

"Nonsense," Rose said. "He's pretending. He can speak English."

I think she thought he was taking an unnecessarily long route in order to inflate his fee.

"No," I insisted, "this guy doesn't understand English. Listen."

My House of Memories

I rolled down the window between the passenger seats and the driver.

"Hey, you stupid son of a bitch," I said. "You're a complete dumb ass."

"Oh sí! Oh sí!" said the Mexican driver, grinning.

"I told you he couldn't understand me," I told Rose.

She suggested we find a restaurant with Mexican employees and use them as translators.

I did, just as we reached Long Beach. There's no telling how far out of the way we had been, but Theresa and I had had a good time going there.

"We're here!" I announced to Rose, on the car phone.

"Where are you?" she asked.

I gave her the cross streets of a neighborhood in the heart of Long Beach's red-light district. Rose moaned out loud.

Meanwhile, we tried to drive the stretch limo through the drive-through at a fast-food place. The car got stuck. So the driver parked beside a Dumpster behind the restaurant.

Theresa and I were starving, so we ordered a mountain of hamburgers. We were happily chowing down by the Dumpster when I noticed a police car approach with its lights off.

"Wonder what he wants?" I said to Theresa.

An officer leapt from his car and ordered me out of mine. In that limo, in that neighborhood, he thought I was a pimp.

Nine hours after embarking on a forty-five-minute trip, I was going to end up in jail. When the policeman saw my identification, he turned out to be a fan.

Excited, he got on the radio to call all his officer buddies. They gathered in the heart of this low-rent neighborhood, then posed for pictures with me, one by one. Pretty soon, the

prostitutes began to emerge from the shadows. I may have had a picture taken with one or two of them.

We had a grand old time.

I had a difficult time kicking one drug, a stimulant, and Theresa had an even harder time. Through nothing less than the power of God, we did. We didn't want to be self-destructive parents, and we didn't want to set bad examples.

We could either lie to our kids, or we could quit using. We quit without going through detox or a twelve-step program. And let me emphasize we were users not abusers. I've survived without the help of any rehab center and have managed to pull myself to the center of the road without the help of a professional. We put our condition in the hands of the Great Physician. Today, we do as many stimulants as we want: We don't want to do any. When God takes away the habit, He also takes away the desire.

Not long after we began dating, Theresa became pregnant. We were overseas, and she was sick most of the five months. She had never had a child and thought she couldn't. So she never dreamed that a pregnancy was the source of her problems.

When we got back to the States, she finally saw a doctor. He told her she was pregnant but he could find no heartbeat.

We were riding calmly along when Theresa doubled over with pain. We took her to a hospital emergency room, where the child was stillborn.

The band and everybody else in our road show were very supportive, but it did little to ease our pain.

Theresa and I cried ourselves to sleep many nights after

the loss of our first child. We had the highway beneath us and our arms around each other. I was fifty years of age and wondered why God had let me sire a stillborn child. Someday I'll ask Him.

When I was fifty-four, Theresa became sick again. Again, pregnancy didn't enter our minds. Theresa eventually decided to buy a home pregnancy test, mostly as a kind of lark.

It registered positive.

That was eight years ago.

Theresa and I wanted this child badly but were afraid to have it. We feared the baby would be born with problems because of the reckless way we had lived. We even talked about potential birth defects. Merely discussing our reluctance to proceed with the pregnancy bothers us to this day. So we don't talk about it. Instead, we talk about our beautiful firstborn, Jenessa.

A baby girl is the epitome of fragile innocence.

I have to confess I feared fatherhood. My attitude changed as soon as I laid eyes on the tiny, living symbol of our love. It had been a stressful day, and Theresa had trouble delivering. She had toxemia, labor was induced, and the baby finally came by way of a cesarean.

I think I felt a baptism of change wash over me when a nurse put Jenessa in my arms. I didn't slow my reckless ways. I stopped them, without even realizing it at first.

Jenessa, like Ben, was a godsend. And something else was a godsend. Pat King was also there. My newly acquired mother-in-law. Somebody once asked, "What's life without a mother-in-law?" Well, after you've had one the likes of Pat

King, once she was gone, life never has been the same. I met Theresa's mother shortly after I met Theresa. And I thought to myself, "I think I like her as much as I like her daughter." I was right. I grew to love her. We lost her to ovarian cancer after a long hard fight. We sometimes sense the feeling of her presence. I sometimes talk to her. I wish I could hear her now. What a help she would've been with our children. Of course, the same feeling exists for my mother. My mama would've enjoyed our two children and she would've admired Theresa. She has a quality of character that my mother would've adored. She faces things head-on. And the only fear that exists in her makeup is the fear of losing me and the children. At the writing of this book, my dad's been gone for fifty-three years. I wonder what he would've thought about it all.

But let me finish telling you how I know that Jenessa, like Ben, was a godsend. It's something I will never forget.

Theresa was seven months into her pregnancy when I woke up from a dream. I hardly ever dream, but I had heard a voice as clearly as I have ever heard any mortal's.

"This child's name shall be Jenessa Roena," the voice commanded. I immediately awakened Theresa to tell her our search for a name had ended.

"Write down this name," I said.

She fumbled in the dark for a pen. She couldn't find one, so the first time Theresa ever wrote "Jenessa Roena" she did so on a scrap paper with an eyebrow pencil.

We later looked up the name in a book. It means "child of God."

My House of Memories

This may all sound like something out of the Old Testament, but it's true. To me, it's a beautiful story that I tell as truthfully as I've told many that weren't so beautiful in these pages. Ask Theresa if she thinks I heard the voice of God and she'll answer yes without a moment's hesitation.

Within six months of Jenessa's birth, we were off the houseboat. We were afraid our child might fall into the water. We haven't lived on the boat since. We left it, and all of our rowdy behavior, at a dock on Lake Shasta. As of this writing, we're refurbishing the boat. We're going to go back from time to time, to ride and fish as a family.

Before we could move though, I had to find a place for my family to live. I still had the big house I had bought for my third wife, but Theresa didn't want to live there, for obvious reasons.

I decided to remodel and expand an old cabin on our land. The place was about to fall down, anyway. The first day I considered redoing it, I was greeted by a "moo" when I pulled up to the front door. A cow was standing in the doorway.

I don't think anybody but me saw the potential of the place. I worked the spring and summer of 1990 with contractors. I wanted our new home to be a surprise.

"You'll have to trust me," I told Theresa. "I'm going to leave every day, and I don't want to tell you where I'm going." The workmen and I tore down walls and put up new ones. We shoveled out debris and laid carpet and tile. We painted and papered. And we did it all after significant structural changes, and rewiring and replumbing the place.

When the work was completed, I got Theresa in the car and I drove the back way to the cabin. She had forgotten about the dilapidated old building on our property.

I showed her the new one.

"How do you like it?" I asked.

"It's beautiful," she said, not believing her eyes and not believing it was ours.

"This is our new home," I said.

She cried instantly, and eventually we moved in. We live there to this day.

Our land is overrun with game. Deer roam like cattle around our 191 acres. Wild turkey are everywhere. And we have a wolf Theresa raised from a pup. She feeds it dog food. The wolf is so docile, it could never survive in the wild.

The family and I fish a lot in the ponds I dug, and we often eat what we catch. The landscape is thick with roses and wildflowers. It couldn't be more homey. There is no place I'd rather be and no people I'd rather be with, than my home and family.

Theresa got pregnant again when I was fifty-six.

"I'm going to have a son," she announced one day.

She hadn't seen a doctor or taken a home pregnancy test.

She wasn't even late with her period. She just knew she was pregnant, and she knew it was a boy. Having a doctor confirm it was nothing more than a formality.

"What do you mean we're going to have a son?" I asked. "Are you pregnant?"

The doctor made his decision six weeks later.

My family was meant to be.

I wasn't afraid during Ben's delivery, as I had been during

MY HOUSE OF MEMORIES

Jenessa's. In fact, I participated, or at least I tried. Theresa again had trouble, and there was another cesarean.

They put my last child and youngest son in my arms. He has been in my heart ever since.

At age five, Ben Haggard announced that he intended to die in the house where he now lives. He said this was his place, and as far as I'm concerned, it is. May he, and his children, grow old here.

Theresa and I got married on our land, in a ceremony performed by my friend Tommy Collins. A few hundred guests came to watch us take our vows as the sun went down.

Then we slipped away from everybody. Our guests were making merry. I won't say what we were making. We later rejoined the group. I'm not sure most of them had missed us. I'm not sure the few who did even cared.

Happiness exhibits itself. Theresa and I wear it like a sign.

My children only leave home to go to school. Even that will cease in the fall of 1999, when they start home schooling. Given the violence in public schools today, I don't want my most prized and precious possessions in a jungle of young warriors. They'll have a tutor at home.

Some folks contend that I'll be shielding my kids from the real world with home schooling. Nonsense. My kids have all their adult lives for the real world. They'll prepare for it in a controlled world—a world controlled by love.

And Theresa and I love to see their personalities unfold without the influence of other youngsters. My kids have their own identities, not some other child's. The fall of 1999 will mark Ben's entry into first grade, Jenessa's into fourth.

I don't know any place on earth more homey than the

Haggard household today. My wife still dresses simply, and I love it. I've had my fill of makeup and glitter. My kids roam around our acreage, usually with me. If I make a record, I make it a half mile from my front door, in a studio that's also on my land.

We rarely leave. We rarely want to. I go on the road, of course, but that, too, will stop. The year 2000 will mark my last highway marker. After thirty-seven years, I'm doing my farewell tour. I'm thinking about opening a restaurant/nightclub in Lewisiana, where my band can play almost every night and I can sing whenever I want to.

The traveling Merle Haggard will be no more. I'm tired. I'm taking one year off at least. What's more fun than a comeback.

I've thrown away a fortune, but I've got a nest egg, and the nest and egg are quite comfortable. And with the help of Theresa and the wise management of Rose Waters, my investments are paying off. Rose has been my business manager for about two years.

Rose is a surrogate member of our family. When she and her husband visit, the six of us sleep on my back porch, under the stars.

Morning finds the family and me at one of our many ponds after breakfast. Before we leave the house, Theresa puts on a pot of beans. We eat them at least once a day, and sometimes with every meal. Many times, beans *are* the meal. There is something wonderfully secure about having a pot of beans on the stove.

Theresa is a gardener's gardener. She breaks the ground in the spring with a rototiller—she'd use a tractor with a plow if

MY HOUSE OF MEMORIES

I'd let her. On bended knee, she plants tomatoes, peppers, lettuce, spinach, broccoli, celery, onions, garlic, corn, squash, zucchini, and watermelon. Black-eye peas and purple hull peas are setting in jars all over the house in preparation for a possible Y2K problem. Just in case something should happen, and the grocery stores are left empty, Theresa and I want to make sure we're prepared.

I've never been worth a lot of cash at any time in my life, but I have a substantial income from the royalties I get from the CDs you have bought throughout the years. I know there's a lot of you who love and respect and covet the chance to say hello someday. The chances of it happening are slim, but who knows. Thanks for the loyalty through the years. Don't think I don't realize that I've been given that one in a billion life. The gift of creative longevity. The music gains momentum every year. Each song is like a living child that has yet to mature. I compare my life to different personalities. My sister, Lillian, says I remind her of King David. I find my life more resembles the life of Job. If I'm right, and Lillian's wrong, I may yet live another 140 years. Just think of the albums we could make. I might even finally get good on the guitar.

If someone asked me what I love most about Theresa, I might say I love how she loves me. The woman's every thought is to attend and please her family.

Then there are the little things. She knows I'll forever be crazy about Bob Wills's music. So she puts it on the stereo as soon as she knows I'm up and around. Or she'll rotate it with Bing Crosby, Milton Brown, or Lefty Frizzell. She asks to go on my road trips, even when she knows she has to stay with

the kids. It breaks my heart to tell her no, and it breaks her heart to hear it. But we're both glad she asks.

I'd be hard-pressed to pick a favorite memory from those made with my family. I've had houses before. This time I have a household. I've had wives. This time I have a best friend and a lover.

There are some people who wish they had our place and our land and everything else that is ours. They almost did.

"You have a son, Mr. Haggard," the nurse said, as she handed Ben to me seven years ago.

The next touch I felt was from a stranger. He, too, handed me something. With my baby in one hand, I held a court paper in another. It said I was being sued by my creditors for failure to pay my debts.

Once again, I was paying a high price for cheap thrills and bad decisions. And I was dunned at one of the most memorable moments of my life.

18

★ ★ ★ ★ ★ ★ ★ ★ ★ ★ ★ ★ ★ ★ ★ ★ ★ ★

"SOMEDAY WE'LL LOOK BACK"

Some members of my band were shocked in October 1997 when I announced on national television that I was "broke." The word is now an exaggeration.

One's financial status is very personal. People will ask those who know me about it, but never ask me directly. When Tom Carter was doing research for this book, the most frequent questions he heard pertained to my money, or lack of it. People couldn't understand how I could make and lose so much in one lifetime.

It's none of their business, but neither is much of what I've discussed in this book. I'm not entirely free to discuss my finances because of lawsuits against some of the people who helped squander my money through conflicts of interest and old-fashioned dishonesty.

People have no idea—no idea—how much overhead an entertainer incurs and how difficult it is to monitor the incoming and outgoing cash. And it takes a graduate degree

in accounting and a staff of professionals to stay abreast of the tax laws.

When your performance and travel schedule consume eighty hours a week, there is no time to address your cash flow, even if you have the financial knowledge. As I've indicated, I can't get away with filing the simple short form for my taxes. My accounting can't be done on a pocket calculator.

So I hire people to wade through the financial maze. I have freely admitted to squandering money on high times and impulse spending. And I've said that my mind was maybe altered or distracted a time or two when I was younger, when it should've been otherwise.

I accept my part of the blame, but I'm not passing the buck when I say the main reason for my financial woes is that I trusted the untrustworthy out of necessity. I was too busy making money to have time to manage it.

Maybe the people you trust are on salary, earning a middle-class living, and no more. Some of them could find it very tempting to dip into your funds because they know you're too overworked to catch them and too trusting to think you should. I've had employees who I've paid generous salaries, bonuses, and perks, only to discover later that they've embezzled from me.

Many people never understood how Willie Nelson wound up owing the Internal Revenue Service seventeen million dollars. I do. His career was hotter than a firecracker in the 1970s and much of the 1980s. He was an old road warrior who was doing about 225 shows a year and riding many hours daily on a bus. Meanwhile, he had a team of accoun-

tants who were working full-time to make payroll, invest money, and pay taxes on it.

It was a lot easier to monitor my money when I was earning $150 a week and had no employees than it was when I was earning thirty million dollars a year and transporting forty people five hundred miles a day.

Frank Mull said he didn't think I should discuss my bankruptcy in this book. He said it would make it appear I didn't pay attention to my finances. He's wrong. It makes me appear as if I didn't pay attention to those who were paid to pay attention. I didn't have the time. No one would have. Otherwise, the things that happened to me wouldn't have happened to so many of us in country music—Dottie West (who died broke), Willie Nelson, Tammy Wynette, and others.

In show business, you work to build a career. When it finally takes off, it can overtake you. You think about slowing down but wonder if you'll always be in such demand and remember a time when you weren't. So you ride the rocket as long as you can for as far as it will go—at the expense of everything else—including your expenses.

Rose Waters has been a source of financial salvation.

She and I had gotten a real early wake-up call. I bought something for eleven dollars and paid with a credit card. The card probably had a $35,000 limit. The eleven-dollar purchase was declined.

"How much have you put on that card?" she asked.

"Rose," I said, "that's the first time I've ever used that card in my life."

She found out that many people in my organization who

had no official reason for the card had a copy nonetheless. She put a stop to that.

She recently suggested that RCA buy an advertisement for me in *Billboard*. It was a photograph of my back over a caption that said, "Merle's Back!"

Thanks to Rose's skills, her assistant Angel Chavez, and my growing wisdom, I am. And I have three years left on my IRS agreement and then I am finally even with them. Maybe I can make a little money for me.

19

★ ★ ★ ★ ★ ★ ★ ★ ★ ★ ★ ★ ★ ★ ★ ★ ★ ★ ★ ★

"THE ROOTS OF MY RAISIN' "

On March 15, 1999, I returned to my story's starting place. I went to Bakersfield. That's when I did the show for the hometown folks that I mentioned earlier. The show was not the primary incentive for my visit. I had taken a curious approach to the writing of this book. I had tapped my memory, and the memories of scores who've known me, for a year. As a final check, I wanted to visit the place where my life, and later my career, had begun. I wanted to see, and to feel, the environment where I had formed habits and friendships, many of which continue to this day.

Memory lane can be a bumpy road. I thought the trip to Bakersfield might be unpleasant. It was, in fact, at times traumatic.

I drove the streets where I had run from the law a half century earlier. The temperature was unseasonably cold, and light rain fell on the windshield. I drove through the mist and my intermittent tears.

I went back to Oildale and Bakersfield in 1999, but I didn't return. I never will. I never can.

Every intersection was jammed with the day's traffic and yesterday's memories. Tom Carter turned on his tape recorder, and Frank Mull and Theresa went along. I hate to talk when I'm not in the mood and the sights and sounds I encountered initially left me speechless. Since I was there to talk, I forced myself to deliver.

I was glad, for purposes of publication, that I went back. I was more glad to leave. I don't know if or when I'll ever make the trip again.

I told you earlier about Lewis Tally and Roy Nichols getting into a fight outside a nightclub and how their skirmish almost cost them their jobs. I indicated how Lewis was probably the most eccentric, indescribable human being I've ever known. I hadn't been driving for five minutes when I passed the spot where Lewis and Roy had their fight, and I instantly flashed to a night in 1978 in Belfast, Northern Ireland. The country was at war, and our concert was covered by international news organizations. The thing I remember most vividly about the evening was my late friend Lewis Tally.

The band and I played a place where ticket prices were seventy-five dollars, unusually high, I felt. In fact, the average salary in Ireland at the time was seventy-five dollars a week, we were told.

The room's previous attendance record had been set by the Beatles and then broken by Elvis. We broke all records with a standing-room-only crowd in a twelve-thousand-seat hall. By overseas standards, that's a big venue.

The stage was about ten feet above the floor, and people

were literally trying to climb posts to get to us on the band-stand. Their deafening screams, and the fact that the hall had the worst acoustics I've ever heard, made our songs unintelligible. We couldn't hear ourselves through our monitors, and the fans couldn't understand us out front. It was an audio nightmare.

Enter Lewis Tally.

Anybody else would have gone to the sound engineer. Or maybe the arena manager. He would have done something logical that would have brought some good to a bad situation. Not Lewis.

He walked onto the stage, waving his arms and screaming, "Stop the show. Stop the show." That marked the second time in my career he had done that. As if things weren't crazy enough, here was this skinny lovable drunk, waving and jumping up and down, hollering for everything to stop in what was fast becoming a tense situation.

Both sides in the war had agreed to a twenty-four-hour cease-fire to accommodate the American entertainers. Try singing ballads when you know that at any time one side could break its word, and the hall and stage could be sprayed with gunfire.

Off the mike, I hollered for Lewis to go back into the wings. As I did, he tripped over an amplifier and fell flat on his face. The crowd roared even more loudly, some in laughter, some in anger, and most in confusion.

Rhythm guitarist Ronnie Reno remembers that he was laughing so hard he lost his tempo, thereby making the bad sound even worse. He was also supposed to sing harmony but couldn't, as he was gasping with belly laughs.

People have asked me countless times what Lewis's official job was with the Merle Haggard show. I've never been able to answer. Then they ask why I kept him on the payroll. That answer is easy: He gave me my first recording contract. And Lewie was the only one I knew for sure in the whole world who was aware of what it was like to be me. He just understood. And I knew he understood. I'm not sure anyone else ever has.

Lewis amused, consoled, and made me furious many times. He launched my career only once. Once was all it took. I never forgot it. I'm not exactly sure what Lewis did for me, but it was always all he could do. And often he'd spend time looking around for things left undone by other employees. There's no way to calculate when a man gives you his soul.

I told you earlier about my vivid recollections of my dad's death when I was nine. As I neared my childhood home in 1999, I remembered again going to live with my Aunt Flora, Mama's sister, after Dad's death. I was too much for Mom to handle by the time I was fourteen, and Lowell and Lillian had already left home.

Living with my aunt and her husband would be a good idea, Mom thought, and it probably was. So I moved to Lamont, California, home of a place called the Smokehouse and a local tough guy named Nelson Blake. The place and the man consumed the imagination of a young boy whose primary male influence and hero had recently died.

Nelson had a regional reputation the likes of which the law won't tolerate anymore. He could whip anybody, every-

body knew it, and tough guys from far and wide came to challenge him.

Nelson just quietly ran his saloon, took on all comers, and never knew how he fascinated this wide-eyed youngster.

Nelson Blake had opened his tavern three years after I was born. I used to love to hear the men, many of whom seemed like seasoned old-timers, tell about the night before, when Nelson had knocked out two guys with one swing and stuff like that. Many of the stories were exaggerated, I'm sure, and gradually became folklore.

But some were true. They had to be. They'd been told too many times by too many people, and they were always told the same way. Today, an ambitious district attorney would have a place like Nelson's declared a public nuisance and closed.

Nelson was mopping at about 10:30 one morning, according to one report, when a man entered the premises. The story goes that the man was so big he had to duck to get under the front door.

"Pardon me," the fellow said politely. "I'm looking for a fellow named Nelson Blake. Does he happen to be around?"

Nelson had been in so many fights he doubtlessly had a sixth sense about brewing trouble. So he didn't identify himself.

"What are you looking for him for?" Nelson supposedly asked.

"I'm here to whip his ass," the stranger replied.

Nelson kept mopping.

I can tell this story as precisely today as I could when I

was young. I heard it dozens of times then, and I've told it dozens of times since.

"Well," Nelson drawled, "you want to whip Nelson Blake's ass, huh? I believe he'll accommodate you. I hear tell he gets here every day at about five o'clock."

The stranger returned that day, promptly at five o'clock. Nelson was standing on the bar. In his hand he held a sock. Inside the sock was a bar of soap. In 1946, a lot of folks still made their own soap, often of lye. A bar could weigh two to three pounds. Two to three pounds at the end of a two-foot sock swung by a four-foot arm presented some dangerous and possibly lethal momentum.

The big man stepped through the door, and as the saying goes, he never knew what hit him.

As I approached my old homeplace I thought about Lamont, and how it was an oil town, one of those places that sprang up about as fast as the gushers upon which its economy was built. There were makeshift streets, but the sidewalks consisted of sand soaked with oil.

I continued down my memory lane last March to that nightclub, the Blackboard. Today it's a Domino's Pizza. The kids working there have acne as their greatest worry and getting laid as their greatest ambition. They have no idea how music and singing and dancing once went on within those sterile walls. Who would tell them? Who could? The teenagers would just think the storyteller was just an old man whose memory wasn't so good. All the drinks they serve at Domino's are soft drinks. But I can't count the number of times I had seen pint bottles of liquor in the parking lot, where a few

cars were bouncing up and down. And where Roy Nichols drank everybody's drink while they were dancing. Frank and Joe, the owners, didn't mind. It was good for business. In the days of the nightclub, every police officer knew where trouble was going to be. Where once the local beer joint, the local dance hall, and the whorehouses were the trouble spots, what we have now are street tramps and drive-by shootings. Seems like we've gone from the fryin' pan to the fryer.

Time changes everything. Officially, the changes at the old Blackboard building are for the better. No one ever got caught with anyone's wife, or got the hell beaten out of him, or cried to a Lefty Frizzell song in a restaurant that specializes in pepperoni pizza.

So why, in the face of all those "improvements," was I so sad? Memories can't hurt and time does not heal. I found that out that morning.

I took my wife and friends that March morning past the Shell station I once robbed by pretending to be an employee. I drove past the grade school I attended for seven and a half years before I was expelled. I drove to the intersection where, five days a week, my mother would catch a bus to her job as a bookkeeper for Quality Meat Company. I stopped in the intersection and looked at the cracked sidewalk in what was once Bakersfield's nicest suburb. It's now rather run-down.

People would have no idea that the grandest lady of them all once waited patiently on this corner so she could work for minimum wage to raise a son who'd eventually waste millions on gambling, bad investments, ex-wives, and be sent to prison by the county seat. And a decade later would be made Man of the Year by the same authority.

Her body is only a few miles away in a grave. But I could see her standing there, waiting for a bus that has long since stopped running that route. I swear I could see her—even through the tears.

There has been talk of naming a boulevard after me in Bakersfield. Rose is all for it. Me, I'd rather see a bronze statue of my mother—lunch sack in her hand, print dress to her calves—erected on that corner.

And then we arrived.

I simply recited the address: 1303 Yosemite Drive.

"That's it, isn't it?" Carter said.

"Yeah," I almost whispered.

There was nothing there but another run-down house. Behind the house, however, sat another. Its decay was more striking. It was long, rectangular, and empty. It had once been a boxcar and then the home of James and Flossie Haggard.

My first home had ridden the rails before I ever did. I suspect it will stand after I'm laid to rest. My mind went to black and white. Something about the time period I remembered. Something to do with films I admired, I guess.

As the four us of got out of the car, two young men emerged from the house in front.

"Hello," I said. "I'm writing a book, and I used to live in that house behind yours. I wonder if I could go through it. My name is Merle Haggard."

The young men said they knew who I was and expressed surprise that I was there. They had heard that I had been born in the shanty behind their house.

MY HOUSE OF MEMORIES

The boxcar's white stucco exterior was stained. Plywood covered the windows through which I had marveled at passing tank trains as a lad. Between the converted boxcar, and the newer house in front, were pens holding chickens. The lawn looked like someone was preparing for a junk sale. A rusting lawn mower, a Christmas-tree stand, old ironing boards, and assorted litter was all over the place.

I was glad my mother couldn't see it. She had taken meticulous care of our home, both inside and out. Flowers had graced the yard and the lawn was always mowed and trimmed as neatly as a golf course.

The driveway to the street was lined with poplar trees. There were also nectarine trees on the place and I earned my first money as a child selling nectarines.

When the four of us walked inside last March, I pointed out what had been a front porch, where I slept until Mom and Dad decided I was old enough for my own room.

As I walked through the place, I saw once again the first bathtub I ever saw in my life. My dad made it by hand out of concrete and steel. I walked into the wash house, a room that held the washer and wringer Mom used every Monday. I don't know why Monday was always wash day for working-class and farm households until the advent of automatics, but there're a lot of songs written about it.

I remember how Dad had painted the entire interior with a brush. Maybe I'm only talking about two or three hundred square feet. But they were so proud of it.

On that March morning, the room that had been mine was covered with felt-tip sketches of naked women and graffiti. The double bed had a bare mattress that was covered

with urine and other stains. There were no other furnishings. I've been in jails that were less stark and more sanitary.

My dad would have died again if he could have seen what had happened to the home he worked so hard to build and Mom struggled to decorate. They were poor, but they were proud. Their belongings were modest, but they were clean and they were in place. Always.

No one lives in the old house today. That's good.

Theresa wanted to take my picture standing in the doorway of the old home, and I let her. She didn't say anything, but she took longer than needed to focus the camera while I let my tears dry themselves.

The two young men were kind to let me walk though the place, but I think they were embarrassed at what had become of it. They kept apologizing for its appearance and talking about the improvements they were going to make someday.

I won't comment as to whether I think they will. It will never be the wood-and-stucco jewel box it had been in the hands of James Haggard. Dad could do anything with his hands.

I put my hands on the solid wood cabinets he had built by hand. The old house was humid that rainy morning. Windows were open. For all practical purposes, those cabinets had been exposed to the elements for all these years. Yet not a single shelf was warped, not a single side curved.

We took a few more pictures, thanked the young men for their kindness, and loaded ourselves into the car. I could have looked Theresa's way and viewed the place a final time through her side window. But I'd seen enough. And I'd seen too much.

My House of Memories

* * *

I started back through Bakersfield.

I drove past the Golden Bear Refinery, which has no significance, except that it exploded in December 1941. The people at the refinery thought the Japanese, who had bombed Pearl Harbor the previous week, had bombed them.

I drove past China Grade, where Tommy Collins wrote "High on a Hilltop," a song on one of my early Capitol albums. Tommy could see the lights of Bakersfield and was inspired to write the song.

On that March 1999 morning, I pulled up to what had been my office in the early 1970s. I hadn't been inside the building for years. Some graves lie exactly two hundred steps from the front door. I know. I once counted.

20

★ ★ ★ ★ ★ ★ ★ ★ ★ ★ ★ ★ ★ ★ ★ ★ ★ ★

"MY HOUSE OF MEMORIES"

I bought the Bakersfield office building in the 1970s. At least four years passed before I walked across the street to my dad's grave. I don't know why I waited. He had been dead since 1946. Mom died in 1984 and Lowell died in 1996. Cancer took my brother through a slow and agonizing death. Bill Ray, Lillian's husband, is also buried in the family plot, he was taken by cancer, too. He was working for former California governor Ronald Reagan when Reagan gave me the full pardon.

Each of my departed lies in a grave marked by stones identical except for their inscriptions. There are no monuments towering above the ground. They lie level just above the surface, so they blend in with others in the cemetery. I like that. In death, people should be equals.

Because the headstones don't stand out, my friends and I had trouble locating them in the winter of 1999. The four of us looked for ten minutes before we found the Haggards.

Then, as I stood above Dad's grave, my mind raced in

reverse. I remembered how strong he was, how he smelled of tobacco, how he feared nothing, and how he was so sensitive. How many thoughts can a mind process at the same time? I wondered.

Death touches everyone eventually. When it touches your family, it stings as if it's never touched anyone else's.

I thought about how Lowell had tried to help run my enterprises, how we had disagreed, how he had admonished Mom about my behavior when I was young, and how I'd refused to listen to his advice way back then.

And then I stood above Mom's stone: FLOSSIE HAGGARD, 1902–1984.

I thought of the times I had lied to her, of how proud she was of my success, of the song "Mama Tried," and of how she always wanted me to be a gospel singer. She loved my gospel songs more than any others.

I thought of what I had done for her and was glad that I was able to help her financially, but I wished I had helped her more. Why? Would she have lived another day?

"Why don't you show the biography to Tom Carter?" someone had suggested to me a few days earlier. My mind rushed to its pages as I shivered in the gray air and fell light rainfall on that chilly morning in Southern California.

My mother was the Oklahoma penmanship champion when she was a girl. She wrote in a cursive as elegant as English script. A few months before passing, she wrote her life story in longhand. She said she'd write more later, but later, for her, never came.

She covered eighty-two years in sixty-eight pages.

I'm mentioned twice. My name appears for the first time

MY HOUSE OF MEMORIES

on page nine and again on the fourth from the last page. The first mention is about my song "Daddy Frank." In the second, she wishes I was a full-time Christian singer. That was the long and short of her discussion of me.

Mom's very first recollection was of throwing her tiny hand into hot coals when she was three. Her mother, Zona, was boiling soap in a cast-iron skillet. Mom also wrote that she remembered traveling by covered wagon from her native Arkansas to Indian Territory, Oklahoma. (Oklahoma did not become a state until 1907.)

She lived in an earthen dugout, with windows at ground level, with her parents, grandparents, aunts, and uncles. Imagine, their walls and floor were dirt. Oklahoma is notorious for torrential rain that floods the flatlands in the spring, leaving the ground as mushy as meal. The water must have turned the dugout into a giant underground mud hole.

I remembered, that day in 1999, how Mom had worried that I'd spent too much money when Bonnie Owens and I bought a home outside Bakersfield, and how she felt the same way about the spread I had with wife number three. Her concerns about my spending were obviously rooted in her own modest past.

Mom's autobiography talks about half-naked Native Americans who rode to the earthen home on horseback and how her mother feared them and their dress, or rather their lack of it.

Mom remembered seeing a talking bird—a parrot—in 1909 in Atoka, Oklahoma. In 1977, Atoka was the site of the largest outdoor country music concert ever held. In the feature film made from the event, Hollywood spliced in enter-

tainers who weren't even on the show, including Marty Robbins. Mom wouldn't have approved of the deception, and actually thought *she* was being deceived when she saw that talking bird nine years after the turn of the century.

Mom wrote that she remembered fighting mosquitoes and the malaria they carried, the way someone would fight disease in a Third World country today. Her dad, she wrote, bought some patent medicine, probably from a touring medicine man, after being assured it would cure his malaria. He doubled his dosage, went insane, and was committed to a sanatorium.

"This must have been a trying time for mother," Mom wrote. The entire text is that understated. There is no complaining about the nonstop fight against men, beasts, and the elements just to stay alive to fight some more. People today will never understand the survival instinct and work ethic that evolved from such a grueling, primitive, and threatening existence.

When Mom was six, she saw her grandpa William Harp kill a rattlesnake so long that its carcass dragged on the ground when slung over his shoulder. The man was more than six feet tall, she wrote.

I suppose some folks think that's a tall tale. They've never lived in rural Oklahoma, parts of which are just as rough today.

Standing above Mom's grave, I thought about all the sacrifices she had made as a child and young woman. It seemed so unfair that she was still living sacrificially well into young womanhood, and that the best home she'd had to that point was a converted boxcar. I wished I'd thought of that when I

was younger. The following statement isn't very original for a regretful son, but it is very sincere: I wish I'd appreciated her more.

And so I stood there that March morning, damp from the cold rain that I'll bet Mom and her people prayed for when they were fighting nature's furnace almost a century earlier.

I suddenly just wanted to be at home with Theresa and the kids, but we had a show to do that night. I would have been much more content with my wolf who thinks it's a dog, my turkey who thinks it's a chicken, and my wife who I know is my lifelong companion. I was glad Theresa was by my side, even if we weren't under our roof. God, I love that woman.

I left Mom's grave well before noon that morning. I walked past each of the family plots a final time, then made my way to the car. And I remember thinking, I wish my sister and I had become closer over the years like my mother had always wanted us to be. We need each other so much. My only brother, Lowell, who passed away in 1996, once said Dad played guitar like Merle Travis and could sing like Jimmie Rodgers. Dad would've been one hundred years old this year. And if God wanted him to, he could've lived. The proof is in the fact that my good friend former Louisiana governor Jimmy Davis celebrates his one hundredth birthday this year. And finally there's Theresa's father, the only one of our four parents who is still alive today, giving me someone of seniority in the family to look up to again. It's an odd feeling. Erv Lane, Theresa's father, and I—we hit it off well. It's neat to have a dad around again.

I found my way out of that cemetery without once looking back.